creative low-budget publication design

MARY PRETZER

NORTH LIGHT BOOKS
cincinnati, ohio

ABOUT THE AUTHOR

Mary Pretzer, owner of a training and design company in Loveland, Colorado, is an internationally known speaker and writer. Her specialty is common sense problem-solving focusing on practical, real-world solutions to editing, writing, design and creativity challenges. Mary has taught thousands of seminars and workshops all over the U.S., Great Britain, Switzerland, Australia and New Zealand.

A one-time reporter and photographer, Mary has worked in all phases of publishing and remembers well the days of true typesetting, waxed galleys and paste ups. She has worked as a publication specialist for a university, owned an ad agency and headed curriculum development for a major training company. She was also the editor of In House Graphics, a subscription newsletter for designers.

She is currently the design columnist for the Editor's Workshop newsletter and a frequent freelance writer for business, trade and association publications.

ACKNOWLEDGMENTS

Special thanks to the designers who contributed to this book. Without their special insight and willingness to freely share a bit of their personal creative process, this book wouldn't have been possible. Also, thanks to Sandra Blum, Jill Townsend, Kitty Moore, Lois Griffin and Jim Walker for patiently listening to me fret and "talk out" the book.

Other fine North Light Books are available from your local bookstore, art supply store or direct from the publisher.

03 02 01 00 99 5 4 3 2 1

Library of Congress Cataloging-in Publication Data

Pretzer, Mary.
 Creative low-budget publication design / Mary Pretzer.
 p. cm.
 Includes index.
ISBN 0-89134-847-6 (alk. paper)
 1. Graphic design (Typography) 2. Newsletters–Design.
3. Pamphlets–Design. I. Title.
Z246.P935 1998
686.2'2–dc21 98-42403
 CIP

Edited by Kate York
Production Edited by Amanda Magoto and Michelle Kramer
Designed by Brian Roeth

This book is dedicated to the memory of my hero, Marie G. Pretzer, my mom, who inspired me and inspires me still with her love of books and words, creativity and laughter.

6 INTRODUCTION

10 SECTION ONE

tackling heavy text

Lots of newsletters and publications have tons of text and not much else. Learn to make the most of it!

24 SECTION TWO

creative use of fonts

Spice up your publication in ways that defy boredom! The use of certain typefaces can make a difference.

38 SECTION THREE

great grids and nontraditional layouts

Get past thinking that if you have to have a grid, you're doomed. Here are some examples that break the mold!

56 SECTION FOUR

using clip art creatively, not compulsively

Clip art can add a lot of interest without adding the cost of photography. Keeping it clean and simple is the trick!

72 SECTION FIVE

photos: making the most of what you have

Client-supplied photos won't necessarily put the kibosh on a good design. Hide them, crop them, make them more interesting!

88 SECTION SIX

beyond 8½" x 11": formats that break the mold

Think outside of the box, or rectangle as the case may be. Don't adhere to one format just because it's always been used.

CONTENTS

102 SECTION SEVEN

powerful, inexpensive production techniques

You'll get the most for your money if you know the ins and outs of prepress, production and printing.

114 SECTION EIGHT

making the most of one- and two-color printing

Get ideas on how to maximize one- and two-color jobs so they look like works of art! More color is not necessarily better!

130 SECTION NINE

DIY—do it yourself

These pieces, while not publications, are great examples of doing the production yourself and saving a bundle in the process!

140 PERMISSIONS AND COPYRIGHTS

141 INDEX OF CLIENTS AND FIRMS

142 INDEX OF TERMS

contents

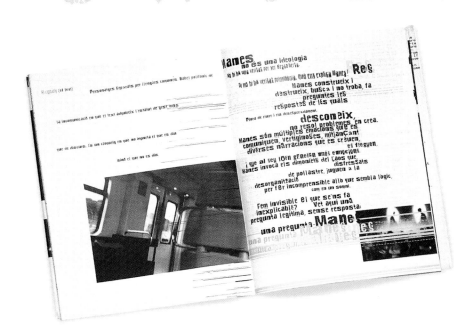

introduction

i n t r

The Economically Challenged Endeavor (or Projects for Peanuts)

Every designer (or editor, manager, committee chair, etc.) is at some point creatively challenged by a low-budget project; some of us are so challenged more often than others. (In fact, we dream of the day someone comes in and signs a blank check for our services.) But what makes the designers featured in this book so amazing is how creative they are in spite of budget adversity—or is it *because* of the adversity?

> *"When all is said and done, monotony may after all be the best condition for creation."*
> MARGARET SACKVILLE

Simply put, creativity is problem solving. In fact, how designers respond to economic challenges is a keen indicator of their overall talent. It's one thing to have excellent, full-color photography and illustration, topnotch copy and premium paper. Being creative and dynamic with unlimited options is easy.

Low-budget projects come bundled with a host of other problems. For instance, have you ever had a client:

- limit your ink colors to one—like grass green?
- tell you that if they're paying for a second ink color you should use it liberally?
- give you pages of text-only copy with the instructions to "jazz it up but keep it conservative?"
- hand you photos that have to be used, even though some of them don't come up to driver's license standards?
- inform you that Carl's Copy Quik is going to print the piece?
- present you with an interesting, even fun, newsletter, brochure or booklet that's simply underfunded?

All the designers featured in this book have unique ways of turning tedious into terrific. They give their projects strong visual power that isn't immediately obvious. However, inspiration comes from different directions. One designer gave new life to a potentially drab, text-only newsletter by adding artwork. Another took a traditional 11" × 17" (27.9cm × 43.2cm) sheet and created a 7" × 10½" (17.8cm × 26.7cm) finished newsletter. Still another put his Adobe Photoshop savvy to good use, turning mundane images into marvels.

Where did you get that idea?

"Design in art, is a recognition of the relation between various things, various elements in the creative flux. You can't invent a design. You recognize it in the fourth dimension. That is, with your blood and your bones, as well as with your eyes."

D.H. Lawrence

You're free to borrow the treatments and ideas that worked so successfully for these designers. This is, after all, an idea book. But you may also want to use them as springboards to your own solutions.

Low-budget projects call for mental dexterity—honing in on unique connections. In search of economical ideas, designers approach the creative process from two directions.

The first group looks for inspiration in what they have and focuses on ways to make molehills into mountains. If all they have is type, for example, they look to type for stimulation. They center their pieces around novel typefaces, extreme sizes, active or mood-setting fonts or grunge faces. They find key words, phrases, headlines or even individual letters for their fertile imaginations to chew on and spew out infinite possibilities.

If they have a second color to work with, they hinge the design's "wow" around that. They choose unusual, trendy or nontraditional colors to establish a mood and get attention. Spot color is splashed and streaked across pages, guiding the reader's eye. Dramatic, unusual shades mingle with shades of black for third color combinations. Sometimes the color is subtle and simple.

Some even turn sparse copy and no visuals into a white space advantage, resulting in elegant and minimalist designs.

The other group seemingly takes the opposite approach by focusing first on what they *don't* have. At first glance this negative approach seems detrimental to creativity. After all, with low-budget projects you don't have a lot of things. These designers target strategies from outside the project. They turn commonplace clip art into arresting illustration. Paper cut and folded into format permutations turns the mundane into marvelous. Everyday objects and bits of scraps are scanned to become one-of-a-kind backgrounds. They ferret out cost-effective add-ons that complement the all-text project or keep the blurred photography out of the limelight.

"Ideas too are a life and a world."
G.C. LICHTENBERG

There's no one-size-fits-all way for turning every low-budget project into a showpiece. Finding the right creative option is impacted by three things besides budget:

1. Your ability to carry out the concept.
2. The amount of time you have to complete the project.
3. Your authority to make changes to the design.

That's why this book is full of so many ideas. In fact, you'll find an "idea engine" at the front of each chapter. The "idea engine" can give you that initial spark—a small "aha" experience—to get a great concept going. Don't be disappointed if nothing on a list or in a chapter clicks for you right away. Keep reading and trying different concepts. A low-budget project doesn't have to lend itself to a quantity of ideas; it just takes one. Reading and leafing through this book can jumpstart a lot of ideas, but so will making your own creative connections.

Here are a few general concepts to keep in mind when you're looking for a creative answer for a low-budget project. Remember, these concepts can be art, type, photos, color, format, layout—anything. Combining concepts is powerful, too. You can make your project impossible to ignore by using something

- Loud. A strong focal point—something that grabs the reader at first glance.
- Odd. Your aim is to make the audience curious or amused.
- Elegant. Simplicity is always "in." Open, light, sophisticated.
- Opposite. Do the exact opposite of what's expected or traditional.
- Time related. Go for an old-fashioned, retro look or the futuristic "wired" look.
- Structured. Sometimes simply the ability to find and reference items quickly is the key to a design that works. Think organized and useful.
- Contrasty. Dark/light, big/small, hard/soft, conservative/contemporary, meek/wild, loud/quiet, fat/thin. Mix elements of different degrees to create visual tension.
- Unexpected. Surprise and startle the reader.
- Emotional. Make readers feel stress, sadness, jealousy, giddiness, silliness, fear, confusion, etc., at first glance.
- Similar. It looks like something the audience has seen before and has a positive impression of.

- Unpredictable. It is not what the reader might assume it is.
- Playful. Games, quizzes, game shows, puzzles, word play—FUN!
- Childlike. Simple, innocent, whimsical, young, "outside the lines."
- Dreamy. Think whimsical and ethereal, light and soft.
- Shape filled. Find or create a geometric pattern.
- Size shifted. Make something extremely large, extremely small or life size.

Concept to concrete—bringing it in at budget

"Great ideas need landing gear as well as wings."
 C. D. JACKSON

The stereotype of creative people is that they are born that way; they just have better ideas. The truth is, they generate more ideas to choose from. Having lots of ideas increases your odds that one of them will actually work. So when you land on one good idea for your low-budget project, don't stop. Being armed with several angles will keep you from being disappointed or surprised by unforeseen concerns. After all, not every great idea works. And sometimes being too creative can backfire. How many times have we heard stories of beautiful brochures that didn't fit in the envelopes? Or a mailer that needed extra postage because of paper weight?

No one wants to redesign or reprint any newsletter, booklet or brochure. But low-budget projects especially can't afford surprises or expensive reprints. Getting technical advice is important.

Common sense dictates that once you have an idea for your project, you may want to run it by the "experts." The experts are different on each project. Experts include

- the person(s) in charge of the project
- the commercial printer(s)
- the technical people (e.g., computer operator, scanner)
- members of the final audience
- copywriters
- photographers
- mailers or distributors
- other designers

You might not need all the experts to buy into an idea, just the necessary ones. So, use this book as a starting point. Only 52 projects are featured, but thousands of ideas lurk between the lines. You don't need a large budget to be creative; you just need a large imagination.

tackling
heavy

one

text

Nothing repels the eye faster than too much copy. Even information junkies like their pages broken into "sight bites"—scannable blocks of bite-size text. We're scanners and skimmers. However, it's not necessarily laziness or an addiction to "eye candy" that makes us this way.

Readers are processing more information from more sources than ever before. The average reader has a two-hundred-word attention span caused by information overload and the influence of electronic media. We've all grown accustomed to heavy doses of stimulation—sound, motion, pictures, color, charts, graphs, illustration, interactivity—from nonprint media (radio, TV, Internet).

Copy-heavy material requires a critical eye for organization of the text coupled with finesse and restraint with added visuals. Add too many images like clip art or photos from CDs and you risk wasting precious paper. (At least once, hasn't everyone had a "paper pauper" as a client—a person who sees a clean, open scholar's margin or a short column and wants to fill that empty space with something?)

Of course there's only so much a designer can do in cramped quarters. To really make a text-heavy publication eye friendly, you have to have room to work. Use inexpensive paper, but use plenty of it. (Although designer Magrit Baurecht saved money in other places so she could afford a more expensive textured paper that added a subtle, yet essential design element to the newsletter.) What you save by cramming eight pages of information into four will cost you readership. You'll save money on paper, but you'll have to issue magnifying glasses with each piece.

Text-heavy articles or publications present a unique design challenge. The designers featured in this section prove that there are easy and inexpensive options.

at a glance:

Lighten up!

Create multiple "ports of entry"

Shorten the paragraphs

Add "hot air"

Shop for an interesting paper

Use soft, light accent colors and screens vs. heavy, dark reverses

Maintain order and functionality

Tweak your text

Proofread

INSIDER ADVICE
Lighten up!

Text is a dark element in copy-heavy publications. Concentrate on letting the paper show through wherever you can. Resist the urge to decorate pages with reverses, little bits of clip art, heavy rules, background screens, etc. Instead of filling space, focus on leaving space.

Create multiple "ports of entry"

Facilitate the skim-reading process. Copy-intense pages not only need "front doors," like headlines, but lots of side doors, like pull quotes and subheadings. Back doors might be bulleted lists, italicized or bold key points or occasional one-line/one-word paragraphs. Scannable text is lighter and easier to access.

A good rule to remember is: Never have a full column of pure text running from the top of the page to the bottom if you can help it.

Shorten the paragraphs

Adding paragraphs adds "air" to the text itself. An old newspaper standard is no paragraph over two sentences long. Another is no paragraphs longer than the column is wide. Not that you want uniform length paragraphs—that'd be dull too. Use common sense and variety. Short paragraphs are restful visual breaks when interspersed with lengthier ones.

Add "hot air"

Increase the normal leading of the text by two to five points, especially if you've opted to use a small, condensed or compacted typeface (Times or Garamond, for example). Yes, this does take up more space, but it instantly airs out stuffy, dense pages. Research shows that sans serif text gets a definite readability boost from added leading as well. Remember, however, it's possible some people will have trouble reading text with too much extra space.

Shop for an interesting paper

While the paper you choose is only as good as the design you put on it, textures and color can add another level of interest to a layout. Be careful of flecked and speckled sheets, as these textures often interfere with the readability of text-heavy pages. Paper with "hairs" and spots of color don't fax very well either, so keep the end user and use uppermost in your mind. That still leaves plenty of options for more subtle textures (such as pinstripes or stipples) and endless color choices.

Use soft, light accent colors and screens vs. heavy, dark reverses

A second ink color easily pays for itself by adding visual interest to text-heavy pages. Keep the color dark enough to be readable when used for copy—headlines, pull quotes, subheadings, etc. Use percentages of the color to set off sidebars, highlight and organize tables or charts, or accent rules. Generally, reversed copy out of dark inks is too weighty. Heavy spots of color are riveting and distracting to the eye in contrast to the text.

Maintain order and functionality

Function doesn't negate form. The designers in this section prove that it's easy for a copy-heavy newsletter or booklet to be organized, efficient and appealing to the eye. The definite hierarchy of information is achieved with repetitive font sizes for specific types of information and consistent graphic treatments.

Tweak your text

Typographical flaws—like widows and orphans, double hyphens instead of em dashes—are more obvious in all-text pages. Granted, the average readers don't consciously see typographical faux pas. Rather, they see the publication as a whole as amateurish, sloppy or unprofessional. Of course, text should always be cleaned up, but text without the benefit of interesting photos or art is subconsciously scrutinized more closely. Take time to use special characters like em and en dashes, insert an ellipsis character rather than three periods, fix improper hyphenation, etc.

Proofread

Of course, everything, text-heavy or not, should be proofread diligently. Nothing screams louder on a page of pure text than a misspelled word or name—even in six-point type! Don't let a brilliantly executed layout be editorially executed because of a typographical error.

If a publication is pure text, have the information proofread closely by someone who hasn't read the material before. Never trust yourself to proofread something you've designed. Since type is a graphic element, designers don't necessarily read the copy they're working with. It's easy to work on a publication for days, even weeks, and not spot typos.

pinstripe paper perfect for law office newsletter

WILLIAMS, KASTNER & GIBBS LAW OFFICE NEWSLETTER REDESIGN

CREATIVE COMMENTS:

"The original newsletter was three ink colors, very dated and dense looking," says Baurecht. "I wanted to lighten it up."

The cool, corporate look introduced in The Advisor's black sans serif nameplate and bold sans serif headlines are softened by the use of warm teal as a second color and a friendly serif typeface for body text. Black reverses are used minimally in the upper corners and along the bottom margin to anchor the outer edges of the pages and provide a solid frame. The large screens of teal on the narrow outside columns are an excellent balance to the two wider text-only columns.

The entire layout is rectangular and blockish, composed of short stories broken up liberally with bulleted lists, initial caps and hairline column rules. The layout looks and feels solid—like a reliable law firm. Healthy margins, extra leading and justified left alignment add white space without being obvious or leaving "empty" spaces.

The money Baurecht saved by using only two ink colors was channeled into the paper stock. The vertical pinstripe in the paper is a subtle yet integral part of the law firm's newsletter design. "The pattern of the paper is actually a horizontal stripe. Printing the newsletter so the stripes run vertically required more paper, but the client didn't mind," explains Baurecht. "The pinstripe is perfect for the law office."

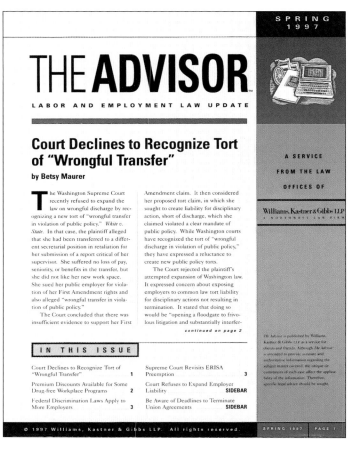

Baurecht isn't afraid of text-heavy design challenges. "My approach is intuitive and analytical," she says. "If clients communicate well, like this one did, I start seeing the design as they talk. They describe the look they want and what sort of image they have. Then it's just a matter of creating what I'm already seeing in my head."

On April 15, 1997, Governor Locke approved legislation which generally abolishes the administration and enforcement of the State Family Leave Act. It is not difficult to discern the reasons for the change, considering that Washington originally adopted its family leave provisions in 1989, about four years before the similar protections of the federal FMLA. However, less understandable are the two aspects of the State Family Leave Act that the legislature expressly left intact. First, after a qualifying leave, the employee must be returned to a workplace within TWENTY miles of the location of the employee's workplace when the leave commenced. Second, federal FMLA leave must be "in addition to" leave for sickness or temporary disability because of pregnancy or childbirth which employers are required to provide for the duration of the disability. Many unanswered questions are raised by this second provision. For example, does it apply only to employers covered by the State Family Leave Act (100-plus employees)? Is the Washington legislature amending the federal FMLA, and if so, under what authority? How does an employer comply with the differing medical benefit mandates under the new legislation and the federal FMLA? Please contact us if you would like to discuss our approach to these and similar questions. ■

employer's attempt to strong-arm an employee into adopting its political position. The newspaper also argued that the statutory provision was not intended to create a new protected group–political activists–which would be similar to those protected by Washington's anti-discrimination laws. The court rejected the newspaper's arguments, holding that this statute generally protected employee political activists.

However, the court had to go further to analyze the special constitutional status of this employer, a newspaper which is protected by the First Amendment to the United States Constitution's guarantee of freedom of the press. It concluded that the legislature could not constitutionally prohibit the newspaper from requiring that its reporters be politically abstinent. A newspaper is one of the few employers which will have constitutional protections specific to it that will

"trump" the Fair Campaign Practices Act.

There are many questions left to be answered, one of the most important being whether this statute applies only to political activity related to a particular candidate, ballot proposition, political party or political committee, or does it also protect more generic political expressions (such as the right to bear arms, abortion rights, domestic violence, or father's rights) where there may not be a current ballot proposition, political party or candidate involved?

Until such time as the courts or legislature give us more guidance, employers should exercise extreme caution in disciplining for, or attempting to control, an employee's political activity or expression of political ideas, regardless of whether it is tied to a candidate, ballot proposition, political party or committee. ■

Off-Site Truck Drivers Not Covered Under Federal Davis-Bacon Law

by Judd Lees

The Sixth Circuit Court of Appeals has ruled that truck drivers delivering materials from a dedicated off-site batch plant to a federally assisted highway project in Indiana, are not entitled to prevailing wage rates as determined under the Davis-Bacon Act. In *L.P. Cavett Company v. United States Department of Labor*, the court held that prevailing wages applied only to those workers "employed directly upon the site of work."

The truck drivers in question hauled materials from a batch plant three miles from a highway project and specifically dedicated to that project. The court determined that no ambiguity existed under the Davis-Bacon Act and thus the statutory phrase "employed directly upon the site

of work" means that only employees working directly on a physical site of the public work under construction have to be paid prevailing wage rates. The court determined that a batch plant located several miles away does not constitute the site of work.

The decision helps to clarify and narrow the scope of the federal Davis-Bacon Act. However, contractors are reminded that Washington's "little" Davis-Bacon Act is not limited to the site of work. The Washington Supreme Court has held that Washington's prevailing wage statutes may reach off-site fabrication. By extension, unlike federal law, Washington law could reach the transportation of nonstandard materials and supplies to a state public works project. ■

Microsoft Update: Ninth Circuit Reconsiders its Decision by Kurt Linsenmayer

One year ago, a three-judge panel of the Ninth Circuit Court of Appeals issued a significant employment decision against Microsoft, holding that certain freelancers working under written "independent contractor" agreements (which acknowledged the workers' responsibility for their own benefits) should nonetheless be considered eligible to participate in Microsoft's 401(k) and stock purchase plans. All the judges of the Ninth Circuit have now reconsidered that decision and held that the freelancers remain entitled to benefits.

The new decision takes a step back from the panel's interpretation of the 401(k) plan's eligibility criteria. The court held that the plan administrator should have, but did not, interpret whether the critical language of the 401(k) plan (employees who are "on the United States payroll") included the freelancers. According to the court, the panel should not have imposed its own views prior to receiving the plan administrator's interpre-

tation, so the court remanded this aspect of the case back to the plan administrator.

Regarding the stock purchase plan, the court focused on whether a valid contract for the stock purchase plan benefits existed between the freelancers and Microsoft under Washington law. The court found that it did, and ordered the trial court to determine an appropriate remedy under the plan.

While the court somewhat departs from the prior panel's reasoning and two-part decision, the freelancers still prevailed. Because of the magnitude of this most recent decision, Microsoft could seek review by the Supreme Court of the United States, so the final answer may not yet be in. Nonetheless, employers should remain cautious both in creating temporary employee or independent contractor relationships and in dealing with them once they are created. Further, employee benefit plans should be carefully worded to ensure that the employer's intent regarding benefits is lawful, clear and enforceable. ■

Be Careful of Innocuous Promises of Job Security by Judd Lees

Employers need to walk a fine line in providing reassurance to employees about job security. The Ninth Circuit Court of Appeals recently ruled that such statements may create an enforceable employment contract. In *Koepping v. Tri-County Metropolitan Transportation District of Oregon*, the appellate court reversed the trial court's dismissal of a lawsuit for breach of employment contract. The plaintiff worked as a

bus driver in Oregon and was covered by a collective bargaining agreement under which employees could only be terminated for cause. His employer promoted him to a supervisory position. The plaintiff expressed concern about the promotion and the resulting loss of "just cause" protection under the collective bargaining agreement. A department director advised him that "as long as he felt we were doing

continued on page 4

The EEOC has recently interpreted the ADA to conclude that an employer may share medical information with a union if the disclosure is necessary for the union to determine whether a reasonable accommodation in a bargaining unit job is needed. Often, an accommodation may include considerations of modifying the job or placing an employee in another job, both of which may contravene a collective bargaining agreement. There are important qualifications on this sharing of information: (1) the union must keep the information confidential, just as is required of the employer; and (2) the union may disclose the information (or even information regarding the need for an accommodation) only with union decisionmakers or consultants regarding the accommodation, not with a grievant or rank-and-file union member. ■

DESIGNER:

Magrit Baurecht

ORGANIZATION:

Magrit Baurecht Design

SIZE:

8½" x 11" (21.6cm x 27.9cm)

QUANTITY:

2,000

COST:

$1,550 (printing and production)

OBJECTIVE:

Replace an existing newsletter design with one that is more contemporary, but remain corporate and conservative.

HOW WE SAVED:

The purpose was not so much to save money overall, but to redistribute funds and make better use of the existing budget.

recipe for text-heavy success

DISTRIBUTOR NEWSLINE NEWSLETTER FOR CUTLER-HAMMER

CREATIVE COMMENTS:

Combine large amounts of product description with client-provided product photos. Stir in a liberal dose of extra leading, a generous supply of subheading and a seasoned eye for detail, and you've got *Distributor Newsline.*

"Initially we wanted to use red as a second color throughout the whole newsletter," says Puckett. "But that got a little expensive, so we opted to use the color as an eye-catcher on the front and back only.

"*Newsline* has to be useful and easy to read. I achieve this with simple, straightforward layouts and typography," Puckett explains. "I keep the text clean and sophisticated by being careful about typographic details such as widow and orphan control." Puckett uses a contemporary down-style headline treatment—only the first word and proper nouns are capitalized.

Newsline is extremely consistent from issue to issue. The body copy font is always the same serif, with a complementary black sans serif used on headlines and subheadings for maximum contrast. Stories are broken up visually with plenty of bulleted items. A three-column grid is religiously adhered to. The result is a dependable, attractive newsletter that is highly readable and organized for the busy target audience.

"Sometimes designing low-budget projects is difficult," admits Puckett. His creative approach when working with new clients involves trying to figure out immediately what type of design appeals to them.

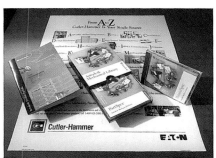

CD-ROMs facilitate access to information…

Cutler-Hammer product data included in PartSpec CD-ROM

(This article and the two following describe how electronic media such as CD-ROMs are replacing printed catalog pages and making life easier for distributors and customers.)

The cover article of the June 1996 *Distributor Newsline* described the total package of Cutler-Hammer breakers and control products that provides comprehensive solutions for control OEMs serving the machine tool, material handling, HVAC, plastic molding, automated assembly, packaging, and processing industries.

It stated, "We have an exciting product story to tell OEMs and panel builders. When you combine the superior performance of our IEC and NEMA control product lines with the technically advanced design of our circuit breaker/circuit protective products, you have an unbeatable combination."

AutoCad layout for OEMs

We now have an easy way for OEM customers to incorporate Cutler-Hammer products into their layout drawings.

Customers can access information on 14,000 different Cutler-Hammer part numbers by computer through PartSpec, a CD-ROM from Autodesk, Inc. Cutler-Hammer is one of more than 70 suppliers represented.

According to Cutler-Hammer Product Engineer Rob Elliott, PartSpec works like a data base to narrow down a search to a specific product. The first option is company. Then a product listing appears with photos. When the required product is located, pressing the Search button displays catalog numbers, a description and an AutoCad drawing—both front and right view. The software is complementary with the major AutoCad systems, and Cutler-Hammer drawings can be inserted with a simple click of a button into the customer's specification and drawings at a scale of one to one.

Cutler-Hammer has promoted its wide range of products. Now customers can access many of them by PartSpec. The company is one of more than 70 suppliers in the PartSpec CD-ROM offered by Autodesk, Inc. Drawings for more than 14,000 Cutler-Hammer part numbers are included.

(please see page 4)

In this issue:

- Tips on using co-op funds *(page 2)*
- Promoting distribution products *(page 3)*
- Commercial Return Policy *(page 7)*
- Roden Electric promotion *(page 9)*
- Control transition updates *(pages 10, 11)*
- Teamwork and IMPACC sale *(page 13)*
- More on after-hours service *(pages 14, 15)*
- Customer training seminars *(pages 18, 19)*
- Win barbecue grills *(page 20)*

"Lots of times I start by showing the new client newsletters I've already designed. I ask them, 'What appeals to you? What would suit your needs?' They almost always gravitate toward a certain style or look," he explains. "This saves me time because I know what they're looking for. I don't waste time on designs they'd never go for. The ideas I present are down their alley right away."

'Your Electrical Solutions'...

(continued from page 1)

aftermarket and life-extension products. Included in the promotional category are a number of tri-fold mailers you can also use as counter handouts. Each has a spot for addition of a distributor label and a place to put a customer address label."

Your Electrical Solutions

This 300-page reference guide is designed to help customers identify existing electrical equipment and to find the support available for it. Copies will be mailed to distributors, field sales and selected customers in April.

YES includes many more products than the previous catalog, such as contactors and starters and loadcenters, as well as additional panelboards and motor control

centers. Also incorporated are technology upgrades, pricing information, a one-line diagram index, and an alphabetized index.

Each section of YES includes product description, product history and timeline, replacement capabilities, many photos, and further information. All sections include applicable technology upgrades and product-support services, as well.

Developing a need

Potential customers are the decision makers in the maintenance or facilities department of any industrial, commercial or institutional account. These are the people who have the responsibility for maintaining the

> **"Potential customers are the decision makers in the maintenance or facilities department of any industrial, commercial or institutional account."**

facility and keeping the processes running.

If your customers don't have needs, what are the chances of their buying something from you?

The "Develop The Need...Provide The Solution" folder is a tool designed to help you in the process of learning more about your customer. This is an ongoing process, not a one-shot deal. The customer facility profile form, included in the folder, allows you to gather information about your customer's business and electrical distribution system—including some areas where there have been problems in the past.

Once you get into a specific product, then you can use product question sheets from the folder. There are 11 individual sheets, including panelboards/switchboards, molded-case circuit breakers, motor control centers, medium-voltage starters, low-voltage busway, low-voltage and medium-voltage switchgear, and more.

Each sheet has questions designed to develop needs, key phrases you may hear in response to your questions, possible product solutions, a list of reference materials, and names and phone numbers of people to call for help. You may want to get copies of the reference materials before you make the call.

As an example, you may uncover the fact that there is no funding in the capital improvements budget to replace the 480V switchgear that is old and has caused some tripping problems. Pull out the switchgear question sheet from the

(continued)

The "Don't Gamble With your Electrical Distribution System" folder contains literature that warns customers of the dangers of buying electrical equipment on the gray market.

The "Develop The Need...Provide The Solution" folder includes product-needs-development questions (shown here) as well as a customer facility profile form and a sales aid.

folder and develop the need. Then go to Tab S of the YES catalog for information on trip unit retrofit kits. Why replace the whole switchgear when the problem is the trip unit?

Countering the gray market

A Texas chemical plant discovered that relays it had installed on a safety shutdown system were not what had been specified. The relays, which were purchased as new, had actually been manufactured 22 years ago. If they had been energized and the anticipated shutdown had not occurred, the results could have been disastrous.

Your customer may agree with your proposed solution for an electrical problem but may try to source that product from a non-factory-authorized source. Make sure the customer is aware of the dangers inherent in the gray market.

These dangers are described in a folder titled "Don't Gamble With Your Electrical Distribution System." It contains position papers on various Cutler-Hammer products, emphasizing such points as the importance of using only genuine replacement parts. It also includes reprints of gray-market articles from *IEEE Transactions* and *Electrical Construction & Maintenance*.

This folder will initially be distributed only to Cutler-Hammer sales engineers and distributors, as they will have been trained on the use of the YES catalog.

Training and promotional support

A five-day Aftermarket Products and Services course (AMKT 346) for distributor personnel is conducted in Asheville,

N.C. and Greenwood, S.C. Dates for the remainder of 1997 are June 23-27, September 8-12 and November 17-21.

Scripted presentations can be scheduled for customers as well as distributor personnel on various Cutler-Hammer products. A description of this presentation library is available. Also available is a detailed list of aftermarket and life-extension literature.

There are tri-fold "We Have The Solutions" mailers on molded-case circuit breakers, motor control centers, medium-voltage switchgear, and TVSS solutions for MCCs. Coming in May are mailers on control parts and replacement DS breakers.

For information on the course plus copies of all the items mentioned in this section, contact Joyce Moore at 412-937-6221 or fax 412-937-6770.

Major opportunities

Adds Dick Bopp, "Each piece of installed equipment represents significant opportunity—for the customer as well as the distributor. This opportunity goes far beyond providing replacement parts. Each time distributor salespeople are able to help a customer understand the advantages of upgrading equipment—by retrofitting their MCC with Advantage starters or by installing Digitrip retrofit kits, for example—they are contributing true value, enhanced productivity.

> **"Each piece of installed equipment represents significant opportunity— for the customer as well as the distributor."**

"That's what it's all about. That's what Cutler-Hammer Aftermarket is all about— solutions the customer can depend on!"

"Our Aftermarket organization is prepared to offer sales support, training liter-

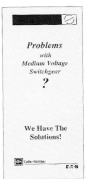

Problems with Medium Voltage Switchgear ?

We Have The Solutions!

Cutler-Hammer

E·T·N

Tri-fold mailers such as this open the door to discussions about your products that can help customers extend the life of their existing equipment.

ature, scripted presentations, and tradeshow materials. During April, Cutler-Hammer engineers will receive copies of this material and training in its use. This will allow them to assist distributors in taking advantage of the major opportunities that are awaiting." •

(For additional copies of YES, call Trafford Fulfillment Services at 1-800-269-5134 or fax 1-800-255-1215.)

DESIGNER:

Thomas S. Puckett

ORGANIZATION:

Intelligent Design Enforcement Agency

SIZE:

8½" × 11" (21.6cm × 27.9cm)

QUANTITY:

17,500

COST:

NA

OBJECTIVE:

Create a reference newsletter of company products to be used by sales professionals and other employees.

HOW WE SAVED:

Printing all but the outside covers in black ink only. (The covers are two colors, red and black.) Photographs are supplied by the client.

one-size-fits-all layout

TECH-RENTALS DATA SHEETS AND PRODUCT PRICE LISTS

CREATIVE COMMENTS:

"When you find a format that works well, use it for everything!" This could be Croft's motto when it comes to tackling typically dry data sheets and product price lists in an economical and timely fashion.

Without professional graphic design training, Croft was given the challenge of developing a multipurpose layout for informational pages ranging from pure text (mostly technical) to semi-text-heavy with only a product picture for visual relief. Often the documents are one ink only, although he does get added color on some of the projects.

Croft has developed a simple, versatile and functional layout. The three-column layout is always the same. "We have created a collection of most often used panels which, thanks to the grid format, we can quickly paste in depending on the use."

Croft has a good eye for keeping technical material approachable without changing fonts or font size. He consistently uses bulleted lists, short paragraphs, lots of subheadings.

The few art and product images he gets to use aren't shy. He often uses graphic images dramatically large, which provide the strong visual focal point many copy-heavy pages lack. "I think there is value in having a major graphic to catch attention. I try to stay away from boring product photos," he says. "Line art with people is my preference."

Tech-Rentals has three major product areas, each with a unique color code. Information sheets from or about a specific product area use black ink plus the corresponding ink color. Even the color placement is consistent. Croft exercises great restraint with the second color, using it to organize and lead the eye. Too much higgledy-piggledy color placement distracts rather than focuses the reader on what's important.

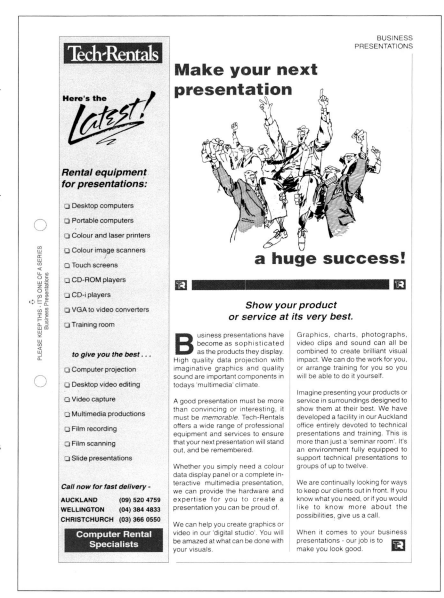

"The methods I use have evolved during fifteen years of trying to keep current technical equipment data sheets and product price lists in front of a very small customer base," explains Croft. He is the managing director for Tech-Rentals in New Zealand and has a background in electronics. Sometimes, common sense and an eye for organization are the best incentives for creativity.

COMPANY
PROFILE

An international organisation

dedicated to service and support

Even with all of the technology available today, the success of your business still depends upon knowledge, talent and skill. Technology is just another name for tools, and using the best tools available will never replace skill and talent, but it certainly can help.

Tech-Rentals' business is about helping you produce your best by making the best tools available to you - when you need them.

Since 1980 Tech-Rentals has been enthusiastically committed to supporting New Zealand customers with the very latest technology accompanied by top-class service. Founded in Melbourne in 1978, Tech-Rentals is now the largest rental organisation in the Southern Hemisphere for electronic test and measurement instruments, personal computers and peripherals.

The key to this steady growth and increasing strength in the market has been our uncompromising attitude towards customer service and product support.

The guiding philosophy is quite simple - to efficiently and reliably provide each client with the most suitable equipment for a particular application.

As a result, the company's sphere of activity has grown from test equipment rentals to encompass the rental of personal computers, peripherals, sophisticated graphic workstations, imaging equipment, environmental monitoring devices and much more. Sales of ex-rental equipment forms an important part of the business.

Tech-Rentals has pioneered various options for rental, sales and leasing which give customers the choice of acquiring equipment in a manner best suited to their circumstances.

So whether it's for the city office, service department, field trials or anywhere in between, Tech-Rentals is ready to assist you from offices in Auckland, Wellington, Christchurch, all states of Australia, Malaysia, Singapore and the Czech Republic.

DESIGNER:
Jud Croft, Tech-Rentals

ORGANIZATION:
Tech-Rentals

SIZE:
8½" × 11" (21.6cm × 27.9cm)

QUANTITY:
Varies depending on need; most often 2,000

COST:
NZ$.12 each (includes preprint cost and overprint on in-house equipment)

OBJECTIVE:
A repetitive layout that
1. could be changed quickly;
2. would work for everything— mailers, seminar handouts, faxed information, binder insert material and more; and
3. gives a consistent look and feel to the Tech-Rentals name.

HOW WE SAVED:
Preprinting.

herbal studies outlined in booklet aimed at M.D.s

PHYTOTHERAPY RESEARCH COMPENDIUM FOR NATURAL PRODUCT RESEARCH CONSULTANTS

CREATIVE COMMENTS:

The target audience for this booklet (twenty-four pages plus cover) might have a bias against the subject. "Herbal remedies aren't always taken seriously by regular medical doctors," Baurecht explains. She needed a design that was not only attractive, but one that looked credible, professional and organized.

"I chose two shades of green for the cover. Using them in a monochromatic way is more elegant and sophisticated than picking two completely different colors like red and blue," she explains.

The cover stock is an off-white flecked and textured paper, a perfect complement to the soft background screen of herbal plants that frames the front page. Just a piece of this artwork wraps around to the back cover as well. As a package, the ink and paper choices fit the industry—healthy, natural.

The justified title *PHYTOTHERAPY RESEARCH COMPENDIUM* adds a contemporary touch.

The inside is well organized and highly scannable. "I find that adding leading to the text opens up a text-heavy page," says Baurecht. "It makes it easier to read and more inviting."

She makes no effort to fill in short columns or square off the lower margins. The text inside is allowed to flow naturally, broken up only by standardized headings and a line drawing of an herb at the beginning of each section. Physicians can quickly scan the information and easily reference a study number. The codes and abbreviations are consistent and obvious.

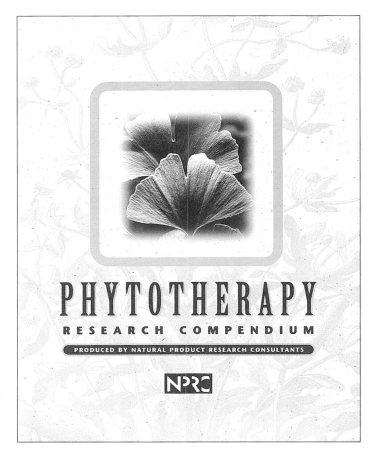

"If I draw a blank on a design," says Baurecht, "I flip through design magazines and books for inspiration. I gather ideas and think about how I need to achieve the image that the client wants. I make sketches.

"Of course, the piece that comes out of that never looks like anything I was looking at anyway," she admits.

mune cirrhosis, known cancer, end-stage liver failure or other very serious causes of cirrhosis were excluded. Patients took either placebo or 200 mg of milk thistle extract (standardized to 70% silymarin) three times daily. After the last patient enrolled finished two years of therapy, the trial ended. There was a 23% rate of mortality in the group treated with silymarin, significantly lower than the 33% mortality in the placebo group. This extended to four year mortality, with the cumulative survival rate being 58% in the silymarin group, significantly higher than the 38% cumulative survival in the placebo group. When subgroups of patients were analyzed, the benefit from silymarin treatment was found superior in those with milder (Child class A) alcohol cirrhosis. No significant change in serum levels of liver enzymes were noted. Approximately 60% of the alcoholic patients continued to drink alcohol through the study, as indicated by consistently elevated GGT levels in the blood. There were only two very mild reported side effects from silymarin and an equal number to placebo.

MTE-5 Buzzelli G, Moscarella S, et al. A pilot study on the liver protective effect of silybin-phosphatidylcholine complex (IdB1016) in chronic active hepatitis. *Int J Clin Pharm Ther Toxicol* 1993; 31(9):456–60.
Key Topic: Chronic active hepatitis
Number of Subjects: 20
Methodology: Double-blind, placebo-controlled clinical trial
Duration: 7 days
Summary: Patients took either two capsules of IdB1016 (equivalent to 240 mg of silibinin) or placebo twice daily before meals. The treatment period lasted seven days. All had biopsy-confirmed chronic viral hepatitis due to either HBV, HCV or both. There was a significant decline in measures of hepatocyte necrosis, including serum levels of SGOT, SGPT and GGT, after treatment with IdB1016 compared to placebo. Blood copper and zinc levels were not different between the groups at any point during the trial. Measures of lipid peroxidation, such as serum levels of MDA, did not fall by a significant margin in either group. The authors conclude the IdB1016 preparation reduces signs of hepatocellular necrosis due to chronic viral hepatitis after a short period of treatment.

MTE-6 Lirussi F, Okolicsanyi L. Cytoprotection in the nineties: Experience with ursodeoxycholic acid and silymarin in chronic liver disease. *Acta Physiol Hungar* 1992; 80(1-4):363–7.
Key Topic: Chronic active hepatitis
Number of Subjects: 40

Methodology: Double-blind, crossover clinical trial
Duration: 6 months, 25 months
Summary: The first study involves comparison treatment of chronic active hepatitis of various etiologies by silymarin, the flavonoid complex from *Silybum marianum*, and the bile acid ursodeoxycholic acid (UDCA). A total of 21 patients, male and female, were randomized to either silymarin 420 mg daily or UDCA 600 mg daily for six months. At that time, serum liver enzyme levels (SGPT, SGOT and GGT) dropped significantly compared to baseline in the UDCA group, and SGPT and SGOT did the same in the silymarin group. Galactose elimination capacity and antipyrine clearance did not deteriorate in either group, indicating a stable functional liver mass. There were no adverse effects known to be due to the treatments, though four patients developed ascites and one patient liver cancer. The patients then either crossed over to taking UDCA and silymarin simultaneously or to discontinuing all treatment. There was a progressive deterioration in serum liver enzymes in untreated patients, compared with similar benefits seen previously with single agents in patients receiving treatment. No advantage to combination therapy (compared to therapy with either agent in isolation) was noted.

MTE-7 Palasciano G, Portincasa P, et al. The effect of silymarin on plasma levels of malondialdehyde in patients receiving long-term treatment with psychotropic drugs. *Curr Ther Res* 1994; 55:537–45.
Key Topic: Hepatotoxicity from psychotropic drugs
Number of Subjects: 60
Methodology: Double-blind, placebo-controlled clinical trial
Duration: 90 days
Summary: Women from age 40 to 60 who had been taking phenothiazines or butyrophenones for at least five years and who also had elevated serum levels of liver enzymes were given 800 mg of silymarin or placebo. None of the patients had liver disease from any other cause, other significant illnesses or drug intake. Two groups stopped taking the psychotropics during the study, while two groups continued taking the drugs. Those who stopped taking the drugs had the greatest drops in serum malondialdehyde (MDA), an indicator of lipid peroxidation. Those who took silymarin and continued the psychotropics had a decrease in MDA levels which were significant compared to placebo. The authors conclude that silymarin could be valuable in treating hepatotoxic and other side effects of long-term use of psychotropic medications.

ST. JOHN'S WORT (*Hypericum perforatum*)

SJW-1 Hölzl J. Constituents and mechanism of action of St. John's wort. *Zeitschr Phytother* 1993; 14:255–64.
Key Topic: Pharmacological actions, Depression
Number of Subjects: n/a
Methodology: Review article
Duration: n/a
Summary: This article summarizes the available information regarding the medicinal value of St. John's wort (*Hypericum perforatum*). A discussion of the chemical constituents of St. John's wort and their activities follows a botanical description of the plant. A review of traditional uses for the herb is then given. In vitro, in vivo and human studies are reviewed which reveal the antidepressant actions of various extracts and constituents of St. John's wort. Empirical and clinical trials are then discussed. The author states that 20 clinical trials have been performed on several different St. John's wort extracts and that all have shown antidepressant activity significantly greater than placebo or equal to that of synthetic antidepressant drugs. Finally, a discussion of the possibility of photosensitivity reactions developing in people taking St. John's wort is discussed, including the minimum dose and the accompanying light wavelength necessary to induce a reaction. Summarizing tables are included of the studies discussed in the article.

SJW-2 Ernst E. St. John's wort, an anti-depressant? A systematic, criteria-based review. *Phytomed* 1995; 2:67–71.
Key Topic: Depression
Number of Subjects: 902 in 12 studies
Methodology: Review article
Summary: The author reviews 12 controlled clinical trials (11 double blind) using various preparations of St. John's wort for the treatment of depression. The 12 trials were chosen from among 19 controlled trials based on methodological rigor. Each trial is described, including number of subjects, preparation and dose, statistical findings and adverse reactions reported. Among the 12 trials covered, 9 involved a comparison between St. John's wort and placebo and 3 involved a comparison between St. John's wort and one of two synthetic antidepressants (maprotiline or imipramine). All reviewed trials showed either a significant benefit of St. John's wort extracts in treating depression compared to placebo, or equal or greater benefit compared to synthetic antidepressants. Possible problems with the trials are then discussed, including methodological flaws and a wide range in placebo response and adverse reactions reported among trials.

SJW-3 Harrer G, Sommer H. Treatment of mild/moderate depressions with *Hypericum*. *Phytomed* 1994; 1:3–8.
Key Topic: Depression
Number of Subjects: 89
Methodology: Controlled clinical trial
Duration: 4 weeks
Summary: Male and female patients were randomized to receive either 300 mg three times daily of an extract of St. John's wort (standardized to contain 0.9 mg of hypericin per 300 mg) or placebo. All 105 participants suffered mild to moderate depression, quantified as a Hamilton Depression Scale (HAMD) score less than 20. After two and four weeks patients were reassessed. There were nine dropouts and seven patients whose HAMD scores did not match inclusion criteria for the study. Among the remaining 89 patients, there was a significantly greater improvement in HAMD scores among participants taking St. John's wort extract compared to those taking placebo. Sixty-seven percent of patients taking St. John's wort extract had their HAMD score drop under 10, as compared to 28% in the placebo group. Symptoms which particularly improved while taking St. John's wort extract compared to placebo were depressive mood, difficulties falling asleep and emotional fear. There were no serious adverse effects.

DESIGNER:

Magrit Baurecht

ORGANIZATION:

Magrit Baurecht Design

SIZE:

8½" × 11" (21.6cm × 27.9cm)

QUANTITY:

25,000

COST:

$22,599 (printing, design and production)

OBJECTIVE:

Design a text-heavy informational booklet that looks professional and serious and impresses doctors enough to consider incorporating herbal remedies into their regular treatments.

HOW WE SAVED:

The inside pages are printed in black and white on a smooth, less expensive paper than the cover.

sound bites make design sing

ST. LOUIS EFFORT FOR AIDS BROCHURE

CREATIVE COMMENTS:

"St. Louis Effort for AIDS originally had a more touchy-feely fund-raising brochure that worked well for some audiences, but wasn't getting corporate attention," explains Floresca. "In addition, this piece had to be a mailable size and stand out in display racks as well."

Floresca chose a tall 11" (27.9cm) format that would be especially noticeable in a rack of more common 8½" (21.6cm) or 9" (22.9cm) pieces.

"It may sound cliché," says Floresca, "but when I have a low-budget project like this, I work with what I've got. Knowing the goals of the piece is an important part of being creative."

The brochure carries a lot of information. "I wanted the brochure to be a quick read in spite of all that copy," Floresca explains. "Chances are most people wouldn't have the time to read everything. Yet, being an informational brochure, we had to have everything in there for those who want it or need it." So, taking a cue from *USA Today*—large, dramatic headlines married to short copy blocks—Floresca broke the copy into what he calls "sound bites."

The brochure strikes the perfect balance between consistency and inconsistency. For example, the body text is consistently the same serif font with key words set off in the same sans serif font used for all the headlines. Additionally, only four-point black rules are used throughout. Small inconsistencies—like the use of different initial caps on headlines and copy, the changing color treatments of headings, and a large block of reversed copy—add visual energy. The slight variations in the copy blocks facilitate the scanning process, allowing for a quick or in-depth read.

Extra leading between the lines adds length to the copy blocks. But in a pure text publication such as this, the extra air makes the

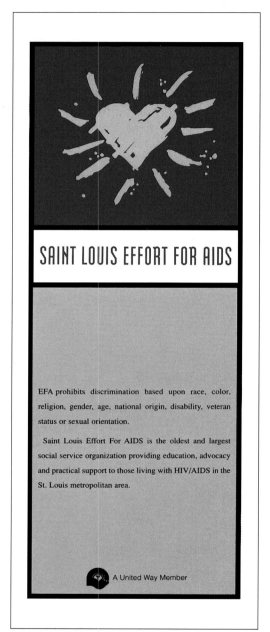

information seem less daunting even if it is long.

The key to this design's success is not in three ink colors. It's in the juxtaposition of contrasting styles. Floresca has found a path somewhere between the *Wall Street Journal* and *Wired* magazine schools of design.

MISSION STATEMENT

The mission of Saint Louis Effort For AIDS is to provide education on prevention of HIV infection and comprehensive support services to those affected by HIV/AIDS.

EDUCATIONAL SERVICES

Saint Louis Effort For AIDS devotes significant time, energy and program resources toward public outreach and AIDS prevention education. Prevention strategies that target risky behaviors are our society's only weapon against further outbreak of this viral epidemic whose cure continues to elude us. To change behavior, you have to change thinking; to change thinking, you have to educate.

Our Education Department offers informative OUTREACH EDUCATION PROGRAMS tailored for specific communities considered at risk for HIV infection including gays and bisexuals, college students, the multi-cultural community and women. These programs involve peer training, workshops, theater, street-beat discussions, video viewings and poster campaigns designed to help reduce HIV transmission.

An AIDS INFORMATION HOTLINE, staffed by trained volunteers, provides the St. Louis community with free, confidential information on HIV/AIDS. To reach the Hotline, call 647-1144 or 1-800-337-AIDS.

Our SPEAKERS/EXHIBITS BUREAU raises public awareness of HIV/AIDS through community outreach to interested area groups. Trained volunteers present information on AIDS related issues to hundreds of St. Louisans each month through presentations and portable exhibits.

EFA sponsors a TREATMENT ISSUES LIBRARY offering up-to-date medical information on the latest treatments and new developments in AIDS research.

The AIDS INTERFAITH NETWORK is a religious community outreach which offers presentations and volunteer opportunities to congregations and synagogues.

Volunteering highlights our interdependence as human beings. Whether they're facilitating outreach prevention programs, training new volunteers or helping those already affected by HIV/AIDS, dedicated volunteers provide the momentum behind EFA's programs and services.

Historically, friends and neighbors join together for mutual support during challenging times. In our time, AIDS constitutes the challenge. YOU CAN MAKE THE DIFFERENCE by volunteering your time and energies toward service-oriented efforts that enhance or preserve the lives of others and ultimately enrich your own. You can also help through financial support of EFA programs and services. EFA is largely funded by tax-deductible donations from caring people like you. For more information on how you can help, call 645-6451.

St. Louis EFA thanks the following contributors for making this brochure possible: Design and writing: Kiku Obata & Company Printing and Paper: ADSeft

CLIENT SERVICES

HIV and AIDS affect all aspects of a person's life. To assist with what can sometimes be overwhelming changes and developments, EFA provides CASE MANAGEMENT and CLIENT ADVOCACY for persons with HIV/AIDS. The agency coordinates available financial, social and medical services as needed, offers advice on state and federal assistance programs, and helps with all associated paperwork.

Through EFA's BUDDY PROGRAM, persons with HIV/AIDS enjoy the companionship and support of caring volunteers, easing the isolation that too often accompanies AIDS.

Friends come together at the SHARING CENTER . . . a safe environment in which persons with HIV/AIDS, friends and volunteers may socialize, participate in special events and access information.

EFA volunteers facilitate a range of confidential SUPPORT GROUPS throughout the city for persons of all backgrounds living with HIV/AIDS, their friends and family.

VOLUNTEER OPPORTUNITIES

AIDS (acquired immunodeficiency syndrome) and the virus that causes it, HIV (human immunodeficiency virus), are epidemic and, as yet, incurable.

Since the 1980s, over one million Americans have been infected with HIV.

AIDS does not discriminate – men, women and children, rich and poor, black and white, heterosexual and gay – all live with HIV and AIDS.

WHY WE ARE HERE

AIDS impacts employment, insurance, financial support and relationships with family and friends. People living with HIV/AIDS can find themselves suddenly alone and unable to provide for their most basic necessities.

Today, one in every 250 Americans is infected with HIV.

Saint Louis Effort For AIDS empowers people living with or affected by HIV/AIDS through emotional and practical support, short-term financial assistance, education and advocacy. Educational outreach programs promote understanding and awareness and focus on the single fact about this epidemic that remains a constant:

PREVENTION ALONE STOPS AIDS.

Saint Louis Effort For Aids
1425 Hampton
St. Louis, MO 63139
Phone: 314-645-6451
Hotline: 314-647-1144 or 1-800-337-AIDS

DESIGNER:
Joe Floresca

COPYWRITER:
Carole Jerome

ORGANIZATION:
Kiku Obata & Company

SIZE:
17" x 11" (43.2cm x 27.9cm) folded to
4¼" x 11" (10.8cm x 27.9cm)

QUANTITY:
20,000

COST:
Pro bono

OBJECTIVE:
Create an eye-catching, "corporate friendly" informational and fund-raising brochure that doesn't look dry and stodgy.

HOW WE SAVED:
No added photos or graphics. A basic paper size with no bleeds.

creative
use of

t w o

fonts

T W O

Creative typography is probably the best way to punch up a low-budget page design quickly. Not only are there infinitely more fonts to choose from than ever before, but they're unbelievably affordable (free, in some cases). Page layout software has expanded the possibilities even further by adding instantly available special effects like curves, shading and distortions. Even word processing programs have added features that can twist and add depth and dimension to your everyday resident fonts.

Of course, this renaissance of font creativity is a recipe for design suicide in the wrong hands. Overuse or misuse of type creates "ransom note" layouts or worse, destroys readability.

Ask a dozen designers to define "good creative typography" and you get twelve different answers. The universal theme, however, is common sense. The typographic treatment must suit the message and the audience. A good font for one piece may not be a good font for another. That doesn't mean that you can't push the envelope of an audience's tolerance, however. We see "grunge" fonts sneaking into conservative corporate publications in the form of feature headings, nameplate design, subheadings and page numbers. The old-fashioned typewriter faces show up frequently on CD covers, posters and brochures aimed at the teenage market.

Good typography is practical. It reflects the message carried in the words themselves. It has purpose, such as:

- Attracting attention where attention is needed
- Organizing a layout
- Breaking up text-heavy or text-only layouts
- Creating visual movement
- Evoking an emotion (sadness, laughter, happiness, anger, irritation, carefree joy)
- Establishing a tone (formal, informal, conservative, wild, youthful)

at a glance:

Use hot heads!

Capitalize on key wording

Vary the levels

Be contradictory

Complement your photos

Think "I" appeal vs. "Eye" appeal

Set type in motion

Think outside your personal preferences

Does the font look right?

Going from Macintosh to PC and back

Prowl the Internet

Try "touch me, feel me" fonts

Make words take shape

Treat type right

The designers featured in this section have either used type as their sole focal point in the layout or opted to enhance the visuals with a compatible type family.

INSIDER ADVICE
Use hot heads!

When you're short on visuals and/or copy, let your headlines take command of the page. Make them large and loud.

Capitalize on key wording

Make the key words of a headline or title larger than the other words. Let them be the drawing cards that pique reader interest. Once the main point hooks them they'll naturally fill in the smaller, less significant words. This is especially useful when the headline is somewhat dull. The type can give it life if done well.

Vary the levels

Create a hierarchy of headlines, also known as multiple deck headings. Make the main title large, then the secondary heading a little smaller. There may even be a third line to the heading as well.

Be contradictory

Choose a display face with a look that's the exact opposite of what the copy is trying to convey. For example: Use a child's scrawling type as a heading on a serious business message.

Complement your photos

Great photos? Vibrant visuals? Strong message? Pick a typeface that illustrates the image in the pictures. Photographs are attention grabbers. If you've got well-taken, powerful visuals, don't put your type in competition for attention.

Think "I" appeal vs. "Eye" appeal

Readers are self-centered. They want certain types of information presented clearly with minimal fuss. Order forms, directories, instructional handbooks and some newsletters fall into this category. Fonts should be chosen for their readability and treated consistently throughout the layout. When function is the main purpose of the project, it doesn't hurt to give the readers what they want. Order, after all, is somewhat attractive when you need to find information in a hurry.

Set type in motion

Reading left to right, top to bottom is a predictable, comfortable reading pattern. Give your large type life. Have it move in a spiral, bleed off the page to the inside (an incentive to turn the page), disrupt an even baseline! Conservative options include simply putting the headlines flush right instead of centered or flush left. If your aim is to lead the reader's eye toward the copy, skew the headlines in the direction of the text.

Think outside your personal preferences

If you like serif faces, use sans serif. If you're a fan of funky, chunky fonts, pull up some of the classics. If you're a safe traditionalist, download some outlandish typefaces from the Internet and experiment.

Does the font look right?

Bond with your service bureau and/or printer. It's hard to find a designer without one or two horror stories about font problems. If you plan to electronically transfer a publication on disk, tape or via E-mail, run a test first. Font substitution is an ugly thing on a finished layout.

Going from Macintosh to PC and back

Transporting documents between platforms is fairly easy. Fonts, however, don't "beam" as well. Yes, it is possible to convert a font from one platform to another. Utilities for this vary in their success rate, however. Often the letterforms are fine, but the spacing—kerning and tracking values—suffer. Even if the PC and the Macintosh have the identical font name in their systems, converted pages need to be inspected carefully for hiccups in line width, hyphenation, etc.

Prowl the Internet

Finding fonts on the Internet is like shooting fish in a barrel. They're cheap (even free) too! But, cliché as it sounds, you do get what you pay for. That doesn't mean that a funky, free font won't work for a one-off headline in large type. Maybe the look is what you want, so why pay more? You won't know however unless you shop around. Warning: When it comes to readable fonts with complete character sets, stick with reliable type vendors.

Try "touch me, feel me" fonts

Take textures out of the background and put them in the font! Make display type touchable—carved, scratched, metallic, wet, spiny, etc. If the organization limits you to using the same one or two fonts, due to graphic standards for example, this is a great graphic loophole. Adding a texture, even a slight stipple or a simple graduated screen, can give the regular font a whole new character and life. At the same time, keeping the font in the family maintains a feel of unity.

Make words take shape

When you're really light on visuals and need a fast fix, think about putting text in a shape that complements the content. Maybe curve and stretch one word in the shape of a heart for example. Or use several typestyles and create the shape of a city skyline symbolizing all the different voices. You might even think about the old typewriter picture technique for a more funky, artsy approach. (Remember the pictures of Abraham Lincoln made by using various typewriter characters?)

Treat type right

Nothing cheapens a low-budget publication faster than amateur typography. Heck, nothing cheapens an expensive publication faster. Everything counts: proper use of dashes (–, — and - are not interchangeable), well-justified columns (without lakes and rivers), one space after a period (as opposed to the "terrible twos"), true small caps (rather than scaled small caps created by the software) and ligatures (for tight-fitting letter combinations like *fi, fl, ffi* or *ffl*) are just a few techniques that separate polished, sophisticated typography from fonts flung on a page with abandon.

funky font adds flavor without overwhelming audience

CORNISH COLLEGE OF THE ARTS FUND-RAISING MAILER

CREATIVE COMMENTS:

"The client's vision was 'corporate artsy,'" says Baurecht. "The brochure is marketing an art school to donors, not students. Students would be drawn toward a more exotic layout. I needed to make the design accessible to people who aren't accustomed to cutting-edge graphics.

"The design had to be solid without losing the youthful flair and excitement of the school," she adds. On top of this challenging design image was the deadline. The whole thing had to be done in less than a week.

Baurecht did have access to plenty of college photos. However, the photos, while well taken, are typical—very collegiate, the type of thing you'd see in any course catalog. The designer couldn't rely on them to quickly convey the catchy, quasi-corporate appeal she was after. So, with ink color and a limited dose of an off-the-wall font, Baurecht built a youthful, compelling, yet dependable layout.

Baurecht opted for two unusual, but warm and inviting, ink colors: teal and metallic copper. Because the brochure is rather light on copy she could use the photographs large, forming horizontal and vertical blocks. Some of the pictures are printed in teal while others are in copper.

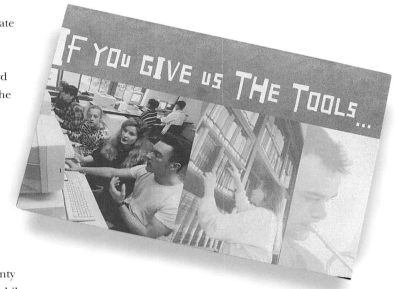

A highly readable sans serif is used for any informational copy, reserving the funky, chunky Tape Type font for large headings and key words like "YES" on the reply panel. (Any direct-mail expert would be thrilled to see the positive response accentuated this strongly.) Restraint is the key here. Overusing the trendy typeface might be counterproductive to the brochure's fund-raising purpose.

"Sometimes to get a design going I gather all the elements on my blank page— photos, copy, illustration. Then I start playing and moving them around. The design grows from there," Baurecht explains.

DESIGNER:
Magrit Baurecht

ORGANIZATION:
Magrit Baurecht Design

SIZE:
7¾" × 21" (19.7cm × 53.3cm) folded to
7¾" × 5¼" (19.7cm × 13.5cm)

QUANTITY:
18,500

COST:
$7,223 (printing, design and production)

OBJECTIVE:
"Do it in one day! One *long* day."

HOW WE SAVED:
Client-provided photos, scanned clip art, two colors as opposed to four and a fun font called Tape Type.

WE'LL GIVE YOU THE ARTs!

The arts in Seattle and throughout the country are richer because of Cornish College of the Arts. Since 1914, Cornish has been providing outstanding training for talented artists -- the same artists who are on our stages and in our museums and galleries today, contributing to a strong and lively artistic community.
Peter Donnelly
President, Corporate Council for the Arts

The artist is the foundation of the arts. Without the artist, we would not have our theaters, music, or dance. Cornish College provides the professional training and education for artists which prepares them for success.
Judith Nihei
Artistic Director, Northwest Asian American Theater

I want to support the Cornish College Annual Fund with a ☐ gift ☐ pledge of $_____
Name(s)_____
Address_____
City_____
_____State_____Zip_____
☐ I wish my gift to remain anonymous
☐ I am a Cornish alumnus/a Dept.:_____
☐ My check for _____ is enclosed
☐ I wish to charge my gift of $_____ to my ☐ Visa or ☐ Mastercard Account no._____
☐ I pledge an additional $_____ to be paid by May 31
expiration date_____Signature_____
☐ I have enclosed my company's matching gift form.
☐ Please send me information about making gifts of securities.

Please make checks payable to Cornish College of the Arts.

YES

Cornish College is a 501(c)3 charitable organization registered with the Secretary of State. Contributions are deductible to the extent allowed by law.
Cornish is not a recipient of CCA funding.

CORNISH COLLEGE of THE ARTS...

...where the arts begin!

fonts cast in supporting role

MANES, A BOOK FOR LA FURA DELS BAUS

CREATIVE COMMENTS:

"La Fura dels Baus is one of the most experimental and interesting theater groups in Spain," say Balius and Casasin. "We were commissioned to design a book that would capture the ideas and concepts from their theater show *MANES.*"

The photographs are edgy, dramatic, eerie and extremely well taken. The designers chose a type family they designed themselves, FaxFont, to work in tandem with the strong visuals. The type on each page and spread is designed specifically to suit the message in the photographs. The role of the font in this case is not that of a bit player, but of a supporting actor. Generally this rough, edgy font is secondary, but when the pictures are smaller and less dramatic, the font is set large and bold. It sets the tone in some cases.

A second font family, Not-Typewriter-but-Printer, also designed by the graphic artists, is used on the book cover.

"New technologies let us design typefaces more easily than ever before," say Balius and Casasin. "We like to take advantage of it."

When asked how they stay creative on tight-budget projects, Casasin provided these simple suggestions:

1. Don't expect to be rich;
2. be positive;
3. think;
4. feel good vibrations with the client;
5. enjoy your work;
6. publish a big quantity and it'll cost less per issue;
7. don't think about the money while working;
8. 'more is less' (or is it 'less is more'?).

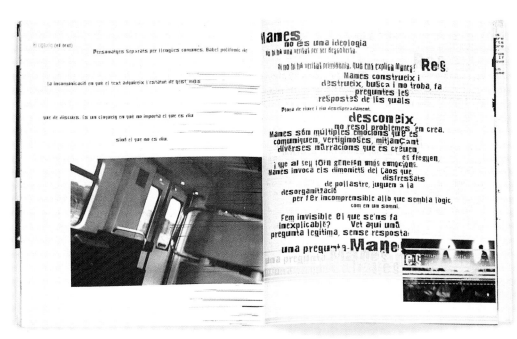

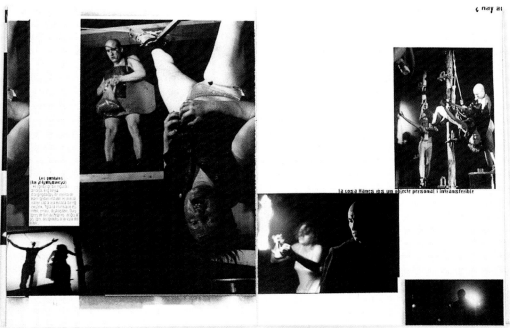

DESIGNER:
Andreu Balius & Joan Carles Pérez Casasin

ORGANIZATION:
Typerware

SIZE:
8 5/16" × 11" (21.1cm × 27.9cm) hardback book

QUANTITY:
2,100

COST:
400 Spanish pesetas each

OBJECTIVE:
Capture the concepts and ideas from the La Fura dels Baus theater show *MANES*.

HOW WE SAVED:
Careful print bidding and negotiating on paper and color.

"an ecstatic expression of feeling or enthusiasm"

LOUISIANA PHILHARMONIC ORCHESTRA *RHAPSODY* NEWSLETTER

CREATIVE COMMENTS:

Rhapsody:

1. A musical composition irregular in form and suggestive of improvisation.
2. An ecstatic expression of feeling or enthusiasm.
3. An epic poem or a part of such a poem.
4. An unusually intense, emotional literary work or discourse.
5. Archaic, miscellaneous collection, jumble.

It's this literal definition, taken from the inside of the newsletter, that Varisco defines visually throughout the publication. "I wanted the piece to define rhapsody," he says.

The newsletter is loaded with information, but there's enough white space to keep it from feeling overwhelming. "*Rhapsody* needed to be fun to read and assure subscribers that there's a lot going on with the orchestra. It's also a public relations piece. They need to feel privy to information that others don't get," he adds.

The text type—Mrs. Eaves from Emigre—is quite small, but very readable and sturdy even in the reverse on the front page. The nameplate, "a miscellaneous collection or jumble of letters," is also in Mrs. Eaves. (There's that strong visual connection to the literal definition again.)

Although Varisco had enough photos to make the newsletter interesting, it's really the background typography that makes the layout unique. To break up long text blocks, Varisco screens parts of the rhapsody definition in the background in a pale olive green. "An ecstatic expression suggestive of improvisation" wafts across two inside panels in forty-eight-point type. Varying not only the screen percentages but also the size of type for other quotes throughout the newsletter puts lyrics in motion. These pages

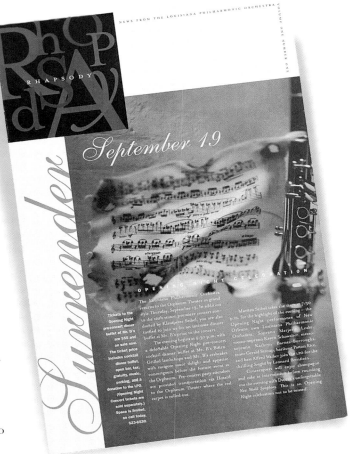

have life. Take this type away and you simply have an attractive newsletter that just lies there.

Short factoids like "Currently, only 17 percent of all conductors in this country are female" appear at right angles in the corners of the pages. The placement of this type mirrors the subtitle and volume number on the front and the address information on the back.

"Now days there are lots of ways to save money on projects," says Varisco, a twenty-plus-year veteran of design. "If you design long enough, it becomes second nature to think in terms of scaling a project to fit the budget.

"When you're confused, keep it simple," he advises. "Limit yourself to one color; change the size or number of pages. I've gone from a brochure to a postcard format in one conversation."

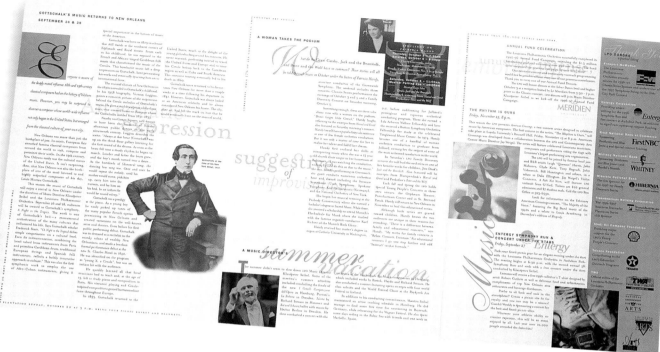

DESIGNER:

Tom Varisco

ORGANIZATION:

Tom Varisco Designs

SIZE:

24" × 12" (61cm × 30.5cm) folded in
thirds to 8" × 12" (20.3cm × 30.5cm)

QUANTITY:

3,000-3,500

COST:

$.85 each (design and printing)

OBJECTIVE:

A newsletter for subscribers, donors
and volunteers of the Louisiana
Philharmonic Orchestra.

HOW WE SAVED:

Six pages instead of eight so it could
be folded and not saddle stitched; two
ink colors; self-mailer so no envelope
is required.

scratching and crumpling builds character

UNIVERSITY OF UTAH CONTINUING EDUCATION
THEATRE SCHOOL FOR YOUTH NEWSPAPER AD

DESIGNER:
Wade Palmer

ART DIRECTOR:
Scott Greer

WRITER:
Joan Levi

ORGANIZATION:
DCE Design

SIZE:
4¼" × 8" (10.8cm × 20.3cm) ad

QUANTITY:
NA

COST:
NA

OBJECTIVE:
A striking ad that boldly illustrates the Theatre School for Youth is more than just an acting school.

HOW WE SAVED:
Black-and-white ad.

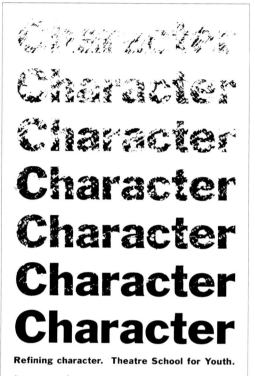

Refining character. Theatre School for Youth.

Preteen session for ages 8-12 runs June 12-28. Teen session for ages 13-18 runs July 8-August 2. Act Now! Call 581-6448 for an audition. Returning students call 581-6984. For more information telephone Dr. Xan Johnson at 581-4927. Department of Theatre.

ACT NOW!

CONTINUING EDUCATION • UNIVERSITY OF UTAH

CREATIVE COMMENTS:

Palmer takes a hands-on approach when it comes to building character. "I laser printed six lines of the word Character in Franklin Gothic on an 11" × 17" (27.9cm × 43.2cm) piece of paper. Then, using an X-Acto knife I started scratching and chipping away at the toner. I even crumpled up the paper," he explains. "When I was done, I scanned what I had left into the computer to use as art. I typeset the rest of the ad, including the last, unscratched *Character*."

Yes, there's probably a software program that could have roughed up the type, but this do-it-yourself approach was fast and creative for Palmer. He dramatically captures the instructor's underlying message. "The head of the school wanted to emphasize that the program was about building character, not just acting. As you learn to act, you build on inner qualities of self-confidence and motivation, etc. He kept talking about your emotional quotient," said Palmer.

No pictures, no color and very little text—just simple movement made this ad work even in poster size. The subtle changes in the type draw the eye naturally to the bottom where the key information is.

Palmer views his computer as a tool, only as good as the artist using it. Creativity for Palmer begins with preliminary pencil sketches on a pad. "I'll even show clients roughed-up drawings," he points out.

Only when a concept is tight does he move to the computer. "As a production tool, the computer is very fast. As a design tool, it's less effective and slower," he explains.

fonts with feeling

LAUGH, CRY, BUY FLYER FOR UNIVERSITY OF UTAH
CONTINUING EDUCATION CREATIVITY IN ADVERTISING

DESIGNER:
Wade Palmer

ART DIRECTOR:
Scott Greer

WRITER:
Joan Levi

ORGANIZATION:
DCE Design

SIZE:
8½" × 11" (21.6cm × 27.9cm)

QUANTITY:
50

COST:
NA (printed internally)

OBJECTIVE:
Creatively market a Creativity in Advertising course.

HOW WE SAVED:
Two colors and a simple layout.

CREATIVE COMMENTS:

When your project is not only budget light but copy light, sixty-six words in this case, you've got to make a big statement visually. Palmer's approach is strikingly simple.

"I drew the smileys. The last one with the dollar sign is my attempt to add a little subtle humor," he explains. Without the accompanying headline, the illustration wouldn't make sense. Palmer chose to enhance the illustration by changing the font of each word in the headline to match the feeling evoked from *laugh, cry and buy.*

Obviously, the flyer would have worked if the whole headline had been in Helvetica, for example. But the type adds impact and interest, while the various lines and arrows add a little unexpected motion.

Palmer didn't have a lot to work with when he started out. His invented visual uses the space, rather than just filling it for the sake of covering the paper.

Staying creative and coming up with fresh ideas is a natural part of Palmer's philosophy that, "If you want to be a good designer, you've got to get involved with good design. You're influenced heavily by the world you live in. You have to pay attention, observe, learn."

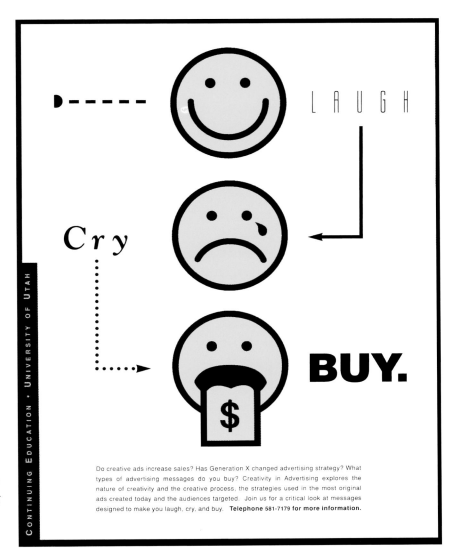

Do creative ads increase sales? Has Generation X changed advertising strategy? What types of advertising messages do you buy? Creativity in Advertising explores the nature of creativity and the creative process, the strategies used in the most original ads created today and the audiences targeted. Join us for a critical look at messages designed to make you laugh, cry, and buy. **Telephone 581-7179 for more information.**

multilingual challenge met with simple, bold "characters"

TEKTRONIX *THE CHARACTER OF OUR COMPANY* BOOKLET

"I don't see anything as being a limitation," observes McMurray. "You execute what you have."

In tackling the Tektronix project, McMurray had to adhere to a corporate identity program which limited his choice of typefaces to Helvetica Condensed and Melior. He also had to create a concept that would communicate the corporation's values and ethics policy effectively to a global employee base. Finally, the booklet design had to allow translation into several languages.

"These limitations aren't detrimental," McMurray says matter-of-factly. "The copy drove the piece."

Mary Cohn, manager of employee communications for Tektronix, says the piece has been very well received. "It has a lot of impact and reinforces the message," she explains. "We knew there was no good way to use illustration in a project like this," she adds. "We would have had to analyze the artwork from the point of view of each culture."

"Adding anything to the copy would have detracted from the message," observes McMurray.

The design is simple, almost stark. The type is large. Headings are short and concise. Key words linked to key concepts like "innovative," "trust," "strive," "prize" are billboarded in the headlines.

The headings are all reversed out of a dark purplish blue, one of Tektronix's corporate colors and the primary ink color for all the text in the booklet. The other corporate color—red—is used sparingly and strikingly on the outside covers.

The overall effect of the design is strong, forceful and basic. The booklet is easy to read and easily translated as well. Since English is the primary language of the company, the headings in the foreign editions were left in English

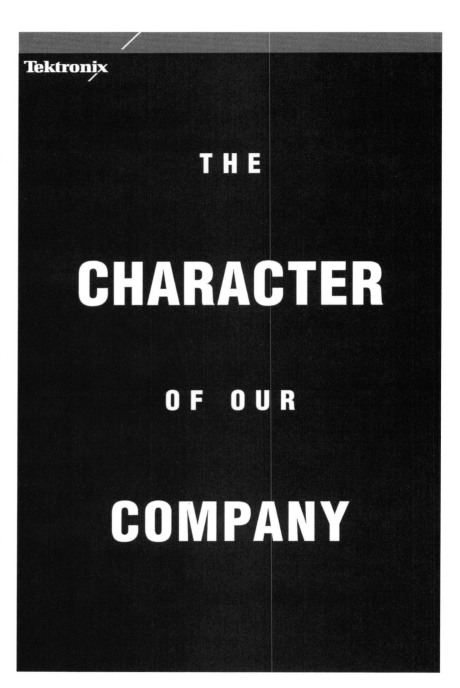

and translated at the top of the accompanying text page.

McMurray is practical and easygoing in his approach to projects with restrictions. "Take nothing for granted. Take the simplest thing and use it to break through the clutter," he advises.

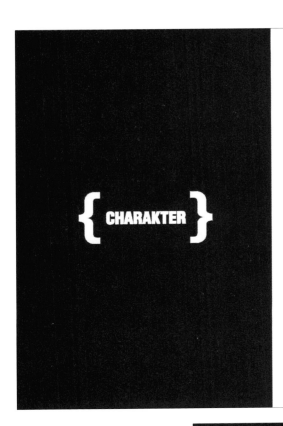

Der Charakter unseres Unternehmens

Charakter

Dieser Faktor läßt sich nicht so einfach messen wie Wachstum, und er ist nicht so konkret faßbar wie unsere Marketinginitiativen – trotzdem ist er genauso entscheidend für den Erfolg von Tektronix. Der Charakter von Tektronix ist die Verkörperung unserer Unternehmenskultur und unseres Geschäftsstils – d.h. unserer Wertvorstellungen im Umgang mit unseren Kunden und miteinander.
Meine täglichen, im Interesse von Tektronix durchgeführten Handlungen werden größtenteils von Wertvorstellungen bestimmt – von jenen des Unternehmens und von meinen eigenen.

Ich bin fest davon überzeugt, daß:
Jedes Geschäft mit dem Kunden beginnt.
Wir unsere Verpflichtungen erfüllen müssen.
Wir aktiv handeln müssen.

Ich möchte, daß Sie unsere Unternehmensphilosophie voll und ganz verstehen. Sie ist das Spiegelbild unserer Wertvorstellungen und Verhaltensweisen. Wenn wir alle mit ihren Grundeigenschaften vertraut sind, steigt ihr Stellenwert, und sie wird zu einer wichtigen Orientierungshilfe bei unserer tagtäglichen Arbeit für Tektronix.

Jerome J. Meyer

Jerry Meyer
Chairman und CEO

DESIGNER:
Martin McMurray

ORGANIZATION:
Broom & Broom

SIZE:
5½" x 8½" (14cm x 21.6cm)

QUANTITY:
15,000

COST:
$11,300

OBJECTIVES:
A layout that would
1. cross cultures easily;
2. strongly display the values of Tektronix; and
3. appeal primarily to employees, but also be attractive to vendors, customers, clients, etc.

HOW WE SAVED:
Strictly text, no art or photographs.

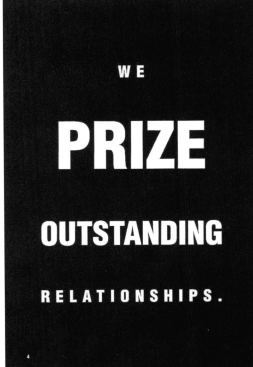

We prize outstanding relationships with our customers, each other, our business partners and our communities.

We work as a team.

We are quick to express appreciation and give recognition to those who help us succeed.

We offer creative solutions for balancing work and personal life.

great grids

and

three

THREE

nontraditional layouts

Grids are truly the invisible design element. Average readers don't pay much attention to how many columns there are on a page unless there's a problem with readability.

Students can't get through design school without some form of Grid Basics 101. Grids give publications pleasing proportion, a sense of underlying order, structure, cohesiveness. More importantly, they provide for readability in publications where information is key. It's no wonder the grid is always one of the first things to be thrown out by rebellious avant-garde designers. Grid abuse reached new heights of horror and chaos in the last few years when paid professional graphic designers turned out publications reminiscent of unmade beds complete with cracker crumbs and mismatched sheets. Columns of text were layered over each other. Blocks of type were skewed at random, intersecting others for no particular reason. Visuals were plunked around unpredictably with copy landing wherever there was room.

It made for good press for a long time. Professionals sagely analyzed and dissected the trend. Most practitioners of graphic design took the whole thing in stride as always. Bits of the grid revolution got picked up and absorbed into more mainstream publications. Instead of a basic page divided into three or four or five equal columns, designers were spicing things up with uneven columns, floating columns and unusual margins.

at a glance:

Make column widths uneven

Interrupt the grid

Break up the underlying grid into narrower columns or smaller blocks

Curve and skew columns

Think grid, not girdle

Add surprise to the standard grid

Wake up the background

Consider horizontal as well as vertical space

Use the neutral space

Compartmentalize with various grids

Of course, a grid makes a layout easier in most cases, especially for repeat publications like newsletters or a brochure series. Anything that saves design time is important to low-budget projects. Pouring text into a predictable layout frees the designer to work on other visuals.

A simple standard grid is best for amateur designers as well. Avoiding complicated layout decisions saves them time and keeps them from creating confusing, awkward pages. Knowing not only the budget limit but the limits of your own design "eye" is important. Trained designers with an eye for balance and unity can often pull off a multigrid or no-grid layout.

INSIDER ADVICE
Make column widths uneven

Where is it written that a grid has to divide the page into columns of equal width? Nowhere. Try something simple like two narrow outside columns with a wide one in between—or vice versa. You might even try three or four or five (depending on the size of your publication) columns that are all different widths.

Interrupt the grid

Centering artwork or a photograph on a grid line is common. The text flows around the image in whatever space is left. However, it is a bit cliché and symmetrical. Amateurs often make the text portion too narrow, which ruins the aesthetics of the technique. A picture or a piece of artwork that overlaps the grid line into the neighboring column is a visual surprise. "Interrupting" the grid just a little adds interest and variety. It's a three- dimensional visual of sorts. It's not as predictable and static as centering the artwork on a grid line.

Break up the underlying grid into narrower columns or smaller blocks

The grid should make the layout easier, not more difficult. If a newsletter, for example, frequently has charts or tables or photos that don't fit, the grid should be adjusted. That might mean turning a two-column grid into four, six or even eight very narrow columns. The more complex a publication becomes, the more complex the underlying grid should be.

Curve and skew columns

A strong, straight left margin is the general rule for languages that read left to right. Research and common sense tell us that the left side of a column of text is an anchor for the eye to bounce back to at the end of each line on the right. Short bits of text such as captions or pull quotes are fine set ragged left. Long columns, however, are hard to read if the left margin is too erratic. We don't see much ragged left text in newsletters and informational brochures and booklets for this reason. That doesn't mean that the eye can't tolerate a skewed left text margin or a wavy angle.

Think grid, not girdle

Uniformity, yes. Conformity, no. Although a grid gives a multipage document unity, that doesn't mean that every element has to blindly conform to fit in one of the columns. Some newsletters, for example, have a three-column layout with text, headlines, photographs and artwork all sized to fit in one of the columns. Text-only or text-heavy documents especially need grid variety. You can maintain the same underlying grid if you want. Simply stretch a summary paragraph across all of the columns. Enlarge the type to maintain readability. Run pull quotes across several columns. Let photos span two or three or more columns.

Add surprise to the standard grid

Run headlines or short blocks of text vertically instead of horizontally. Place blocks of text or headings at angles within a column.

Wake up the background

Maybe you need a strict, functional standard grid, say a calendar or events program or a directory. Layer the "grid-locked" copy on top of screened art or images that don't conform to that grid. Create background music for the eye.

Consider horizontal as well as vertical space

Page layout programs create grids that break the page into tall, vertical columns. Traditional grids were made up of smaller blocks running vertically and horizontally. It's easier to align elements across columns this way. Photos, for example, fit not only the vertical grid lines, but the horizontal standard too. This visual alignment with other elements or with the text makes the pages look more polished and complete. Horizontal grid lines ensure consistent spacing between stories and headlines or text and artwork.

Use the neutral space

Grids do provide unity, but in some cases unity gets downright boring. The margins, alleys between columns and the gutters between pages shouldn't be ignored. Line rules, screens, color blocks, arresting page numbers, etc., can add interest to these "neutral areas" of a standard grid.

Compartmentalize with various grids

Changing the grid to differentiate between sections makes sense. For example, the editorial pages of a booklet might be three columns while the directory section is five columns. A newsletter might treat the center spread as a feature section and use a different grid each time. Changing the underlying structure is a subliminal but strong visual cue to the reader that there is something different in this portion of the publication.

grid changes with the season

DELAWARE THEATRE COMPANY *ENCORE* NEWSLETTER

CREATIVE COMMENTS:

"Each season we have a new style for the newsletter," explains Lisa Harris. That style comes from actually reading all five plays that the theater has scheduled. "We look for a theme and translate that into different ways to liven up the pages."

The Harris team uses a lot of grid variety while maintaining cohesiveness with typefaces, color and headline treatments. They not only vary the number of columns per page, but create interesting layouts with grid columns of different widths.

Jack and Lisa Harris don't leave the neutral areas untapped either. One season's newsletter has page margins wrapped with wide, uneven bands of dark blue and tan blocks. Broken lines run across grid lines and lead the eye in interesting patterns around the pages. The effect is wild and contemporary.

The next season looks much more conservative and corporate. The pages have a solid perimeter with a double line marking the margin. Cohesiveness is still maintained via type treatment and ink color, but the grid changes from page to page. This season is more traditional. Columns are the standard two or three. The effect is still modern and contemporary, simply more restrained.

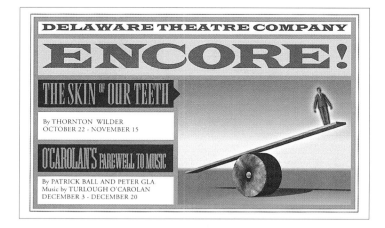

"We don't have a design style like a boutique," explains Lisa Harris. "We really get to know the client and the audience."

To help keep costs down she frequently negotiates a year's contract with printers. "We prevent paper price increases this way," she says.

The newsletter is part of a total package. The Harrises also design the advertising, show cards and lobby signs. This not only maintains a uniform look to the pieces, but is more economical for the client. "You can quote a better price this way than you could on a project-by-project basis. It allows us to save money here and shift it there when we need to," explains Lisa Harris.

THE DELAWARE THEATRE COMPANY'S BOARD OF DIRECTORS UNANIMOUSLY ELECTED FOUR NEW MEMBERS AT ITS ANNUAL MEETING IN JUNE

A PARTY, CASUAL BUT WILDLY FUN, FOLLOWS THE PERFORMANCE ON THE SECOND FRIDAY OF EVERY SHOW.

CREATIVE DIRECTOR:

Jack Harris

DESIGNER:

George White

PRESIDENT:

Lisa Harris

ORGANIZATION:

Harris Design d/b/a Orbit Integrated

SIZE:

Eight 8½" × 11" (21.6cm × 27.9cm) pages

QUANTITY:

4,500

COST:

Approximately $4,095 (printing)

OBJECTIVE:

Communicate with subscribers of a local theater three times a year.

HOW WE SAVED:

Inexpensive paper, existing photos, long-term printing contracts.

grid designed to accommodate short articles

NEVADA MILEPOST NEWSLETTERS

DESIGNER:

Syd Brown

ORGANIZATION:

brown, brandt, mitchell & murphy

SIZE:

8½" × 11" (21.6cm × 27.9cm)

QUANTITY:

NA

COST:

NA

OBJECTIVE:

A lively and interesting layout for a technical quarterly newsletter providing the latest information on transportation for local and county highway personnel. (Published by the Transportation Technology Transfer Center at the University of Nevada.)

HOW WE SAVED:

Two ink colors, writing to fit the layout, client-provided photos.

Fall 1996 Nevada's Technology Transfer Quarterly Vol. 6, No. 3

FOCUS DUST CONTROL

THE DIRTY SIDE OF DUSTY ROADS

Unpaved roads make up more than 50 percent of the road mileage in the United States. They are an economic necessity for access to rural areas in Nevada where low traffic volumes do not justify the cost of constructing and maintaining asphalt surface roads.

Although economically necessary, unpaved roads create dust problems. According to the Environmental Protection Agency (EPA), the dust generated from vehicles driven over unpaved roads is the largest source of particulate pollution in the country:

Source	kg/yr Per million cubic feet of air
Unpaved roads	245,000
Construction activities	25,000
Wind erosion	25,000
Paved roads	6,000
Wild fires	2,000
Agriculture tilling	2,000
Mineral extraction	2,000

Control of dust from unpaved roads is essential to improving air quality in Nevada's rural areas. The quantity of dust emissions from unpaved roads depends on:

- vehicle miles traveled
- vehicle weight and number of tires
- speed
- road surface properties

The counties' ability to control dust emissions on unpaved roads largely depends on the modification of the road surface properties — grain size distribution, density and moisture content.

Grain size — If the road surface has limited fine materials, there will be few dust emissions. However, construction of a gravel road requires the use of fine materials to bind coarser aggregate particles together.

Density — The stronger the surface, the better it can withstand traffic loads without degrading and subsequently producing dust.

Moisture content — Increasing the moisture content of the road surface from 2 percent to 4 percent can reduce dust emissions from 70 percent to 90 percent.

Control of dust emissions in arid areas such as Nevada is challenging because of unfavorable environmental conditions. In Nevada, soils lack the required binder content for construction of quality gravel roads. Thus artificial stabilization of the surface is particularly important to control dust emissions.

Unpaved road maintenance tips

It is essential to replace fines in gravel mix to keep an unpaved road stable under traffic. Fines often can be reclaimed from the shoulder edge, regraded and mixed with existing gravel. This should be done as routine maintenance while restoring and maintaining the crown.

Loose or unstable aggregate may be displaced by traffic to form ridges. Generally, gravel will be moved from the wheel path and form ridges at the center of lanes and at the roadway edges. Loose aggregate also can accumulate where vehicles frequently turn or stop. The aggregate may be temporarily bladed to the shoulder, although you must be careful not to restrict drainage. By remixing loose aggregate with fines from the roadway edge, it is possible to produce a well-graded mix. However, a severe accumulation of loose aggregate usually requires mixing with additional well-graded surface gravel.

■ IN THIS ISSUE

- This issue spotlights dust control. You'll learn different methods to reduce the dust problems related to unpaved roads (pages 1, and 3–5).

- In his column "L² on the Road," Larry Lunz looks at how lignin sulfonate is being used as a dust suppressant around the state (page 10).

- The "In Nevada" section contains the latest statistics on traffic deaths in the state and details on a new program designed to promote traffic safety (page 8).

- It's time once again to check out Aunt Jenny. Or more precisely the new publications and videos she has for you in the T² library (page 12).

- You'll probably also want to find out how Peter the Meter Man is doing in his second issue with us. Remember, he was hired after his predecessor fell victim to "lovely Rita." More sordid details inside (page 11).

■ ROUTING SLIP

Don't file this Quarterly in your in-box. Please — read it, photocopy what you want, initial below, and send it on, especially to the frontline troops.

NEVADA, HERE I COME

Highway travel increased 40.7 percent between 1982 and 1992. The increase was much larger in several states, particularly in the South and Southwest. Arizona, Nevada, Alabama and Georgia were the states with the fastest increase in travel.

INTERMODAL PROJECT IN LAS VEGAS

The Las Vegas McCarran International Airport Connector, funded from passenger facility charges, opened last December. It ties the airport terminal to the Las Vegas Beltway and I-15, making it an intermodal project. Way to go Las Vegas!

Flapless in Fallon

ever had a reoccurring problem that screams for a solution? Well, the Churchill County Road Department had a problem with mud flaps on their 10 wheelers. Every time they turned around the police were citing them for lack of flaps. The mechanics shop couldn't flap'em on fast enough. Seems that often when they dumped a load or backed up to a gravel pile, they came away flapless. This was causing quite a flap with the mechanics so out of frustration they flapped things around among themselves and came up with a flappable solution. Using spare parts they had lying around the shop, they came up with a good way to stay flapped. How about retractable flaps? Ones that would roll up out of the way when they weren't traveling on the highway.

Here's a diagram of their solution.

For additional information, call Mike Martin at (702) 423-4133.

DUMP BED FRAME MEMBER

AIR SWITCH IN CAB TO ACTUATE SYSTEM

FLAPS UP

FLAPS DOWN

SPRING

TIRE TIRE

AIR CYLINDER

TIRE TIRE

BICYCLE CHAIN

FLAP SPROCKET GEAR FLAP

A sound, sound barrier

a new sound barrier was installed in Las Vegas on the I-15 off-ramp at Sahara Avenue. The barrier which sits on a concrete retaining wall is made out of discarded tires, 18,000 pounds of them!

The used tire material is encased in a shell made of a fiberglass-reinforced polymer. It exceeds the sound barrier properties of other materials. The noise reduction coefficient is 0.15, compared to 0.1 for concrete (the higher the number, the better the noise reduction).

The barrier comes in sections which are 8 feet long by 6 feet, 9 inches high. Each section, which weights about 400 pounds, is lifted in place by a crane. When two sections are stacked together, they create a wall that is 13 feet, 6 inches high. Because the panels arrive at the site in sections, they take less time to install than a conventional concrete barrier which is poured in place.

The barrier sections, which should last 50 years, come in different colors from light brown to gray and green. Brown was the color selected for the Las Vegas project. The outer shell material will not burn and is easy to clean. Spray paint and other graffiti wash off easily.

One mile of this sound barrier uses 20,800 tires. Each year American motorists discard 250,000 million tires. That is 60 billion pounds of waste! The barrier is probably the largest single use of discarded tires.

The sound barrier was invented by Donald Schmanski, president of Carsonite, a manufacturer of highway safety markers. For more information call Donald at (702) 883-5104.

The new sound barrier on the I-15 off-ramp at Sahara Avenue in Las Vegas.

L² on the Road

On the road has expanded to include in the air as I now make frequent flights to Las Vegas because of T²'s expanded program in Clark County. After two trips I have *almost* met with all the federal, state and local officials involved with roads, streets and highways in southern Nevada.

The last week in March I picked up a fellow named John Hopkins at the Reno Airport. This is not John Hopkins as in university, but John Hopkins, director of the Arizona T² Center who teaches our Gravel Road Maintenance workshop. My job was to see that he got to Tonopah, Elko and back to Reno again for his classes. This meant I got to sit through his classes and I actually learned a thing or two.

The following week I met Bill Mobbs at the Las Vegas airport. He is a county public works director from New York State who teaches workshops for the New York T² Center. He teaches our class on Managing People. He taught this class in Las Vegas and Reno and again I was in charge of getting him to and from the classes. It is a big responsibility, but someone has to do it.

The reason I bring these classes up is because I am the Roads Scholar Program coordinator charged with its promotion. These classes are part of the program. The program is designed to give participants the flexibility to select classes that will give an individual new knowledge that is useful. This knowledge will not only help the graduate perform better on the job, but also provide a better opportunity for advancement.

To become a Roads Scholar you must, within a four year period, attend 10 workshops from a designated list. Four specific classes are required with the remaining six being electives. Currently, we have 38 people enrolled in the program, but at this time there are no graduates. Sign up now and who knows, you could have the honor of being the first graduate.

To receive your own application for the Roads Scholar Program mark the No-Brainer Page.

John Hopkins (left) directs a demonstration of gravel stabilization using geogrids at the Tonopah workshop.

Just a stone's throw away...

What I learned may be common knowledge to some of you, but I am so excited with my new knowledge, I am going to share it with you anyway.

When installing a corrugated metal drainage pipe across a roadway, the ditch should be dug twice the width of the pipe. Place the pipe in the center of the ditch. You now have ample room for proper compaction on both sides. Also, during this installation you need at least a foot of fill over the top of the pipe. Follow these two simple guidelines to avoid collapsed drainage culverts.

NEVADA TRANSPORTATION **t²**

TEST TRACK

FHWA awarded a contract for the construction and operation of an experimental road test facility. The 1.8 mile test track (dubbed "WesTrack") will be built on the grounds of the Nevada Automotive Test Center located about 60 miles southeast of Reno.

WesTrack will provide early field verification of the SHRP Superpave Level III (high traffic volumes) mix design procedures and will continue to develop performance-related specifications for hot mix asphalt.

Apparently Idaho was just a stone's throw away when Larry Lunz came across this state line marker in his travels.

CREATIVE COMMENTS:

Nevada Milepost is proof that technical publications don't have to read or look dull. In fact, Brown has a lot of fun with a regimented layout.

The grid is the same on every page: two columns 16½ picas wide and one 9¾ picas wide. The narrow columns are always on the outside edge and set off with a teal green screen. The format was developed to help organize the layout. Extremely short stories fit nicely in the narrow "scholar's margin." Longer features and news stories complete with photographs are squared off in the two wide columns.

The repetitious layout focuses attention on the art and the occasional "renegade" story. A story might span all three columns, for example.

Interrupting the predictable grid makes it impossible for the reader to miss the story.

The nameplate is unusual too because it undergoes a minor overhaul each issue. Brown adds seasonal art and weaves cartoon characters into the banner type. Lighthearted cartoon personalities are also used inside to accompany various standing columns such as "Aunt Jenny," "Fred the Meterman" and the "Old Codger."

"The Center's director, Maria Ardila-Coulson, helps me come up with ideas," admits Brown. "She has the same off-the-wall sense of humor that I do." Obviously the readers enjoy the humorous asides to the technical material. The newsletter has recently expanded with an Arizona edition as well.

"excuse me, but your grid is showing"

TULANE UNIVERSITY MEDICAL CENTER *RESULTS* BROCHURE

CREATIVE COMMENTS:

Low budget is a relative term. Something that costs just under $14 per unit to print may not be everyone's idea of economical, but in relation to the $100 million campaign it was representing, the cost seems appropriate. The idea, however, could easily be scaled down to almost any budget.

"A 'work in progress' is what someone called the campaign at one of our first meetings on the project," explains Varisco. "The term stuck. The idea came together quickly. It was just a matter of putting the design on paper then."

The *Results* brochure is a literal work in progress. Grid lines are inked in, and register marks are obvious, as are hand-written edit marks. Photographs are strewn across the pages as if the artist was puzzling over size and proportion. Narrow half sheets (4½" × 9" (11.4cm × 22.9cm) are bound between some of the pages listing donors.

"We're letting people in on the process," says Varisco, "even though you don't see many mechanicals like this any more." Whether or not you understand the pasteup process, the brochure is hard to miss. The effect is casual, fun and curious.

Only three or four photos were taken especially for the publication. "I knew I was going to be getting ordinary existing pictures of checks being passed and people shaking hands," he says. This layout draws the attention away from the routine visuals, yet incorporates them in a sophisticated way.

This brochure sets the stage for the final brochure due at the end of the campaign.

ART DIRECTOR/DESIGNER:
Tom Varisco

DESIGNER:
Jennifer Kahn

WRITER:
Stacy Day

PRINCIPAL PHOTOGRAPHY:
Jackson Hill, Southern Lights Studio

ORGANIZATION:
Tom Varisco Designs

SIZE:
9" x 12" (22.9cm x 30.5cm);
spiral binding; twenty-seven pages
plus two front cover sheets

QUANTITY:
1,000

COST:
Approximately $13,759 (printing)

OBJECTIVE:
Present the results to date of a
$100 million capital campaign for
Tulane University Medical Center
and encourage more support.

HOW WE SAVED:
Using existing photos.

the book of lists

TULANE UNIVERSITY MEDICAL CENTER *RECOGNITION* BROCHURE

CREATIVE COMMENTS:

The final brochure announcing all of the contributors to the $100 million capital campaign for Tulane University Medical Center is much more reserved and less expensive than its predecessor. It is however, finished and polished and very sophisticated looking.

"This layout was easier," Varisco says. "It's essentially a running list of donors."

The three-column grid allows for plenty of white space. But even when a grid is standardized, it helps to wake it up with small things. Varisco spiced up the layout with existing photos. Large photos, printed in metallic teal, straddle the grid and gutters behind the text. Smaller photos are in the foreground printed as duotones in black and teal. Several of the pictures bleed off the page.

The page numbers are grid breakers too. Also printed in teal, they boldly go into the text in the lower outside corners.

"After twenty-five years as a designer you just know how to cut corners," observes Varisco. "Most people don't want to spend a lot of money. They expect you to do that [cut corners] automatically."

The first places Varisco tries to cut back on are format, ink and photos. "When a newsletter, for example, needs to be done economically, I start by trying to come up with a fold that won't require binding. Something that's not 8½" × 11" (21.6cm × 27.9cm), however, so it stands out. I work with no more than two inks. Then I try to get all the photographs we need taken at once or look for existing photos."

ART DIRECTOR/DESIGNER:

Tom Varisco

ORGANIZATION:

Tom Varisco Designs

SIZE:

9" × 12" (22.9cm × 30.5cm); saddle
stitched; twenty pages plus covers
and tissue overlays

QUANTITY:

1,000

COST:

Approximately $12,000 (printing)

OBJECTIVE:

Showcase the contributors to the
$100 million capital campaign for
Tulane University Medical Center.

HOW WE SAVED:

Using existing photos, standard
three-column grid for easy layout.

squares never go out of style

WEXNER CENTER CALENDAR OF EVENTS

CREATIVE COMMENTS:

A square is actually an odd shape in American culture. Most publications rely on more familiar rectangles. This schedule of events is based on squares originating from the individual invisible one-pica squares of the grid all the way up to the 8¼" × 8¼" (21cm × 21cm) square mailing format.

"This is the Center's core piece. The publication has a long history," says Jones. "The original concept sprang from a logo composed of four squares. The logo no longer exists, but the grid stayed."

The whole layout is based on a one-hundred-pica square grid, the total size of a two-page spread. "I use a four-column grid on each page for the schedule information," says Jones. "But a lot of other stuff steps outside that grid."

The layout is packed and lively. The publication gives you the impression that there's a lot going on at the Center. "I try to look at how the pictures and images will interact with each other in the layout," explains Jones.

Pictures sprawl across columns in circles, and cutouts; textures and screens dance in the background. Even within the four text columns, Jones aims for variety. He reverses type out of various inks. Screens of color butt up against photos, and background words tumble across the foreground text.

The publication is always printed in two colors, but feels like three or more. Jones mixes

shades liberally, stretching the color palette. Black screened with a yellowish tan produces a khaki green. Lavender and black mix to create a deep violet.

"We pride ourselves on doing creative things economically," says Jones. "Having money for four-color wouldn't necessarily make the designs any better."

performing arts

support

Major support for the
1996-97 performing arts season
provided by Stanley Steemer.

Additional season support pro-
vided by the Ohio Arts Council
and the Wexner Center
Foundation.

Brazil's Balé Folclórico da Bahia

Wed, Feb 19
8 pm Mershon Auditorium
$15, $11.25 members
$20, $15 public

You'll feel the tropical spirit of
Carnival in February when this fes-
tive Afro-Brazilian ensemble arrives.
The virtuosic company has electrified
audiences around the world with
the colorful fantasia of swirling
skirts and *samba,* windmilling high
kicks in the martial art-rooted *capo-
eira,* and tempests of percussion
that send the dancers surging into
ecstatic bursts of action. The
troupe's magnificent singers and
musicians ignite infectious Brazilian
rhythms that captivate listeners
while propelling the dancers to
amazing acrobatic feats or under-
scoring their more lyrical turns. The
New York Times reports, "Energy
explodes uninhibitedly in this mar-
velous Brazilian company....this exu-
berant Brazilian group should
absolutely be seen."

**Presented in association with
the King Arts Complex.**

**Promotional support provided
by WCBE-FM, 90.5.**

Mikhail Baryshnikov's White Oak Dance Project
Special Benefit Concerts for the National Dance Project

Just added

Members only pre-sale
through January 19!

Fri & Sat, Mar 14 & 15
8 pm Mershon Auditorium
$52, $44, $36
$28/OSU students (zone 3 only)
No other discounts are available for
these special benefit performances.

Dance superstar Mikhail Baryshnikov
returns to the Wexner Center with his
superb ensemble of 10 dancers
(accompanied by live chamber music)
for two concerts. All proceeds benefit
the National Dance Project, a consor-
tium of 12 leading arts organizations
dedicated to supporting dance artistry.
The Wexner Center is honored to be
designated one of the 12 "Hub Sites"
of the National Dance Project and to
collaborate with White Oak Dance
Project in furthering the aims of
this important project.

**Promotional support
provided by Classical
89.7, WOSU-FM.**

above (both images)
**Brazil's Balé Folclórico
da Bahia**

above right
Baaba Maal
photo: Juergen Teller, courtesy
Mango Records and Island.

right
Mikhail Baryshnikov
photo: Annie Leibovitz

Upcoming events

Sat, Mar 1
8 pm Mershon Auditorium
$9, $7 members
$18, $14 public

Afro-pop's most heralded and
impassioned singer thrills world
music fans with his celebratory
sound. Accompanied by his crack
12-piece band and two high-step-
ping dancers, Maal presents soaring
vocals and gliding beats in a concert
you won't forget!

**Promotional support provided
by WCBE-FM, 90.5.**

Joshua Redman Quartet

Sat, Mar 8
7:30 & 9:30 pm King Arts Complex
$15 members, $20 public

The young tenor sax ace returns
with an all new band and his latest
jazz hit, *Freedom in the Groove*—#1
on the *Billboard* magazine chart.
This concert replaces the previously
announced show with Steve Turre's
Sanctified Shells, which has been
canceled.

**Presented by the King Arts
Complex in association with the
Wexner Center.**

DESIGNER:
M. Christopher Jones

EDITOR:
Ann Bremner

ORGANIZATION:
Wexner Center for the Arts

SIZE:
16½" × 8¼" (41.9cm × 21cm)
folded to 8¼" × 8¼" (21cm ×
21cm); saddle stitched; self-cover;
twelve to sixteen pages

QUANTITY:
22,000

COST:
Approximately $5,940 (printing)

OBJECTIVE:
Bimonthly schedule of events.

HOW WE SAVED:
Inexpensive paper, existing photos,
two ink colors.

white space is not empty space

THE CLEVELAND CLINIC FOUNDATION *CANCER PERSPECTIVES* NEWSLETTER

CREATIVE COMMENTS:

Cancer Perspectives is spacious and contemporary. Liberal amounts of white space balance large, sometimes dark illustrations. The articles are concise. All of the pages are more or less based on some sort of three-column grid; that is, the grid is always the same, but different.

"If I'm bored, the reader's probably going to be bored," says Feldman, who speaks disdainfully of pages that endlessly repeat the exact same grid treatment. "I can use the same grid on every page, but alter it slightly," she explains. Feldman applies a trained eye to maintaining a look, but subtly adjusting it for visual variety.

You'd never have a problem recognizing *Cancer Perspectives*. The front page layout is always the same. "I want people to recognize it immediately," she says. However, even here Feldman runs the feature story over two of the three columns for variety. The feature continues to page two where the three-column grid is more obvious, but again Feldman tweaks it slightly. The key word from the cover feature runs vertically, almost creating a narrow fourth column. Because she uses generous alleys throughout the entire publication, the heading running between the columns is not out of place.

The "Special Information" section has a grid of its own—two wide columns and one narrow—to distinguish it from the rest of the publication. "This section has evolved," explains Feldman. "Even the typefaces are different."

The newsletter always uses black ink plus another color that changes with each issue. The paper, Strathmore Elements, also changes

each time. The Strathmore Elements line offers a selection of patterns and colors that are very subtle and almost imperceptible. Feldman uses the variation as another quiet way to add interest and variety without being obvious.

"I'm constantly looking around for ideas," says Feldman. "I think it's important to know the audience and the competition. What else are these people getting, and how can I make mine stand out?"

quit... just do it

How to Curb Your Appetite

With the return of your sense of taste and smell after you quit smoking, food may suddenly seem very appealing. However, by planning ahead, you can avoid gaining unwanted pounds. Before and after every meal, drink a glass of water. Also, try to drink water during the course of your day. Begin an exercise program, even if it is just a walk around the block at first. In general, adopt a take-charge attitude — remember that you control what you eat. Don't let the fear of gaining weight keep you from quitting. Look at gaining weight as an option you don't have to choose.

Every Breath you Take...

Smoking is the largest preventable cause of premature death in the United States, claiming the lives of 430,000 adults per year, according to the Centers for Disease Control.

That should be enough to make anyone want to quit. But if you need more information to be convinced, here it is: Your risk of developing lung cancer is multiplied ten times by smoking. Chronic emphysema, also caused by smoking, makes it difficult for your lungs to expand and contract, impairing function and quality of life.

Researchers are finding that smoking may also be a contributor to other types of cancers. In fact, smokers have an increased risk of cancer of the larynx, oral cavity, esophagus, urinary bladder, kidney, pancreas, stomach and uterine cervix. Smoking also substantially raises the risk of developing heart disease.

If you are a current smoker, stop. If you don't smoke and know someone who does, use the following tips to encourage them to quit for good.

How to quit successfully

Anyone who has tried to quit smoking knows it is not easy. Smoking is an addiction that involves chemicals that affect emotions and behavior. However, "it is not impossible," according to Cleveland Clinic psychologist Garland DeNelsky, Ph.D. "Nearly 55 million smokers have successfully quit—that is more than half of the total number of smokers in the United States. And although it is not easy, 80 to 95 percent of those who quit did so on their own with no formal program."

If you decide to quit, prepare to do so wholeheartedly. Since smoking is habitual, try to refrain from any of the usual actions that lead to lighting up. If you always smoke after a meal, decide instead to take a walk after eating. If you used to smoke while on the phone, notice how much more you get out of the conversation now when you use to pull on a cigarette.

Before your stop date, begin preparing for the big day. Some good ideas are: get rid of favorite lighters and ashtrays; wash all clothes to get rid of the smell; start buying packs of cigarettes, not cartons; change to a different brand; and try to delay smoking when you get the urge. In your own way, make yourself conscious of every cigarette you attempt to smoke.

If you had a favorite upholstered chair you sat in while smoking, have it professionally cleaned. In fact, it is a good idea to have your curtains, drapes, walls and windows cleaned to remove the stale odor and yellow stain that typically occurs in a smoking environment. It will give you a fresh start.

Set a stop date and stick to it. Make a list of why you want to quit smoking and review it periodically. Tell family and friends that you are quitting and would like their support. Dr. DeNelsky also advises that you ask any smokers you live with to not smoke in your presence, and to not leave any cigarettes or ashtrays around.

Think positive. You will be prolonging your life when you quit smoking. So, when the urge arises, think about what you are doing for yourself. The urge will go away whether you smoke or not.

"Even if you smoke one or two cigarettes after you have decided to quit, the odds are high that you will return to being a regular smoker," says Dr. DeNelsky. "But keep in mind that many who quit for good did not do so on their first try. Quitting smoking is a challenge, and requires a strong commitment to stop for good. If you try to quit and are unsuccessful, it does not mean that you cannot try again and succeed."

The More you Know... The Better

If you do not know your family's history of cancer, your lifetime prevention program will be compromised. The key to early diagnosis and treatment rests with information — from the knowledge you acquire by looking back several generations to assess the incidence of cancer in your family, as well as to the information you obtain when you assess your lifestyle choices that may increase your chance of developing the disease.

Evaluating Risk

Risk assessment is a comprehensive evaluation of your personal and family medical history and your individual risk factors for cancer.

The following questions will help you evaluate diet, environmental and occupational risks. If you answer yes to any of these questions, you are at increased cancer risk. Take steps now to change your lifestyle choices and occupational exposure, if possible.

1. Do you smoke?
2. Do you use smokeless tobacco products?
3. Do you often work or play in the sun?
4. Do you take estrogen supplements?
5. Do you work with or near industrial cancer-causing agents, such as asbestos, nickel, uranium, chromates, petroleum or vinyl chloride?
6. Do you have X-rays taken frequently?
7. Is your diet high in fat?
8. Do you drink two or more alcoholic beverages daily?

Physicians consider the following when determining if you have a strong family history for cancer. If any of these apply to you, you may wish to consider risk assessment.

- early onset of cancer, generally before age 40
- two or more relatives with the same or related cancers, such as cancer of the breast and/or ovaries
- two or more first degree relatives (parents, brothers, sisters, children) with cancer
- development of a rare type of cancer
- more than one tumor in the same organ
- occurrence of one type of cancer after another

If you have a strong family history, you may wish to consider risk assessment.

special information

This special section of Cancer Perspectives focuses on topics of interest to families at high risk for cancer. If you have questions or concerns, please contact Medical Genetics Risk Assessment, 216/445-5686, or 800/998-4785.

prevention

The first step to cancer prevention — Assess Your Risk

Answer the following questions to determine your risk for developing cancer. If you answer yes to any of these questions, you are at increased risk of cancer.

Take steps now to change your lifestyle choices.

1. Do you smoke?
2. Do you use smokeless tobacco products?
3. Do you often work or play in the sun?
4. Do you take estrogen supplements?
5. Do you work with or near industrial cancer-causing agents, such as asbestos, nickel, uranium, chromates, petroleum or vinyl chloride?
6. Do you have X-rays taken frequently?
7. Is your diet high in fat?
8. Do you drink more than two alcoholic beverages a day?

The Cleveland Clinic is participating in a number of chemo-prevention trials, including:

ASPIRIN trial for those at high risk of colon cancer

FINASTERIDE (Proscar) for those at high risk of prostate cancer

13-CIS-RETINOIC ACID (Accutane) for those who have been treated previously for lung cancer

BETA-CAROTENE for those treated previously for head and neck cancer

TAMOXIFEN for women at high risk of breast cancer

If you would like more information about these trials, and/or if you are interested in being a participant, please call the Cleveland Clinic Cancer Center, 216/444-7923.

(continued from page 2)

cancer in women at high risk for the disease. Tamoxifen has been used to halt the spread of breast cancer after surgery; now scientists believe it may prevent the disease from occurring in the first place.

Beginning this year, a new Cleveland Clinic study will evaluate whether aspirin can prevent the recurrence of pre-cancerous colon polyps.

"The aspirin trial is very exciting," says Rosalind van Stolk, M.D., a Cleveland Clinic gastroenterologist. "Studies have shown that people who take aspirin regularly seem to have a decreased risk of colon cancer." This study, sponsored by the National Cancer Institute, will include patients at high risk of colon cancer – those who have had pre-cancerous colon polyps removed.

In combination with identifying new chemo-preventive substances, future cancer prevention research will focus on genetic testing to identify people at high risk for certain types of cancer, according to Richard S. Lang, M.D., head of the Cleveland Clinic's Section of Preventive Medicine.

"Progress is being made to develop further the techniques for genetic testing," he says.

"While chemo-prevention and genetic testing represent the newest frontiers in cancer

prevention, the most effective preventive measures today are related to lifestyle," Dr. Lang notes.

"This is a point I can't emphasize enough. The single most important action people can take to stay healthy involves a lifestyle choice - quitting smoking."

Smokers are ten times more likely to develop lung cancer than non-smokers, Dr. Lang explains. They're also more at risk for other types of cancer and a host of non-cancer problems as well, including heart disease, emphysema, bronchitis and stroke.

What else can you do to reduce your risk of getting cancer? Eat a low-fat, high-fiber diet that includes plenty of fresh fruits and vegetables, avoid known carcinogens such as asbestos, and limit your exposure to the sun. Also, know your personal risk for developing cancer (see above) and protect yourself with regular screenings such as Pap smears, mammograms and prostate exams.

"It's important to remember that cancer prevention doesn't happen overnight," says Dr. Lang. "There's no magic pill. It takes years for healthy cells to develop into cancerous cells – and it takes long-term lifestyle modifications to prevent this disease."

DESIGNER:
Jamie Feldman

ORGANIZATION:
Feldman Design

EDITOR:
Rosemary Halun, The Cleveland Clinic Foundation

SIZE:
Eight 10" × 15" (25.4cm × 38.1cm) pages

QUANTITY:
Approximately 12,000

COST:
NA

OBJECTIVE:
Inform and educate consumers about cancer research and treatments.

HOW WE SAVED:
Two ink colors, illustration rather than photography.

the idler: an oddly easy read

THE *IDLER* MAGAZINE

CREATIVE COMMENTS:

Don't let the name fool you. This British magazine may be dedicated to loafing, but anyone who's ever published a magazine knows there's little idling involved personally. Talking to the busy staffers while the magazine was in production was almost impossible.

Pick a grid, any grid. You'll probably find it in *the Idler.* The inconsistency is a pattern of sorts. What saves the design from being disorganized and makes it interesting instead are

1. the consistent type treatments;
2. the fact that the layout is usually standard straight columns of equal width; and
3. liberal use of photos.

Unlike many unconventional magazines, *the Idler* is easy to read and entertaining to the eye. There is no type superimposed on top of type or text obscured by graphics. Added color is usually restrained.

When the designers want to make a statement, however, they often do it with an unusual adjustment to the grid: slanted columns or wavy margins. They use white space liberally, often employing a "scholar's margin" layout which leaves one outside column very clean and empty in some cases.

A question and answer article, "In Conversation With Alex Chilton," takes a different approach to the standard three-column layout. Bits of the interview are laid out in L-shaped blocks that interlock on the page. The sequence is interesting and not at all difficult to follow.

easy sounds

Guns and Guitars and Godfathers

Wayne Kramer (below) is the ex lead guitarist of The MC5, legendary late Sixties militant proto-punk band from Detroit. With songs like Kick Out the Jams [...Motherfucker] their radicalism contrasted deeply with the "jingly jangly lame folk-rock" of the hippy movement. His influence has been immense, including clearing a path for Iggy and The Stooges. The Idler asks him:

KIRA JOLLIFFE

LINK WRAY

ADRIAN WAINWRIGHT

EDITOR:

Tom Hodgkinson

ART DIRECTOR:

Gavin Pretor-Pinney

DESIGNER:

Liz Harris

ORGANIZATION:

Zone Publishing

SIZE:

8¼" × 11¹¹⁄₁₆" (21cm × 29.7cm); saddle-stitched magazine

QUANTITY:

NA

COST:

NA

OBJECTIVE:

Magazine "for those who love to loaf."

HOW WE SAVED:

Four-color covers only, generally one or two colors inside, inexpensive paper.

using clip art

Clip art—it's not just filler anymore. And it's not just for amateur designers anymore either. Once dubbed "canned" creativity or "fast-food" illustration, "real" designers snubbed clip art as amateurish and uninspiring. Clip art has reached new levels of sophistication. Today's sketches, cartoons, icons, tintypes, avant-garde illustration and special-effect images like paint streaks and swashes are a far cry from the old, traditional, dry art associated with grocery store advertising. Because it's instantly available, clip art is a good answer for money-strapped projects that need to be put together fast.

There are two types of clip art users in the world: compulsive and creative. Compulsive clip art users generally fill holes left by short copy in a layout. More often than not, they end up with a strong visual at the end of a page or panel instead of near the headline where it might draw the reader's attention for good reason. Compulsive clip art users decorate rather than design. They create chaos with too many small pieces all over rather than creating strong focal points for the readers.

Creative "clip artists" incorporate the art from the beginning of the design. They usually customize the images with screens and color. The clip art is blended into the layout, not lumped in as an afterthought.

FOUR

creatively,
not compulsively

F O U R

Clip art should have a purpose other than filling white space. Use clip art as

- an attention getter. Make images large, unique and/or dramatic. Think about what other publications this one will be competing with for attention. Best for covers, feature stories, flyers, advertising.
- an organizing element. Facilitate the skim-reading process with visual cues. Tie the images to the subject of the text. Best for newsletter editorial columns and standing heads, booklet sections or chapters, brochure subheadings.
- a mood establisher or enhancer. Incorporate visuals that add to the tone of the piece or individual article. How the art is drawn is just as important as the image itself. Is it a soft sketch, a hard-lined contemporary drawing, a retro cartoon or an old- fashioned woodcut?

The temptation to overuse the free images that come bundled with popular software programs is a problem for compulsive clip art users. Think of showing up at a party with four or five other people wearing the exact same outfit only in petite, tall and extra large. While it's not the end of the world, it's a bit embarrassing. If you're going to be using clip art regularly in your publication, invest in some good clip art that gives you a variety of images to draw from and customize.

at a
glance:

Think big, bold, dramatic

Think small, secondary, delicate

Customize and manipulate

Wrap text for readability

Use as a welcome distraction

Use a fast fix for text-heavy reference material

Be original

Try font pictures

Screen the art wisely

Place several small pieces of clip art together in a montage

Marry type and art

Access the Internet

Go "dotty" with chunky, bumpy bit maps

Don't toss out the old clip art books and collections

INSIDER ADVICE
Think big, bold, dramatic

Don't be shy. Use clip art to get attention or call attention to a headline or section. Treat good images like good photographs— large, prominent drawing cards. One piece of dominant clip art will focus the reader. Several small pieces scattered around a page usually confuse the eye rather than lead it.

Think small, secondary, delicate

Due in part to the World Wide Web, icons or small symbols have boomed in print media. These images are a subtle touch. They might be useful things, such as a phone, fax machine and an envelope to indicate the phone and fax numbers and the mailing address. Small bits of art might even be screened behind an initial cap or repeated over page numbers.

Customize and manipulate

Combine or crop clip art images. Stretch them. Squeeze them. Distort them. Add texture. Even simple page layout programs allow users to manipulate graphics.

Wrap text for readability

What once took hours for a typesetter to churn out can now be done at the flick of a button on almost any word processing program. It's easy and eye-catching, but make sure the text doesn't get so ragged it's unreadable. Since we're a left-to- right reading culture, it's better to wrap text to the left of an image, thus maintaining a hard left margin. Another quasi cliché is clip art centered on the grid line. Everyone seems to be doing it.

Use as a welcome distraction

Poor client-provided photos that must be used? Maybe out of focus or uneventful or cliché? Clip art can rescue the layout, and you can still keep the client happy. Use the art large and dominant and keep it away from the pictures. Add color if you have it.

Use a fast fix for text-heavy reference material

Directories, reports, summaries, lists, any kind of strictly functional, copy-intense material will benefit visually from clip art. In this instance the art isn't meant to be the drawing card or lure for attention like it would be on a brochure cover or in a newsletter. It's simply meant to relieve the tension of too much text. Give the art a theme that's tied either to the organization or the topic the material refers to. For example, use school images in a directory of teachers. If the publication is seasonal you might even tie the art to the time of year.

Be original

Headlines with the words *international* or *worldwide* or *global* don't call for a globe every time, nor does a column called "Spotlight" cry for a spotlight of some sort. Overusing commonplace clip art is amateurish.

Try font pictures

Clip art is only a keystroke away if you use the Dingbat or Wingdings fonts that come resident on most computers. It's easy to overlook these art archives which are right at your fingertips. Typically, these fonts are pulled out when you need something functional like a bullet or a check box or an icon. In order to use picture fonts, you need to take a look at what each keystroke offers. Think about using typical characters, like the envelope or telephone images, in unexpected ways. Combine the characters for interesting effects.

Screen the art wisely

The background is not a dumping ground. "Watermarks" or images screened lightly behind text are everywhere. About every other one is actually unreadable.

Place several small pieces of clip art together in a montage

Maybe one image doesn't do the topic justice, but several small ones do. Instead of sprinkling them around the layout, group them into a single, dramatic focal point. This can be as easy as a square or rectangle, or more interesting as an odd shape like a star or a heart. Even more dramatic might be an overall outline of some object that relates to the copy, say a coffee cup or mountain peaks.

Marry type and art

Instead of simply using a text wrap around the clip art, run a headline or pull quote in a single line following the outline of the image. Make the type large and bold or small and subtle.

Access the Internet

Many associations and special interest groups have started warehousing clip art on their Web sites as a public service. Agricultural or environmental groups, for example, are more than happy to provide copyright-free images to accompany articles related to their topics.

Go "dotty" with chunky, bumpy bit maps

Don't ignore that rough looking, bit-mapped art. Screen it in the background or use a special effect on it to blur or distort it.

Don't toss out the old clip art books and collections

It may seem redundant, but not every image has been translated to disk yet. Besides, why buy stuff you already have? Plus, retro clip art is hot again. Dated images can be easily scanned and cleaned up without investing in any more electronic collections.

an apple a page is a sure way to engage

FOCUS ON WELLNESS BOOKLET FOR THE HARRIS CORPORATION

CREATIVE COMMENTS:

Twenty-five years of designing experience has taught Schowalter to "deal with what you've got." The *Focus on Wellness* publication has a lot of text and a lot of new information for employees to absorb.

Schowalter uses the art to establish a theme of sorts for the publication. She chose an apple theme, implying that "an apple a day keeps the doctor away." The apple is not only part of the cover art, but it's sprinkled throughout the entire booklet: screened behind initial caps, cut into eight sections as illustration for eight keys to healthy living, and in apple trees signifying growth and a "lifetime of prevention." The apple idea ties all the articles together well, making them part of a cohesive whole.

Schowalter varies the boldness of the art. Sometimes she illustrates an article lightly with soft screens, and other times the clip art is the dominating point of the page or spread. The large pieces of clip art always contain a bright red apple contrasted with purple. The art serves to draw readers toward important information.

Because the clip art was so instantly available, Schowalter thought it was a natural for the booklet. "The clip art makes the material reader friendly," she explains. Since the wellness program was a new idea for the employees, the old-fashioned tintype clip art that Schowalter chose is a good move. It makes the new program seem less threatening.

A lifetime of prevention

Age	2 Months	4 Months	6 Months	15 Months	18/24/36 Months	4-6 Years	7-12 Years	13-17 Years	18-39 Years	40-64 Years	65 + Years
Immunizations	DTP/1 OPV/1 HBV/1 HIB/1	DTP/2 OPV/2 HBV/2 HIB/2	DTP/3 HBV/3 HIB/3	DTP/4 OPV/3 MMR/1 HIB/4		DTP/5 OPV/4	MMR/2	Td	Td HBV	Td	Td Influenza vaccine Pneumococcal vaccine
Screening/ Diagnostic Procedures (Additional visits at the discretion of the physician)	Well baby exam[1] Hgb or Hct, U/A[4]	Well baby exam[1]	Well baby exam[1]	Well baby exam[1] Hgb or Hct, U/A[4]	Well baby exam[1] Dental checkup[5] Blood pressure[6]	Well child exam[2] Hgb or Hct, U/A[4] Dental checkup[5] Blood pressure[6]	Well child exam[2] Hgb or Hct, U/A[4] Dental checkup[5] Blood pressure[6]	Well child exam[2] Dental checkup[5] Blood pressure[6]	Physical exam[3] Dental checkup[5] Blood pressure[6] Blood cholesterol and HDL[7] ...and for women only Pap smear/pelvic exam[10] Clinical breast exam[11] Baseline mammogram[12]	Physical exam[3] Dental checkup[5] Blood pressure[6] Blood cholesterol and HDL[7] Rectal and colon[8] exam[8] Occult blood testing[9] ...and for women only Pap smear/pelvic exam[10] Clinical breast exam[11] Mammogram[12] ...and for men only Prostate exam[13] PSA[14]	Physical exam[3] Dental checkup[5] Blood pressure[6] Blood cholesterol and HDL[7] Rectal and colon exam[8] Occult blood testing[9] Hearing test Glaucoma test ...and for women only Pap smear/pelvic exam[10] Clinical breast exam[11] Mammogram[12] ...and for men only Prostate exam[13] PSA[14]

Immunizations—Children and Adults
(Frequency as shown on chart unless specified below)
DTP: Diphtheria and tetanus toxoids and pertussis vaccine. Given as five separate occasions.
HBV: Hepatitis B virus vaccine now recommended for all infants by the Centers for Disease Control; then once before entering college.
HIB: Haemophilus influenzae-type causes meningitis, pneumonia and infections of the blood, joints, bones, soft tissues, throat and the covering of the heart. Although the vaccine is typically administered in one dose at age 18 months, our chart follows the four-dose recommendation of the American Academy of Pediatrics.
MMR: Measles, mumps and rubella virus vaccine. Given on two separate occasions.
OPV: Oral polio virus vaccine. Given on four separate occasions.
Td: Tetanus and diphtheria toxoids vaccine. Full dose tetanus toxoid, reduced dose diphtheria toxoid. Once every 10 years, beginning at age 14-16.
Influenza vaccine: Annually after age 65.
Pneumococcal vaccine: Usually administered only once at age 65. (Prevents pneumonia, bacteremia and meningitis.)

Screenings/Diagnostic:
1 **Well baby exam:** 2, 4, 6, 9, 12, 15, 18, 24 and 36 months.
2 **Well child exam:** Age 4; then, repeat every 2 years until 18.
3 **Physical exam:** Age 19 to 39, every 5 years; age 40 to 49, every 3 years; age 50 to 65, every 2 years; over age 65, annually.
4 **Hgb or Hct, U/A:** Hemoglobin or hematocrit and urinalysis once before 12 months; then, between 12 months and 4 years, 4 and 12 years, 12 and 18 years.
5 **Dental checkup:** Starting at age 3, every 6 months.
6 **Blood pressure:** Age 3 to 17, annually. After age 18, repeat at 2-year intervals.
7 **Blood cholesterol and HDL (high density lipoprotein) test:** If normal, repeat every 5 years.
8 **Rectal and colon exam:** Flexible sigmoidoscopy every 3 to 5 years after age 50.
9 **Occult blood testing:** Annual testing (for blood in stool) beginning at age 50.
10 **Pap smear/pelvic exam:** Beginning at age 18 or earlier if sexually active, every year for 3 years; then, every 3 years thereafter, adjusted for risk factors.
11 **Clinical breast exam:** From age 20, every 3 years; beginning at age 40, annually.
12 **Mammogram:** Once between 35 and 40; between 40 and 50, every 2 years; after age 50, annually.
13 **Prostate exam:** Rectal exam as part of physical beginning at age 40.
14 **PSA (prostate specific antigen):** Annually beginning after age 50.

12/92

DESIGNER:
Toni Schowalter

ORGANIZATION:
Toni Schowalter Design

SIZE:
8½" x 11" (21.6cm x 27.9cm)

QUANTITY:
Approximately 5,000

COST:
Approximately $4,250

OBJECTIVE:
Harris Corporation was moving from an indemnity insurance plan to a managed-care program with a concentration on wellness. The company needed an inexpensive yet attractive booklet to explain the new focus.

HOW WE SAVED:
Inexpensive offset paper; clip art; limiting the number of inks.

pack rats take heart!

**MISSISSIPPI PUBLIC HEALTH ASSOCIATION
ANNUAL MEETING PROGRAM BOOKLET AND BROCHURE**

Mississippi Public Health Association

Creating Healthy Communities —
The Public Health Team

CREATIVE COMMENTS:

Inspiration knows no sense of time. When Burnett first heard the materials' theme, "Creating Healthy Communities," she remembered an image she'd seen a long time ago. Burnett, a self-proclaimed pack rat, raided an old clip art book she had at home. "I never throw anything away," laughs Burnett.

She scanned the simple line drawing of a busy town center into Adobe Photoshop where she added color and building names. The County Health Clinic sign is right in the center, implying its role in the community. The image is lighthearted and energetic.

The clip art, which is featured on the cover of the program and brochure, is taken apart and used in bits and pieces on the inside pages of each publication. The floral delivery van, for example, is used with the page numbers inside the all-text program. People figures are copied on the inside of the brochure. The duplication keeps a unifying theme running through the pieces.

Burnett negotiated an even lower print cost by exchanging a credit line for a price break. The printer's logo and phone number are printed prominently on the inside back cover of the program.

"People kid me that I live my job," jokes Burnett. Fortunately, she also loves her job as a one-person, in-house design shop for the Department of Health. Creativity for her comes from the variety of projects she's called to work on. "I do everything from newsletters to signs to T-shirts."

"Design is like fashion. It changes, and I have to keep up," she explains. "I read design magazines and books. I belong to associations that help me keep in touch with other outside design agencies."

Conference Checklist

Mark your choice of activities based on full descriptions in the detailed program booklet; use this as a quick reminder of your schedule of events.

Tuesday — September 24

- ☐ 3 pm - Registration Team Meeting
- ☐ 6 pm - Executive Committee Meeting

Wednesday — September 25

- ☐ 9 am to 5 pm - Registration and Voting - Grand Ballroom Foyer
- ☐ 1 pm to 5:30 pm - Exhibits - Gulf Hall
- ☐ 1 pm - Opening Session - Grand Ballroom
- ☐ 2:15 pm - Section Awards
- ☐ 3:30 pm to 5 pm - Section Meetings
 - ◆ Clerical - Emerald
 - ◆ Community Health - Atlantic
 - ◆ Epidemiology - Caprice
 - ◆ Environmental Health - Petit Bois
 - ◆ Health Administration - Caribbean
 - ◆ Medical Care - Pacific
 - ◆ Nutrition - Chandeleur
 - ◆ Public Health Nursing - Ship Isle
 - ◆ Social Work - Topaz
- ☐ 6 pm - "Meet The Candidates"
 - ◆ Allied Medical - Deer Isle
 - ◆ Coggins & Associates - Suite 622

Thursday — September 26

- ☐ 8 am to Noon - Registration and Voting - Grand Ballroom Foyer
- ☐ 8:30 am to 9:45 am - Workshops I
- ☐ 9 am to 11:30 am - Exhibits - Gulf Hall
- ☐ 9:45 am to 10:15 am - Break - Gulf Hall
- ☐ 10:15 am to 11:30 am - Workshops II
- ☐ 11:45 am to 1:15 pm - Luncheon - Grand Ballroom
 Prestige Awards Presentation
- ☐ 1:30 pm to 2:45 pm - Workshops III
- ☐ 2:45 pm to 3:15 pm - Break - Gulf Hall
- ☐ 3:15 pm to 4:30 pm - Workshops IV
- ☐ 6 pm to 7:30 pm - President's Reception - Boardwalk
- ☐ 8 pm to Midnight - Dance - Grand Ballroom

Friday — September 27

- ☐ 8 am - Exhibits - Gulf Hall
- ☐ 8:30 am - Breakfast Meeting
- ☐ 9:30 am -
 - ◆ Longevity Awards
 - ◆ Public Health Week Awards
 - ◆ Leadership Institute Presentation
 - ◆ Door Prize Drawings
- ☐ 10 am - Business Meeting
- ☐ 10:30 am - Adjournment

DESIGNER:
Sylvia Burnett

EDITOR/WRITER:
Nancy K. Sullivan Wessman

TYPE DESIGN:
Betty Ellington

ORGANIZATION:
Mississippi State Department of Health

SIZE:
Program booklet—8½" x 11" (21.6cm x 27.9cm); Brochure— 8" x 9" (20.3cm x 22.9cm) folded to 4" x 9" (10.2cm x 22.9cm)

QUANTITY:
750 of each

COST:
Program—$600; Brochure—$250

OBJECTIVE:
Pieces that reflect the theme "Creating Healthy Communities."

HOW WE SAVED:
Bargaining with the printer; black ink only on the inside pages of the program.

must-read material made more eye friendly with clip art

1997 FINAL BILL STATUS REPORT FOR THE
NORTH DAKOTA ASSOCIATION OF COUNTIES

CREATIVE COMMENTS:

A legislative report is rarely a riveting read. But for the government officials who need and depend on finding key information quickly, it needs to be an easily referenced read. And since local taxpayer dollars fund the publication, it has to be done economically and still look polished and professional.

Seibel wanted this year's report to be less daunting than the copy-intense publications of past years. She wanted to make the publication more useful. "I wanted a design that would facilitate easy reading," she says.

"The best designs are often borrowed designs," admits Seibel. "They help form your own unique ideas." The master page design, namely the lines around the page and the bold headers, is borrowed from her resume. The large gray page numbers replace the artwork from her original resume.

The report is broken into sections like "Highway and Drainage Issues," "Insurance and Liability Issues" and "Social Services Issues." Each section is flagged with a representative piece of clip art near the heading. Readers can flip through the pages quickly and use the art as a reference. The art is functional and adds some much needed relief to pages of legislative information.

The redesigned report is open and airy in spite of being copy heavy. "White space is our friend," quips Seibel who actually has a sign on her desk that says just that. Double spaces are used liberally in the "Final Action Summary." Plenty of subheadings break up the running text in the "Narrative Report."

Working to a very tight printing and mailing deadline of less than two weeks, Seibel had a grand total of two and a half days to churn out the design and layout of all fifty pages plus the cover. Fortunately the copy for the book was provided on computer disk.

"It may sound cliché, but I try to keep a running file of cool ideas," she explains. Variety sparks Seibel's creativity. "I'm not a graphic designer. I'm a one-stop PR shop for a government agency. I write, lay out the weekly newspaper, plan conferences, you name it."

DESIGNER:

Sandra L. Seibel, Information Officer

ORGANIZATION:

North Dakota Association of Counties

SIZE:

8½" × 11" (21.6cm × 27.9cm), fifty pages plus cover

QUANTITY:

900

COST:

$1,800

OBJECTIVE:

Redesign the text-heavy legislative report in a format that can be easily read and referenced by county officials statewide.

HOW WE SAVED:

Inexpensive paper stock; black only inside; one-color cover.

whimsical, old-world images mingle well with product photos

SPORTING GOURMET CATALOG

The *Sporting Gourmet*'s existing logo, a lighthearted, cartoonlike fisherman, was just the "hook" Shaw needed as an artistic theme. "The client walked in the door with the idea," she admits.

Shaw needed a representative image for each of the product categories, such as golf, business, cars, gardening and cooking. Scrounging through old Dover clip art books brought the rest of the catalog players to life. "I was looking for images like the one in the logo: funny, lighthearted and whimsical," she explains.

Each piece of art was scanned into Adobe Photoshop and colorized. Then each one was placed in a circular or oval frame similar to the logo and reminiscent of postage stamps. The four-color catalog cover is a wallpaper type effect composed of several of the final images.

Inside the catalog sheet the new clip art images assume the role of informational icons. They blend well with the full-color product shots, yet the contrast between photography and art is enough to help shoppers find the particular type of product they're after.

The folded format is unusual for a catalog. Once you've arrived at the full inside spread measuring 34" × 22" (86.4cm × 55.9cm) you've got a poster-size spread of products. Of course catalog shoppers love browsing, and this large expanse of products seems lively and inviting.

"We got a lot of mileage out of the clip art characters," says Shaw. "We had some of them made into stickers, printed on T-shirts and used them on the store's Web site."

Ideas for tight budgets are easier to come by now, according to Shaw. "We have more tools like scanners and software to expand what we can do. The key is finding the hook for the design."

DESIGNER:
Cathleen Shaw

ORGANIZATION:
Copperleaf Visual Communications, Inc.

SIZE:
34" x 22" (86.4cm x 55.9cm) folded
to 8½" x 11" (21.6cm x 27.9cm)

QUANTITY:
10,000

COST:
$18,536 (design, photography,
printing)

OBJECTIVE:
A catalog layout and format that is
economical for a new company.

HOW WE SAVED:
Printing the catalog on a large sheet
and folding it rather than binding
it; some existing manufacturer-
provided photos.

customized clip art incorporates text

BETTER & BETTER, A SELF-IMPROVEMENT NEWSLETTER

CREATIVE COMMENTS:

The premiere issue of the *Better & Better* newsletter was a free sample aimed at luring potential subscribers. "For this reason it had to be inexpensive," explains Puckett. "At the same time it needed to be as interesting and entertaining as possible."

All of the art in the newsletter looks simple at first glance. Some smaller pieces are screened lightly behind text. Others are strong focal points that upon closer examination are really complex constructions created specifically to fit the stories.

Customizing clip art means combining and creating thematic images as Puckett did on the cover of the newsletter. The artwork is three separate pieces. The final art is uniquely tied to the copy by the repetition of the subheadings around the image. The typeface is small, but readable. The chunky font blends well with the artwork, mirroring the sharp lines and jagged feel of the image itself.

For a story titled "Food & Love," Puckett created a heart shape out of thirty small sketches of individual grocery items. The image takes on three-dimensional proportions due to the shadow effect he applied to each item. As with the cover image, Puckett marries the art to the article it represents. This time he gives the ampersand in the headline the same color and shadow effect as the clip art.

Puckett has a large library of clip art and stock photographs on CD. He collects old, out-of-copyright magazines, books and cookbooks from garage sales and flea markets.

Having clip art and stock photography on hand makes responding to shoestring-budget client demands easier for Puckett. "I don't believe in just plopping clip art on a page," he insists. "Throwing it down rarely gives the layout the aesthetic quality you need."

He doesn't like to overdo an image either. "I don't see the need to go filter crazy," he says. He prefers interesting juxtapositions of type, photography and clip art.

DESIGNER:

Thomas S. Puckett

ORGANIZATION:

Intelligent Design Enforcement Agency

SIZE:

8½" × 11" (21.6cm × 27.9cm)

QUANTITY:

4,000

COST:

$2,800 (printing)

OBJECTIVE:

An economical, yet appealing design for the premiere issue of a new subscription newsletter.

HOW WE SAVED:

Using clip art, two ink colors and an inexpensive no. 2 coated sheet.

cooking with clip art

ON THE TABLE NEWSLETTER FOR SUTTON PLACE GOURMET

EDITOR:

Elizabeth Garside, Sutton Place Gourmet

CREATIVE DIRECTOR:

Jill Tanenbaum

ORGANIZATION:

Jill Tanenbaum Graphic Design & Advertising, Inc.

SIZE:

22" × 17" (55.9cm × 43.2cm) folded to 8½" × 5½" (21.6cm × 14cm) for mailing

QUANTITY:

50,000

COST:

$3,000 (design); $5,875(printing)

OBJECTIVE:

An economical, attractive newsletter design for customers of Sutton Place Gourmet specialty food shops.

HOW WE SAVED:

One ink color; bidding the newsletter out on a one-year contract; folding it small enough to qualify for the least expensive bulk mail rate.

CREATIVE COMMENTS:

Found art, clip art and client-provided art are the not-so-secret ingredients of the lively, playful *On the Table* tabloid.

Each issue pivots around a holiday or cuisine theme: French, Italian, Caribbean and others. The pages are packed with information ranging from recipes and how-to stories to food history and education. Although the articles are short and well written, the pages would be daunting without the clip art splashed boldly throughout.

"The client wanted to really fill the pages," explains Tanenbaum. "We treat the background like a texture with copy on top." Considering the vast amount of text in each issue, the only place left for artwork is the background. So the images are printed in various percentages of color behind the text. With only one ink color to work with, she manages to cook up a lot of variety.

To save even more on the project, Tanenbaum prebid the print job on a one-year contract. "We got a good deal from the printer

TASTING THE ISLANDS

Musings from Executive Chef Steven Roberts

Some of my formative culinary years were spent living and working in the Caribbean. I worked on the islands of St. Croix, St. John, St. Thomas and Virgin Gorda — very influential and inspiring for my cooking style!

My fondest memories center around the local roadside grilling stands. Eating at the stands is like having tropical family picnics every day. Locals and tourists alike gather to eat salty spiced prawns, sofrito rice, goongoo or pigeon peas, and wash it all down with so-called "greenies" (Heinekens).

Seafood is king on the islands, but spiced grilled chicken is also a tourist favorite. Native spices like chilies, allspice, annatto and proprietary jerk blends heighten the flavor of all things grilled. Each island also has its own hot sauce, as simple as chopped chilies in vinegar, or as complex as a blazing tomato-chile-sofrito. Grain mashes called fufu are often eaten in place of bread, and are usually blended with the likes of cassava, corn, plantains or yams. It was a unique experience living in a world where limes, lemons and bay laurel grew in the yard, and coconuts were just a stroll down to the beach!

In July and August, we're cooking Caribbean. We're preparing foods that celebrate the confluence of island ingredients with mainland cultures, such as those of Africa, Spain, England and the Netherlands. You'll find flavorful variations on island cuisine — like Blackberry Habanero Smoked Pork Loin with Tropical Fruit Salsa and Mango BBQ Sea Bass in Banana Leaves. We'll have all sorts of delicious sides, breads and desserts to entice and entertain you, too. So don't hit the beach until you've hit Sutton Place Gourmet, maaan!

CHEF ALLEN'S SAUCES LAND AT SUTTON

Our friend Allen Susser has been a star at the Hay Day Cooking School up north. He comes up from Miami, where he's been wowing diners for years at his restaurant, Chef Allen's. When he last cooked for us, he did dishes from his book, "New World Cuisine," which offers some outspoken approaches to melding spice with native ingredients. The food was divine.

Now Allen has come out with four sauces that capture the fun he has with food (you'll start getting the idea as soon as you see the packages!) These sauces take their cues from island cooking — fruity and spicy, with lots of oomph. And how easy you'll find it to recreate the bold flavors of the islands with these sauces. Sure, you could chop up peppers and mangoes and tamarinds, and cook them and blend them just right...but why take that time when Allen's done it for you? (Did we mention that these flavor-packed sauces are fat free, as well?)

The sauces even sound tropical — Tamarind Chili Spicy Grill Sauce, Papaya-Pineapple BBQ Sauce, Hot Mango Cocktail Sauce and Mango Ketchup. Be forewarned, however, that when he says "hot" on the label (like the cocktail sauce and grill sauce), Chef Allen means it. To start you off gently, try this relatively mild recipe. Then you can step up to the hot stuff later!

Mango-Glazed Turkey Loaf

Serves 6

2 lbs ground turkey meat
1/2 tsp crushed thyme
3 cloves garlic, peeled and minced
1 small onion, peeled and minced
1/4 cup cracker crumbs (got some stale ones?)
2 tsp salt
1 tsp ground black pepper
1 cup Mango Ketchup

Preheat oven to 350°F. In a small bowl, combine the turkey, thyme, garlic, onion, cracker crumbs, salt, pepper and 2 tablespoons of Mango Ketchup. Gently fold all together, and shape into a loaf. Place in a non-stick loaf pan, and spread 3 tablespoons of Mango Ketchup on top. Bake in preheated oven for 45 minutes. Remove from oven and let rest for 5 minutes. Turn loaf out of pan, cut into 1-1/2" thick slices and serve with remaining Mango Ketchup.

SPICY COOLING BEVERAGES: GINGER BREWS

Used to be that a non-alcoholic drink was as strongly flavored as an alcoholic one. Then (in a cultural reversal) Americans started to favor soft drinks whose primary taste was sweet, sweet, sweet. Today, with American cooking embracing the assertive, spicy foods and flavors of the East and the islands, our thirst for boldly flavored drinks has returned. Makes sense, doesn't it? Pair big flavors with big-flavored beverages.

One drink we're delighted to welcome back is ginger beer. This brew is earning top billing on our drink hit-parade for its complex, intoxicatingly peppery flavor. The fresh ginger root, native to tropical Asia but widely grown in the Caribbean Islands, is highly aromatic and pungent. The root is brewed — and that's key, it's actually brewed, not just injected into carbonated water — into a refreshingly spicy beverage enjoyed throughout the tropical climate of the Caribbean where "sweet and heat" have always been characteristic of both cuisine and culture.

Ginger beer is, of course, the ancestor of a much sweeter, mellower beverage, namely ginger ale. The difference between the two is in the brewing process, and in the amount of ginger you'll taste. On the ale side, we've become great fans of both Reed's Ginger Ale and Carver's Ginger Ale. They're spicy and clean-tasting, with a true ginger punch that's often lost in the sweetness of other bottled ginger-ales. Three fabulously refreshing approaches are to serve ginger ale over a tall glass of crushed ice with a wedge of fresh lime; serve it half-and-half with Hay Day's Lemonade for a refreshing Ginger Lemonade, or blend with Paradise Iced Tea for a fruity-sweet fizz.

JERK CHICKEN

"Jerk" is the term for hundreds and hundreds of subtly differing spice rubs from Jamaica. The standard procedure for creating jerk anything is to pound up a spicy paste, rub it into your meat, poultry or fish, and smoke the food slowly over a low fire.

While there are as many recipes for jerk rub as there are smoke-shacks on the beaches, they all have fiery heat in common. This recipe, adapted from "Jerk: Barbecue from Jamaica" by Helen Willinsky, is no different (but in deference to limited time, it does call for a hot grill). So be forewarned, and enjoy with plenty of Sutton Place side dishes and much Red Stripe beer.

Serves 6

6 large chicken breasts, split, bones left in, washed, skinned if desired

2 to 3 teaspoons jerk rub (see below)

Preheat oven to 275°F. Rub spices thickly over chicken. Place in a buttered glass baking dish. Cover and marinate in the refrigerator for 2 to 3 hours. Bake the breasts, covered, for 30 minutes. Remove from baking dish and grill over hot coals, skin side down, 5 minutes per side, turning once — or until the skin is crispy.

The Jerk Rub

Makes 1 cup

1 onion, minced
1/2 cup finely chopped green onion
1 teaspoon fresh thyme
2 teaspoons salt
1 teaspoon ground allspice
1/4 teaspoon ground nutmeg
1/2 teaspoon ground cinnamon
4 to 6 hot chiles (habaneros, jalapenos, serranos, etc.) stemmed, seeded and roughly chopped
1 teaspoon freshly ground black pepper

Combine all ingredients in a food processor and process until a thick paste. Keeps in the refrigerator in a tightly closed jar for about a month.

What Should I Drink with Jerk Chicken?

Our Wine and Beer Guys were not sure about this idea. They've been working hard to bring in some really fabulous French and Italian wines (stay tuned!), so the idea of pairing a beverage with spicy island cuisine sort of hit them from left field. Like the pros they are, however, they came up with answers pretty darn quickly. Here are some suggestions; they vary by region because, of course, liquor laws vary by region, and not all stores can carry all things.

Baltimore
Red Stripe Beer
(Jamaica)
"a highly drinkable sidekick to spicy foods"
$7.99 per six-pack

Vendanges de Soleil
Provence white
Zinfandel
"refreshing summery rose with an electric, quenching finish"
$12.99 per bottle

Bethesda
Carib Lager
(Trinidad)
"malty and dry"
$9.99 per six-pack

Dragon Stout
(Jamaica)
"a milder-mannered Guinness, slightly sweet"
$9.99 per six-pack

Washington
Carib Shandy
(Trinidad)
cinnamon-spiced, low-alcohol beer blend, "great for summer heat when high alcohol-content is not what you want"
$7.99 per six-pack

Virginia
Sanjet Trois Saisons Touraine
Sauvignon blanc from the Loire Valley, "crisp clean fun"
$8.99 per bottle

Les Jamelles 1995
Cinsault rose,
"strawberry scented and bone dry, great with food of all kinds"
$8.99 per bottle

Il Cooro Rosso
California hybrid of Zinfandel, Syrah and Sangiovese grapes, "decidedly versatile red"
$11.99 per bottle

Long Island
Presidente
(Dominican Republic)
"light, crisp and refreshing"
$7.99 per six-pack

Red Stripe Beer
(Jamaica)
"this is perfect with any hot and spicy foods"
$7.99 per six-pack

Dragon Stout
(Jamaica)
"on the sweet side of stout"
$9.99 per bottle

WILD SALMON FOR THE ENTIRE SEASON AT SUTTON PLACE

Remember Copper River salmon? That was the exquisitely flavorful wild salmon we had earlier this summer. The season is painfully short for those fish, but we had 'em as long as we could, and we had the best around.

Well, wild salmon lovers, your day has come: the same devoted (positively single-minded!) fish guys who brought us our Copper River salmon will be bringing us wild Pacific salmon throughout the season. While the season for Copper River Kings is short, there are West-Coast salmon rivers, and salmon species, enough to carry us to September.

Wild Pacific salmon are a breed apart. First of all, they taste more salmony. (Some of you are not so crazy about this — if you prefer a milder yet still full-flavored fish, try our Bay of Fundy Signature Salmon. We will always have that available for you.) Second, they are higher in omega-3 fatty acids, and in other nutrients, than almost any other fish in the ocean. And last but not least, they look amazing, with their bright color attesting to all the Good Stuff on which they've fed.

It's all a bit sketchy, as any wild harvesting is, but here's how we hope it'll play out: we'll carry Kings, Sockeyes and Cohos throughout the season, following the catches to the different bays, rivers and sounds. You'll come into Sutton Place and ask your fishmonger, "where's it from now?", and he or she will say "Bristol Bay," or "Cook Inlet." And you'll go home with great-tasting salmon to toss on the grill, sear up in a pan, or broil with lemon juice and butter.

For those of you who want to cook salmon as it used to be done, we'll also offer planks for cooking your wild salmon. These planks are 100 percent Northwestern cedar, made exclusively for us. Their "breathability" makes for a moist, tender fish, and — kind of like cooking over mesquite — the cedar imparts a delicate flavor to the salmon.

When we were tasting the Copper River Kings, we just popped a lightly oiled, one-and-a-half pound piece in a 350°F oven for about 20-25 minutes, and it tasted superb. However you cook it, try some wild salmon from Sutton Place this summer.

LET'S HAVE SOME WILD THYMES!

One of the great parts of being well-known in the food world is that we get to taste stuff first. When our friend Enid at Wild Thymes was creating a whole new line of products, she gave us a taste (practically before she had labels and jars lined up!). And what we tasted is just our kind of thing: All-natural mustards, marinades, fruit spreads and chutneys that add complex, rich flavor without fuss. Aha, perfect for summer's easy cooking!

Enid left Manhattan many years ago to raise a family in upstate New York. On the Hudson Valley farm where she's raised that family, Enid grows her own herbs, which are part of the Wild Thymes secret. As she put it, Enid created these bright combinations because she "got fond of really bold tastes." The other way she describes what her products offer — again, mirroring our current Philosophy of the Kitchen — is that they offer "sophisticated flavors with no work."

We've got the whole line of Wild Thymes fine condiments in our shops right now. If you know someone who loves mustards, give them a treat with Peppery Pecorino Mustard, a balanced blend of mustard, pepper and real pecorino cheese (try it on a grilled turkey burger). For fans of old-fashioned chutney, we almost can't choose for you. Perhaps we can just recommend the following combinations: Pineapple Peach Chutney with fish, Plum Currant Ginger Chutney with roast pork, and Cranberry Apricot Walnut Chutney with chicken.

The marinades and vinegars range from refined (like the Red Raspberry Balsamic Vinegar, so mild needed for dressing your salad with this!) to wild (toss Sweet Orange Hot Chile Sauce into a chicken stir-fry for some real pizazz). You'll notice that the good stuff inside gathers at the top of the jars; that's because Enid doesn't use any emulsifiers or other questionable stuff to glue her ingredients in place. No cause for alarm, however — just shake well and go to it.

this way because he could order paper in bulk.

"We also did our homework at the post office," she adds. Adding one more fold made the newsletter small enough to qualify for lower bulk mail rates. "That one fold saved us 5½ cents per piece."

Tanenbaum's "out-of-the-box thinking" stems from "thinking backwards." "When I'm trying to save money for a client, I think from the end of the project to the beginning. It's important to do all of your homework—all of the way down the line."

Tanenbaum keeps a vast library for inspiration, but it's the variety of design work that keeps her and her employees creative, along with a sense of humor. "We don't have a look or a style that people come to us for," she explains. "We actually have a 'bare bones' division that specializes in low-budget work."

photos: making

Photographs Generally Come in Four Varieties:

1. Wow!: unusual, striking, the ones that communicate the publication's message perfectly. They're in focus. Interesting. Darn near perfect.

2. Ho-hum: typical, trite, but "politically" necessary and expected to be used in your publication. Think of mug shots, "grip 'n grins," product shots, etc.

3. So-so: average, adequate. These are the OK pictures. They aren't inspirational, but they're functional. Think of technical equipment shots, large groups, employees working, etc.

4. Oh no!: These are the pictures that scare you. They might be out of focus, poorly lit, composed poorly or represent the subjects inappropriately.

The visual pulling power of pictures has been documented over and over again by researchers. Generally, advertising gurus have found that ads with photos outpull ads with illustrations or line drawings. However, even they admit that this isn't a sure thing. The best designers analyze the images with a critical eye to appropriateness, effectiveness, taste, function and quality. They have to keep in mind how the readers will interact with the images. The degree of prominence photographs are given is intertwined with many layout considerations such as available space, grid, other articles or copy, total number of photos to be used, artwork or illustration, ink and paper color, etc.

Client-provided photographs can be a dream or a nightmare. Sure, it's more economical than hosting a photo shoot. But what if the photos suck? Or worse, what if they're just mundane? The client's ego or reputation may be tied up in the pictures. The creativity in this case rests heavily on your ability to convince the client that the layout is better off without them.

Thanks to some super software packages, it's now economical and even a fun challenge to manipulate and actually improve photographs—even the "so-so" and "oh no!" ones. The possibilities are endless with filters, distortion, textures and more.

the most
of what you have

When a client provides "oh no!" pictures that you have to use, don't just admit defeat and throw them into the layout and hope no one finds out you designed it. The rule with bad photographs is to bury them if you have to use them. That means putting them below the fold and making them small. Amateurs frequently make any photo large just to take up space. Mug shots turn into wanted posters and "grip 'n grins" take on a yearbook look. "Oh no!" photos should never be cut into shapes or given heavy borders.

Of course, some designers have a creative eye for turning "oh no!" into "wow!" Sometimes the photo's greatest flaw—say it's out of focus—can be used to an advantage by turning the picture into high contrast line art or giving it a "digitized and dotty" look.

Knockout "wow!" photos are easier to work with, of course. Some layout experts say you shouldn't do anything to these. Simply use them large for drama—in black and white, a duotone or full color. After all, a good photo is powerful in itself. Anything you might do to it, such as cut it into a shape, texturize the edges or angle it, will only draw attention to the technique, not the photo.

Functional photographs, like product or mug shots, can be dressed up creatively with interesting edges or masking.

Groups of photos more than likely need a focal point. Avoid making all the pictures the same size, unless it makes sense to do so (like groups of employee mug shots where you'd probably want everyone's head to be the same size). Photo montages where images are jammed up against each other usually come off looking amateurish and second rate. Instead, make one image twice the size of any of the others.

The best part about using photographs today is that they add a minimal expense to a low- budget project. Designers have more control over the final product. They don't have to necessarily rely on the printer's ability or equipment to provide a special look.

at a glance:

Utilize photo archives

Hire photographers for _free!_

Distort the picture

Stock up on stock photography

Add edges

Repeat an image

Paint over the photo

Be creative with your instant camera or photo booth

Utilize found photographs

Put a caption with each picture

Mix photos and illustrations or clip art

Mix black and white and color

Mix photos with type

Colorize only a portion of a photograph

INSIDER ADVICE
Utilize photo archives

Period shots? Historical angles? Studio shots of VIPs? Newspapers and magazines usually make pictures from their libraries or "morgues" available for a very reasonable fee, sometimes for free. Companies often archive pictures of employees, building shots, special occasion images. It doesn't hurt to call.

Hire photographers for _free!_

Need good photography, but can't afford the photographer's fees? University and technical school students are pros in the making. Call the schools and ask for professors who might want real-life assignments for the students. Many times they'll do it for free or at very minimal cost.

Distort the picture

Out-of-focus shots? Bad angles? Client-provided poses without a lot of impact? Stretch, compress, add a texture, ghost the image, add a color splash, turn it into a line shot.

Stock up on stock photography

Photo CDs are a must nowadays. If you have a client who regularly needs images, you might be able to get the client to buy the CD collections for you. Otherwise, it pays to have these at your disposal so you can instantly dazzle clients with great photos.

Add edges

Edges are hot! Singed, streaked, splintered, oily, dripping, striped, fuzzy—photographs are showing up with any number of special treatments. Many of these effects are special software add-ons that work with a variety of programs. Some of the edges are subtle, like soft shadows, and others are obviously noticeable. The best edges are used to enhance the message in the picture, not to just illustrate how wild your software is. Any technique you use should make sense with the content and other visuals used in the layout.

Repeat an image

High-mileage photography means squeezing the most out of what you have. If you have one good picture, use it several times within the publication. Put it on the mailing panel as a teaser. Use it on the cover. If the story continues to several pages, put a small version of the photo with the jump headline. If you've used a photo on the front of a brochure, break the image into parts to use on inside panels to help call attention to the subheadings. Take one simple photo and use it several times in a strip, altering its size or color each time. These panel pictures add motion and life to a so-so image.

Paint over the photo

Like repeating a photo, you can also take one original picture and distort it on subsequent pages. Add different effects, textures or colors to the same photo as it's used throughout the publication. Use a paint package to "paint" roughly over the original image and then delete the original. You'll be left with a surrealistic impression of the photo.

Be creative with your instant camera or photo booth

Maybe your low-budget project can't afford a professional, but you can do fantastic things with disposable or instant cameras, not to mention a photo booth at the mall. Take pictures of basic things lying around your house or office. A water faucet, a rose, car keys, a stack of books, a rusty can, leaves, a mouth, a luggage tag, a hand holding a pen, a filing cabinet, etc., are all simple images that are actually sold as stock photo images. Having these on hand ahead of time makes them instantly available for those tight-budget, tight-turnaround projects.

Utilize found photographs

What do you have in an album? Wedding pictures? Old family photos? School pictures? Scenery shots? Baby pictures? These might serve up a whole host of ideas.

Put a caption with each picture

Newsletters, booklets and sales brochures should caption every image. Readers generally want to know exactly what's going on in the picture or get a name. If you don't say something under a picture, you've lost a selling opportunity. Even a mood photo needs a caption. If you can't comment on what's in the photo or it's obvious, use the caption to inform the reader about something else.

Mix photos and illustrations or clip art

Rumors that you shouldn't do this are strongly exaggerated. Designers have been mixing images for years. The effect can be cartoony or sophisticated depending on the type of artwork and photo subject. Use clip art as background art with your photos on top. Or, if you're trying to minimize "oh no!" images, let your clip art be the dominant visual.

Mix black and white and color

Some conservatives are afraid of putting black-and-white halftones on pages with duotones or full-color pictures. On the contrary, the variation adds excitement and depth. The lighter percentage images can be used as background or just as a way of making "oh no!" photos appear less offensive. Of course it helps to be able to preview the effects on your computer screen rather than waiting to be surprised by the printer's proof.

Mix photos with type

Marry the headline to the photo by putting the type in the photograph. Embellish a photo with key words for an interesting visual. WYSIWYG (What You See Is What You Get, more or less) makes this easier and more creatively affordable than in the old pre-desktop days. With all the interesting type fonts and effects available (even in word processing programs) you can test-drive various looks without spending a lot of money.

Colorize only a portion of a photograph

Black-and-white ads have this all the time. The product in the photo is in color while the rest of the shot is black-and-white. It's eye-catching and can be done with software or by the printer in any number of ways.

if you've got 'em, flaunt 'em

METROPOLITAN WATER DISTRICT (MWD) OF SOUTHERN CALIFORNIA *PEOPLE* NEWSLETTER

CREATIVE COMMENTS:

People lives up to its name. It's eight pages chock full of people pictures and people stories. No dull desk shots here. There may be some so-so photos lurking, but they definitely take a backseat to the keynote photos.

Designing by committee actually works for this newsletter staff. The designers take ideas from the editor, writers and photographers. Hofer says the designer isn't usually involved until the articles are written and the photographs or illustrations are gathered.

The lively, energetic layout relies heavily on the photos. Using a combination of Adobe Photoshop, Adobe Illustrator and QuarkXPress, Browne is able to make the most of good photos and actually improve so-so photos.

"We have a lot of 'round the table' shots of meetings," explains Hofer. "Even with a good photographer you can't always get something unique or different. Barbara [Browne] has the ability to look 'into' a photograph and actually make something out of it."

For example, Browne tightly cropped the faces from a group shot and used them as individual mug shots in a band across the top of a layout. The animated faces looking in various directions are interesting. One woman is leaning on her hand. Several are smiling. Another is quite serious. On top of that, Browne narrowed the heads. The distortion is slight, but makes what could be a typical mug shot lineup look "artsy."

Browne often uses more than one pose of the same shot. She'll screen a second similar photo in back of the text. She might even duplicate the same photo, adding a texture or special effect, and angle it in back of the original.

The photographs are mixed well with complementary illustration and clip art. The lively layout is a fast, fun read, which is especially important to employees with limited time and varied interests.

Brainstorming is the creative secret behind this publication's success. Hofer says that while writers, editors, photographers and designers don't always agree, they always come up with a doable compromise.

DESIGNERS:
Barbara Browne and Rick Amoya

MANAGING EDITOR:
Garry Hofer

PHOTOGRAPHER:
Linda Okamura

ORGANIZATION:
Metropolitan Water District of Southern California

SIZE:
Tabloid 11" × 13¾" (27.9cm × 34.9cm)

QUANTITY:
Approximately 3,000

COST:
$5,000 (layout, photography, illustration, design, printing and mailing)

OBJECTIVE:
With work locations scattered throughout the state, *People* has to communicate company values and information for MWD.

HOW WE SAVED:
Copy, design, illustration and photography are all done in-house; two ink colors only.

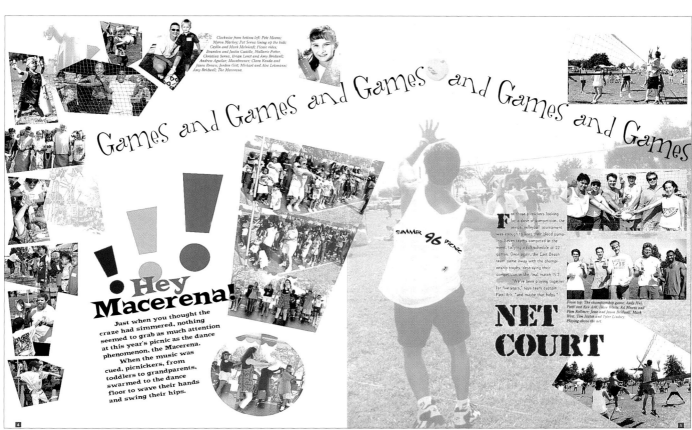

Games and Games and Games and Games and Games and Games

Clockwise from bottom left: Pete Means; Myron Markey; Pat Serna lining up the kids; Caitlin and Mark Melnicoff; Picnic rides; Brandon and Justin Castillo; Mallorie Potter; Andrew Aguilar; Moonbounce; Clara Kensla and Jason Brown; Jordan Gott; Michael and Alec Lehmann; Amy Bridwell; The Macerena.

Hey Macerena!

Just when you thought the craze had simmered, nothing seemed to grab as much attention at this year's picnic as the dance phenomenon, the Macerena.

When the music was cued, picnickers, from toddlers to grandparents, swarmed to the dance floor to wave their hands and swing their hips.

SUMMER 96 PICNIC

For those picnickers looking for a dose of competition, the annual volleyball tournament was enough to keep their blood pumping. Seven teams competed in the event, tallying a full schedule of 22 games. Once again, the East Beach team came away with the championship trophy, destroying their competition in the final match 15-2.

"We've been playing together for five years," says team captain Patti Arlt, "and maybe that helps."

NET COURT

From top: The championship game; Andy Hui, Patti and Ken Arlt; Dave White, Ed Means and Pam Kellmer; Jesse and Jason Bridwell; Mark West, Tim Hatch and Tyler Lindley. Playing above the net.

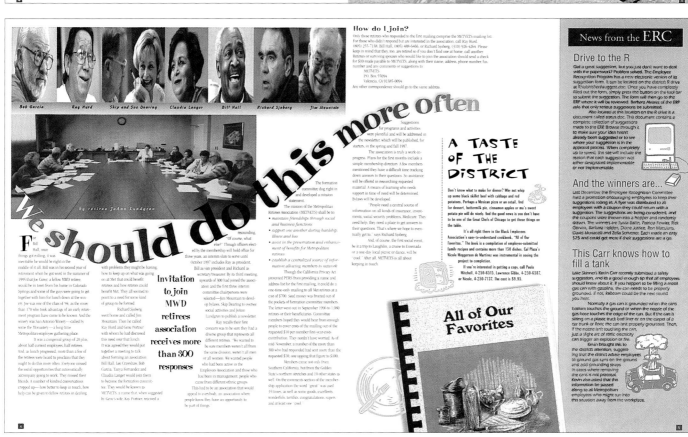

we should do this more often

By retiree JoAnn Lundgren

Bob Garcia Ray Hurd Skip and Sue Dearing Claudia Langer Bill Hall Richard Sjoberg Jim Mountain

For Bill Hall, once things got rolling, it was inevitable he would be right in the middle of it all. Bill was in his second year of retirement when he got word in the summer of 1995 that Joe Cover, a fellow MWD retiree, would be in town from his home in Colorado Springs and some of the guys were going to get together with him for lunch down at the winery. Joe was one of the class of '94, as the more than 170 who took advantage of an early retirement program have come to be known. And the winery was San Antonio Winery—called by some the Monastery—a long time Metropolitan employee gathering place.

It was a congenial group of 20 plus, about half current employees, half retirees. And, as lunch progressed, more than a few of the retirees were heard to proclaim that they ought to do this more often. Everyone missed the social opportunities that automatically accompany going to work. They missed their friends. A number of kindred conversations cropped up—how better to keep in touch, how help can be given to fellow retirees in dealing

with problems they might be having, how to keep up on what was going on at Met that could benefit retirees and how retirees could benefit Met. They all seemed to point to a need for some kind of group to be formed.

Richard Sjoberg went home and called Jim Mountain. Then he called Ray Hurd and Gene Portner with whom he had discussed this need over that lunch. It was agreed they would put together a meeting to talk about forming an association. Bill Hall, Lee Crawshaw, Bob Garcia, Tania Fernandez and Claudia Langer would join them to become the formation committee. They would be known as METVETS, a name that, when suggested by Gene's wife, Kay Portner, received a

resounding, "Of course, what else?" Though officers elected by the membership will hold office for three years, an interim slate to serve until October 1997 includes Ras as president, Bill as vice president and Richard as secretary/treasurer. By its third meeting, upwards of 900 had joined the association and the first three interim committee chairpersons were selected—Jim Mountain to develop bylaws, Skip Dearing to oversee social activities and JoAnn Lundgren to publish a newsletter.

Ray recalls their first concern was to be sure they had a diverse group that represents all different retirees. "We wanted to be sure members weren't all from the same division, weren't all men or all women. We wanted people who had been active in the Employees Association and those who had been in management, people who came from different ethnic groups. This led to be an association that would appeal to everybody, an association where people know they have an opportunity to be part of things."

The formation committee dug right in and developed a mission statement.

The mission of the Metropolitan Retirees Association (METVETS) shall be to:

• maintain friendships through social and business functions

• support one another during hardship, illness and loss

• assist in the preservation and enhancement of benefits for Metropolitan retirees

• establish a centralized source of information alluring members to network

Though the California Privacy Act prevented PERS from providing a name and address list for the first mailing, it could do a one-time-only mailing to all Met retirees at a cost of $700. Seed money was fronted out of the pockets of formation committee members. The letter went out in September 1996 to 1,080 retirees or their beneficiaries. Committee members hoped this would bear fruit enough people to cover costs of the mailing out of the requested $10 per member first-year-costs contribution. They needn't have worried. As of mid-November, a number of the more than 800 who had responded had sent more than the requested $10, one upping that figure to $100. Members came not only from

Southern California, but from the Golden State's northern stretches and 19 other states as well. On the comments section of the membership application the word 'great' was used 35 times, as well as some goods, excellents, wonderfuls, terrifics, congratulations, supers and at least one 'cool'.

Suggestions for programs and activities were plentiful and will be addressed in the newsletter, which will be published, for starters, in the spring and fall 1997.

The association is truly a work-in-progress. Plans for the first months include a simple membership directory. A few members mentioned they have a difficult time tracking down answers to their questions. So assistance will be offered in researching requested material. A means of learning who needs support in time of need will be determined. Bylaws will be developed.

"People need a central source of information on all kinds of insurance, investments, social security problems, Medicare. They need help, they need a place to get answers to their questions. That's where we join so you don't have to get to be one of the Great Chefs of Chicago to get these things on the table," says Richard Sjoberg.

And, of course, the first social event, be it a trip to Laughlin, a cruise to Ensenada or a one-day local picnic or dance, will be 'cool.' After all, METVETS is all about keeping in touch.

How do I join?

Only those retirees who responded to the first mailing comprise the METVETS mailing list. For those who didn't respond but are interested in the association, call Ras Hurd, (805) 255-7138, Bill Hall, (805) 488-6466, or Richard Sjoberg, (310) 926-4264. Please keep in mind that they, too, are retired so if you don't find one at home, call another. Retirees or surviving spouses who would like to join the association should send a check for $10 made payable to METVETS, along with their name, address, phone number, fax number and any comments or suggestions to

METVETS
P.O. Box 55094
Valencia, CA 91385-0094

Any other correspondence should go to the same address.

Invitation to join MWD retirees association receives more than 300 responses

A TASTE OF THE DISTRICT

Don't know what to make for dinner? Why not whip up some black skillet beef with cabbage and red potatoes. Perhaps a Mexican pizza or an oxtail. And for dessert, buttermilk pie, cinnamon apples or ma's sweet potato pie will do nicely. And the good news is you don't have to be one of the Great Chefs of Chicago to get these things on the table.

It's all right there in the Black Employees Association's easy-to-understand cookbook, "All of Our Favorites." The book is a compilation of employee-submitted family recipes and contains more than 150 dishes. Cal Plaza's Nicole Meggerson de Martinez was instrumental in seeing the project to completion.

If you're interested in getting a copy, call Paula Mitchell, 4-250-6515, Lawrence Gibbs, 4-250-6587, or Nicole, 4-250-7137. The cost is $9.95.

All of Our Favorites

News from the ERC

Drive to the R

Got a great suggestion, but you just don't want to deal with the paperwork? Problem solved. The Employee Recognition Program has a new electronic version of its suggestion form. It can be located on the district's R drive at R:\submit\newsuggest.doc. Once you have completely filled out the form, simply press the button on the tool bar to submit your suggestion. The form will then go to the ERP office and will be reviewed. Please note that the ERP asks that only serious suggestions be submitted.

Also located at this location on the R drive is a document called status.doc. This document contains a complete collection of suggestions made to the ERP. Browse through it to make sure your idea hasn't already been suggested or to see where your suggestion is in the approval process. When completely up to speed, the site will include a reason that each suggestion was either designated implementable or not implementable.

And the winners are...

Last December the Employee Recognition Committee held a promotion encouraging employees to keep their suggestions rolling in. A flyer was distributed to all employees with a coupon they could return with a suggestion. The suggestions are being considered, and the coupons were thrown into a hopper and randomly drawn. The winners are Sylvia Batin, Patricia Fowler, Rick Gervais, Barbara Hadden, Diene Jutice, Ron Marulanta, David Monacelli and Zella Scrivener. Each made an easy $25 and could get more if their suggestions are a go.

This Carr knows how to fill a tank

Lake Skinner's Kevin Carr recently submitted a safety suggestion, and it's a good enough tip that all employees should know about it. If you happen to be filling a metal gas can with gasoline, the can needs to be properly grounded. If not, kaboom could be the next sound you hear.

Normally a gas can is grounded when the can's bottom touches the ground or when the nozzle of the gas hose touches the edge of the can. But if the can is sitting on a plastic truck bed liner or on the carpet of a car trunk or floor, the can isn't properly grounded. Then, if the nozzle isn't touching the can, just a slight arc of static electricity can trigger an explosion or fire.

Kevin brought this to the district's attention, suggesting that the district advise employees to ground gas cans on the ground and add grounding straps in cases where removing the can is not practical. Kevin also asked that this information be passed along to all Metropolitan employees who might turn this situation away from the workplace.

you'd never guess . . .

PITTSBURGH X 7 POSTCARD

CREATIVE COMMENTS:

Picture? Is there a picture on this postcard?

Sheirer stretched not only the budget but her imagination by inventing a visual to represent an art exhibition of seven different artists. "All that I had was a printed exhibition catalog," she says. "I didn't even have any transparencies of the artists' works to use."

Although a heavy Christian theme ran throughout all of the exhibition pieces, Sheirer noted that they all approached the subject from a different perspective. Blending their work would be impossible. So, she rifled through her own personal photo albums for "divine" inspiration. "I found a photo of an old roommate standing on the front porch of our house in his bathrobe. It is a bit of a stretch," she admits, "but I thought that the photo was Christlike, so I scanned it into Adobe Photoshop as a gray-scale TIFF."

Up to this point the roommate was still recognizable—until Sheirer kicked her software and creativity into high gear. "I knocked the figure out of the background and blurred the image beyond recognition. I was striving to create a cross-shaped composition."

Since she had two ink colors to work with, she opted for what she calls a "fake duotone" using metallic gold and dark green.

"I imported the gray-scale TIFF into QuarkXPress. I made the TIFF one color and applied another color to the picture box. On the front of the postcard, the TIFF is gold and the background green. The back is a negative version of the front," she explains.

The two colors in the image were allowed to overlap a bit, creating almost a third color effect where shades of the green and gold melded.

The robed figure subtly suggests a crosslike figure, but only to the attentive and imaginative eye. The look is strikingly abstract and rich, artistic in its own right.

DESIGNER:
Lisa Sheirer

ORGANIZATION:
Sheirer Graphic Design for the Stephanie Ann Roper Gallery at Frostburg University

SIZE:
7" × 10½" (17.8cm × 26.7cm)

QUANTITY:
1,000

COST:
$550 (printing); pro bono design

OBJECTIVE:
Announce seven very different artists exhibiting together in our gallery.

HOW WE SAVED:
Used a personal photo, postcard format, two inks only.

father's photo makes great art

FROSTBURG STATE UNIVERSITY STUDENT ART SHOW ANNOUNCEMENT

DESIGNER:
Lisa Sheirer, Patrick Faville and
Michael Lease

ORGANIZATION:
Sheirer Graphic Design

SIZE:
6" × 8½" (15.2cm × 21.6cm)

QUANTITY:
1,000

COST:
Not available (Black photocopies on
white card stock)

OBJECTIVE:
Announce the Student Art Show.

HOW WE SAVED:
Used a personal photo, postcard
format, photocopying.

CREATIVE COMMENTS:

 "We had one afternoon," Sheirer says. "One afternoon to get the whole thing designed."

 Sheirer admits that she does some of her best work under severe time constraints and low budgets. This time she had to work with two Frostburg State University student designers as well. "When you're short on time, your source material has to be whatever's close at hand."

 On this afternoon, her dad's old college basketball team photo was called into active duty. "The students want a fifties retro look," she explains. "The team standing in a row is reminiscent of how the students in the art show feel sometimes too."

 The high contrast photo was created in Adobe Photoshop where it was stretched and customized. Faville, Lease and Sheirer just played with the photo, adding touches here and there. For example, the original college logo on the front of the jerseys was replaced with the word *Art*. The grainy texture of the shadows in

the photo almost look brown, making the inexpensive photocopy project take on a richer feel.

 "I find a lot of my ideas come from sheer panic," Sheirer admits. "I sort of like the pressure. Limitations make me more creative too, although when I'm in the middle of a panic I wouldn't say that."

recipe for success

THE TIME IS RIPE **DIRECT MAIL BROCHURE/BOOKLET FOR CITIZENS FIRST NATIONAL BANK**

The Time is Ripe.

CREATIVE COMMENTS:

Take a two-color budget, add five tomatoes and Suhr. Voila, you've served up a sophisticated booklet for an upscale market.

Suhr's client needed four-color punch from a two-color budget. "The bank was marketing trust services," she explains. "The target audience was a higher-end demographic: conservative, older, with money to invest."

Taking an existing photo of a tomato from one of the bank's ad campaigns, Suhr pulls off a concept that is catchy, reserved and economical. The red tomato is the only artwork in the entire eight pages other than three mug shots of the bank's trust professionals.

Suhr got a lot of mileage out of the tomato image too, repeating it five times throughout the booklet. In fact, the tomato becomes a dramatic full-page bleed all by itself on the inside front cover.

While more visuals might have detracted from the booklet's clean simplicity, Suhr did add quiet touches to the opening pages. The flap is cut at an angle. "It's not a die cut," she says, "but simply a diagonal cut." The slant of the cut matches exactly the diagonal left margin on the flap copy and on the single column of text under the flap on page one.

The publication is text heavy, but healthy margins, ragged right copy and lots of bullets and subheadings organize it for easy reading.

Suhr's creative principle is easy. "Take all the rules and restrictions and push them to the max." She doesn't question or fight the limits set by the budget. She accepts them as a challenge. "This is what we need. These are the restrictions. This is the budget. You go from there," she calmly explains.

Estate Planning

Definition: Investing, managing, and administering a client's property to maximize its growth and income potential for the benefit of future generations.

Who Can Benefit:
- People who need professional assistance in managing and protecting property
- Those who want to minimize the impact of estate and inheritance taxes

Retirement Plans

Definition: A financial program designed to provide a vehicle for retirement savings.

Who Can Benefit:
- Anyone who needs a resource for retirement income
- Self-employed business owners
- Businesses

Examples of Retirement Plans:
- Individual Retirement Accounts – offering tax advantages and competitive investment returns
- Self-employed (Keogh) Plans – specifically for small business owners' needs and eligible employees
- Simplified Employee Pension IRA Plan – the benefits of a profit-sharing plan with lower administration
- Business Programs – retirement plans for businesses and their employees, including:
 - Corporate Profit-Sharing
 - Money Purchase Pensions
 - Regular Pensions
 - 401(k)s

Additional Management Services

Farm Management

The Citizens First National Bank trust team can manage your ag operation with individually tailored programs designed to maximize farm profits and improve productivity. From tenant relationships to weed control, no situation is too comprehensive or challenging for the trust professionals. They will make sound decisions that concur with each client's wishes.

Agency and Fiduciary Arrangements

A variety of written agreements can be established to assist in asset management. Agency and fiduciary agreements allow the trust department to manage an individual's personal and financial affairs, such as a power of attorney. Conservatorships are similar agreements set up through the courts.

The time is ripe for your assets to be protected and managed according to your needs and wishes. Turn to the trust department at The Citizens First National Bank for complete assistance.

Planting the Seed.

Did you know that The Citizens First National Bank Trust Department ...

- Currently manages over $90 million in assets.
- Offers trained professionals with many years of service.
- Maximizes returns by an investment program customized to meet your needs.
- Serves clients in locations across the United States.
- Provides all traditional trust services, and has complete capability for customization to specific asset and investment management needs.

DESIGNER:

Cindy Suhr

ORGANIZATION:

Mills Financial Marketing

SIZE:

15½" × 9" (39.4cm × 22.9cm) folded to 5¾" × 9" (14.6cm × 22.9cm)

QUANTITY:

500

COST:

$1,861

OBJECTIVE:

Market financial services.

HOW WE SAVED:

Using existing photos from an ad campaign.

didn't we just see her?

UNIVERSITY OF UTAH CONTINUING EDUCATION THEATRE SCHOOL FOR YOUTH BROCHURE

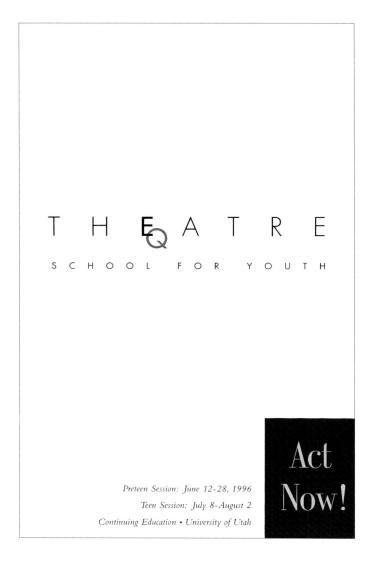

T H E A T R E

S C H O O L F O R Y O U T H

Preteen Session: June 12-28, 1996

Teen Session: July 8-August 2

Continuing Education • University of Utah

Act Now!

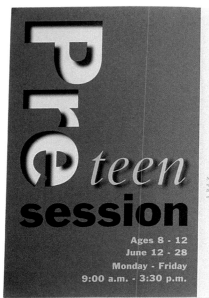

CREATIVE COMMENTS:

"If you look at the photos closely you'll see that the same person is in each one," points out Palmer. "I used them small, real small."

The photos, while well taken, don't do the client's objective justice. They're typical, rather than inspirational. The brochure is basically text—heavy text describing the sessions and housekeeping details, such as location, refund policies and fees. "I knew I had to find another image catcher," Palmer says.

The starring design role in this layout goes to the session and sections headings. Influenced by an ad he saw in a magazine, Palmer created bold, full-panel, all-type graphics. By experimenting with various fonts and using a combination of software (QuarkXPress, Adobe Illustrator and Adobe Photoshop) he invented dynamic images that more suitably represented the brochure's message. A combination of color (yellow, teal and black inks), size, shadows, reversing and 90° angles turned titles into 3-D billboards.

The rest of the brochure is very structured and easy to scan. The three-column grid allows for plenty of white space. The client's black-and-white photos are used small and spaced far enough apart that the average reader would probably not notice the same people in each one.

The back of the brochure is a large version of an ad that Palmer designed for the school. (See the ad in section two of this book.) Once the recipient tears off the reply panel, the brochure can double as a poster. That's high-mileage design!

Palmer believes that to be a good designer you've got to get involved with good designers and learn to recognize good design. "Draw on the world you live in," he says. "Obviously you don't plagiarize, but borrow."

DESIGNER:
Wade Palmer

ART DIRECTOR:
Scott Greer

WRITER:
Joan Levi

ORGANIZATION:
DCE Design

SIZE:
37½" × 10" (95.3cm × 25.4cm) folded to 6¼" × 10" (15.9cm × 25.4cm)

QUANTITY:
4,100

COST:
$2,282 (printing)

OBJECTIVE:
Promote a Theatre School for Youth program.

HOW WE SAVED:
Client-provided photos; used an existing design as a poster for the back side of the brochure.

pictures with a message

CREATIVE DIRECTOR:
Robert Morehouse

ORGANIZATION:
Vermilion Design

SIZE:
6" × 10¾" (15.2cm × 27.3cm)

QUANTITY:
50,000

COST:
Approximately $30,000

OBJECTIVE:
Broaden the appeal of the Institute
to include a more mainstream
audience.

HOW WE SAVED:
Often taking the photos ourselves
and sticking to a tight grid which
speeds up the layout process;
inexpensive paper.

ARTS & CREATIVITY 11

Ysaye Barnwell leads an inspiring workshop on singing in the African American Tradition. **PAGE 11**

Ruth Zaporah and **Nancy Stark Smith** join Action Theater and Contact Improvisation to promote moment to moment embodied awareness.

PAGE 13

COMMUNITY, CULTURE & ENVIRONMENT 21

Terence McKenna guides a philosophical tour of an emerging post-historical society configured by the internet, virtual reality, and psychedelics. **PAGE 21**

Michael Ableman leads us on a journey back to the Earth and to the source of our food. **PAGE 22**

HEALTH, HEALING & PSYCHOLOGY 29

Brad Blanton challenges us to move beyond lies and towards a future founded on honesty, vision, and intention. **PAGE 29**

Margot Anand points to the ecstatic potential of daily life. **PAGE 30**

7th Annual Somatic Psychology Symposium: "Creating Our Community: The First National Conference Of The United States Association For Body Psychotherapy **PAGE 34**

5th Annual Transpersonal Psychology Conference **PAGE 40**

WORLD WISDOM TRADITIONS 45

Sharon Salzberg guides a meditation weekend on lovingkindness. **PAGE 45**

John Daido Loori explores the sacred teaching of wildness. **PAGE 46**

JOURNEYS53

SUMMER WRITING PROGRAM-JACK KEROUAC SCHOOL OF DISEMBODIED POETICS55

SPECIAL EVENTS CALENDAR 6

HOW TO REGISTER ... 71

INDEX ... 76

REGISTRATION FORM ...80

WRITING & POETICS WORKSHOP REQUEST FORM 79

4

5

CREATIVE COMMENTS:

Too often a college course catalog is strictly a functional piece packed with regimented pages of text listings sandwiched between attractive covers. The Naropa Institute Continuing Education catalog is a work of art from cover to cover.

According to the catalog, "Naropa is a private, nonsectarian, liberal arts college inspired by a unique Buddhist heritage." According to Morehouse, "It had a reputation as sort of a 'hippie' college when we took over the account."

With a broad array of courses ranging from health, healing and psychology to arts and creativity to world wisdom traditions, the Institute had a lot to offer the mainstream population. "It's a neat place," says Morehouse. "I wanted to put a face on Naropa"— which he did, literally and figuratively. The covers of the catalogs are people—strong, varied, interesting faces. The inside is packed with full-page photos that represent the courses and the Institute well.

To keep the budget low, Morehouse will often take photos himself. "Usually the better the photo the more you have to work with," he admits. "But we've adopted a process

Leaves turn the color of change.
Delight in the beauty of
moving time. Take this season
to transform your world and color
your life.

The Naropa Institute's School of
Continuing Education offers you the
opportunity to explore transition,
expand vision, deepen inquiry, and
nourish wisdom. Our courses draw
on the roots of tradition and probe
the edges of knowledge.

We invite you to create and
question, to venture and sustain.
To change your colors.
To fall into a new space.

*Pema Chödron is an American
Buddhist nun, and the author of
The Wisdom of No Escape,
Start Where Your Are, and When
Things Fall Apart (see page 42).*

called 'selective focus' that is more forgiving. We go for image rather than high-resolution detail."

Using Adobe Photoshop, the photos are enhanced, manipulated, drawn on and layered with type. Any imperfections in a color 35mm photograph, for example, will be covered up, cropped out or blurred. "The pictures take on layers of meaning," says Morehouse.

All of the photos inside the catalog are duotones. "We want the catalog to have the feel of a documentary," he adds. "It should feel rich without looking like we're wasting money."

The cover, on the other hand, is a "quadratone." Two similar shades plus a third color and black are used. For example, one issue used two tones of metallic copper plus green and black. The effect is a rich, warm, eerie three-dimensional quality.

The paper for the inside pages is a simple, smooth offset, proving that powerful pictures don't always need an expensive presentation.

Earth and Self:
Living in Nature

Richard Dart

Richard Dart, drawing on 30 years of experience, teaches outdoor survival from the perspective that we all share a common hunter/gatherer heritage. He has studied extensively with Tom Brown, Jr., and Dr. James Halfpenny, two of the most knowledgeable naturalist/trackers in North America.

This field class introduces methods for living in harmony with nature, focusing on practical techniques for primitive survival. Topics include: nature observation; awareness training; landscape evaluation; plant and animal communities; animal sign and tracking; land navigation; weather patterns; and the basic skills of obtaining water, getting warm, staying dry, and finding food.

*Friday, Saturday, Sunday, October 3 - 5;
Friday 7:00 - 8:00 pm; Saturday, Sunday 9:00 am - 5:00 pm
ENV015, non-credit, $140*

Clay and Adobe Sculpture

Margaret Josey

Margaret Josey, M.F.A., has taught ceramics and adobe building at Northern Arizona University and throughout Colorado. Her interest is in exploring the creative process through three-dimensional sculptural forms.

In this hands-on workshop, we create various sculptural forms using both clay and adobe techniques. We begin by hand-sculpting clay pots, then design and construct a sawdust fired kiln using adobe building methods from the Middle East and Africa. Finally we fire our clay forms in the kiln we have built. A $5 materials fee is payable to the instructor.

*Saturdays, Sunday, October 11,12,18; 10:00 am - 3:00 pm
ART041, non-credit, $140*

Bowing to the Mountains:
Pilgrimage and Poetry

Steve Glazer and Charlotte Rotterdam

Steve Glazer, M.A., has journeyed to sacred peaks in China, Nepal, and Tibet. Director of Naropa's School of Continuing Education, he is an avid student of poetry, visual arts, and Tibetan Buddhism.

Charlotte Rotterdam, M.T.S., Harvard Divinity School, has written about sacred mountains as models for a contemporary environmental ethic.

The power of mountains has been expressed through a variety of sacred texts, pilgrimage accounts, and poetic verse. Mount Meru of Hindu cosmology, the sacred peaks of the Navajo, the Japanese mountains of the Shugendo Sect - all mountains harbor a wealth of stories and hold the seed of spiritual transformation for those who dwell among them. Friday evening we take a slide journey to sacred peaks around the world; Saturday we record our own experience following in the tradition of Basho and others, as we wander the Indian Peaks.

*Friday, Saturday, September 26 - 27;
Friday 7:00 - 9:00 pm; Saturday 9:00 am - 5:00 pm
WRI006, non-credit, $60
Friday night only: $10 / $5 students, seniors (tickets available at door only)*

Get Registered! Phone 303-402-1190.

beyond
8½" x 11":

Do you suffer from format fatigue? Changing the standard dimensions or the entire format of a publication is a good way to stir tired brain cells. The change can be simple, like folding the brochure into fourths instead of thirds, or more complex, like turning your standard monthly newsletter into a weekly postcard.

Brochure and newsletter designers cling to 8½" × 11" (21.6cm × 27.9cm) or 11" × 17" (27.9cm × 43.2cm) or other standard sizes for sheer economy. There's less waste in the printing process. A big, expensive press isn't required. Variety and availability are good.

But many times we cling to the standard sizes and folds because we've always done it that way. Or we've never seen it done any other way. Or worse yet, it's just habit.

There is more than one way to slice and fold any piece of paper—even a standard-size sheet.

Think about changing the overall format of your publication if you want to

• Stand out from the crowd, competition or norm

• Save money

• Design something fresh

• Solve recurring layout problems (not enough room for text; too much space left to fill; copy doesn't flow smoothly; pictures, artwork or graphs don't fit well, etc.)

Newsletters must be 8½" × 11" (21.6cm × 27.9cm) or tabloid. Brochures must be tall and thin and folded in thirds. Booklets must be 8½" × 5½" (21.6cm × 14cm). Now, of course these statements aren't true. But they're the basis for the average reader's assumptions, the norms. Anything outside these preconceived parameters, even slightly, will snag the reader's attention.

formats that
break the mold

SIX

A change of format can be a budget-trimming solution. For example, you might be able to redesign your newsletter to fit in a smaller, less expensive envelope. Design the newsletter as a self-mailer to save even more. Changing the format might save money that you can use for other design elements like color or photography.

If you plan to mail your publication, check with the postal service prior to printing. You don't want to spend the money you've saved on printing on increased mailing costs. Odd-shaped mailings often have to be inserted in envelopes to qualify for bulk mail rates.

The average American is deluged with at least twelve hundred commercial messages a day from TV, radio, direct mail, print advertising and billboards, not to mention Internet and E-mail bombardment. A change of format can make your piece stand out and get noticed. So, when you're picking a format, look at what everyone else is doing—especially your competitors, who are targeting the same groups. Consider doing the opposite of what they're doing, making your brochure larger or smaller, your newsletter more pages and thicker or smaller and easier to scan.

Finally, a change of format should be considered when the old (or traditional) format isn't working anymore. If every issue is a struggle or if you're spending far too much time just getting the layout of the publication to flow, it's time to take a critical look at the overall size and dimensions of the piece.

The designers in this section prove that it's safe to walk outside the traditional paper lines. In fact, doing so often makes your piece an eyepopper in a field of 8½" × 11" (21.6cm × 27.9cm) publications.

at a glance:

Go beyond the tabloid 11" x 17" sheets or standard 8½" x 11" pages

Borrow a format

Print two (or more) projects together

Fold a standard three-panel brochure sheet in fourths

Discuss new formats with your printer

Use a preprinted format for several projects

Change the publication size

Combine or separate publications

INSIDER ADVICE
Go beyond the tabloid 11" x 17" sheets or standard 8½" x 11" pages

Why not fold the 8½" × 11" (21.6cm × 27.9cm) sheet in half for a newsletter that's 4½" (14cm) wide and 11" (27.9cm) tall? How about a newsletter on a postcard? A horizontal newsletter that's 11" (27.9cm) wide by 8½" (21.6cm) long? Once you start thinking outside tradition, there are all sorts of possibilities.

Borrow a format

Unfortunately, we have preconceived notions about what brochures and booklets should look like. Applying the standards from one area to another is how new formats are born. For example, can the brochure look like a mini-newsletter? How about translating packaging parameters into publication formats? Can the top lift off? Can the covers of the brochure open like a cardboard box? Browse the greeting card aisle for folds and formats that might work for a booklet or brochure.

Print two (or more) projects together

If you're concerned about paper waste involved with an odd-sized format, think of something to print on the waste portion. How about bookmarks, business cards, personalized notepads, an insert for another project, postcards?

Fold a standard three-panel brochure sheet in fourths

Try a Z-fold, an accordion or roll fold, a French fold or a gatefold. Don't forget to fold it lengthwise and widthwise. Use different sizes of paper.

Discuss new formats with your printer

Printers often add or update equipment to expand their capabilities. If you're a regular customer, they may forget to tell you. They could just be waiting for you to ask. Regularly prowl the print shops for samples. Most of all, don't automatically assume that a larger format will cost more.

Use a preprinted format for several projects

A product sheet shell might turn into a newsletter that might turn into an informational flyer that might be used for stationery, for example. Functional formats that span several projects are an ideal way to save money. The windfall might be funneled into a more critical marketing piece instead.

Change the publication size

Changing your preconceived perceptions about size goes a long way toward fueling inspiration. Thinking outside the normal lines doesn't necessarily mean you're going to change the format. Just imagining the publication in another size can lead to new design ideas and associations with other layouts.

Combine or separate publications

Think about putting several newsletters into one—a digest format, perhaps with more pages. It will feel more substantial. On the other hand, you might segment an existing newsletter for different audiences. How about a standard "shell" newsletter with news and information for all the audiences with a special insert tucked inside. The same concept can apply to brochures.

interactive fold opens a whole new world

(UMD) ENVIRONMENTAL STUDIES BROCHURE WITH REPLY CARD

ART DIRECTOR:
Brent Swanson

DESIGNERS:
Tom DiTolla, Katie Kessler

ORGANIZATION:
UMD Graphic Design Service

SIZE: BROCHURE:
Brochure—10⅞" × 8⅞" (27.6cm ×
21.4cm) folded to 5⁷⁄₁₆" × 4⅜" (13.8cm
× 11.1cm); Reply card—5⅜" × 4¼"
(13.7cm × 10.8cm)

QUANTITY:
1,000

COST:
$700 (printing); pro bono design

OBJECTIVE:
The head of the newly created
Environmental Studies Program wanted
a piece to send out to high schools to
introduce the program to graduating
seniors.

HOW WE SAVED:
Two colors only; taking our own photos;
self-mailer format.

CREATIVE COMMENTS:
Brainstorming and playing with 8½" ×
11" (21.6cm × 27.9cm) sheets of paper gave this
self-mailer it's "interactive" format. "We wanted
a smaller-than-normal brochure that would open
up a layer at a time, revealing more information
about the program while at the same time expos-
ing a larger image of the world," explains
Swanson.

The world in this case is a close-up
of a globe sitting on crumpled kraft paper, a
photograph Swanson took himself. The image
dominates both sides of the brochure and the
reply card. This rather abstract, blurred-focus
picture is used as a duotone in earth tone
green and dark navy. The recycled paper stock,
a medium tan color, adds to the earthy and
environmentally conscious theme of the piece.

The initial feel of the "package" is
eerie—dark, but intriguing. You can't resist

opening it. Some might argue that the deep blue
text, which almost looks black, doesn't contrast
well enough with the photo. You have to strain
somewhat to read the small stuff in the shadows
of the picture. But considering the audience,
high-school seniors, this probably isn't a problem.
They're more apt to be grabbed by the dynamics
of the piece. After all, the reply card nestled in
the folds of the brochure makes it obvious that
more information is forthcoming.

"The piece had to be hand folded,"
adds Swanson, "but we worked with the printer
ahead of time on that."

building on a grid theme

UMD FINE ART DEPARTMENT BROCHURE

DESIGNER:
Brent Swanson

ORGANIZATION:
Swanson Graphic Design

SIZE:
15" × 15" (38.1cm × 38.1cm) folded to 5" × 5" (12.7cm × 12.7cm)

QUANTITY:
1,000

COST:
$500 (printing); pro bono design

OBJECTIVE:
Promote the graduates and interns of the Graphic Design Department of the University of Minnesota, Duluth to design firms and in-house art departments.

HOW WE SAVED:
One person doing everything; using a lighter, less expensive paper.

CREATIVE COMMENTS:

"I like to get my fingers into everything," says Swanson, who not only designed the brochure for his alma mater, but took the photos and wrote the copy.

Swanson admits he's "in love" with small, foldable formats. His choice of format for this brochure stems from the underlying grid theme he used for the whole piece. "The layout focuses on one of the most basic and important principles I learned at the school— grid systems."

He uses an actual grid as a background to several panels. Text is justified to form blocks. Headlines are set off in boxes drawn to fit the grid. The large square panels mimic the grid pattern as well.

"I contrasted the hard, strict lines with the soft, grainy photos," he explains. "Large major headings have also been blurred and softened in Adobe Illustrator and QuarkXPress."

The photos are all simple shots of designer's hands using a mouse, a craft knife and a pencil. All of these imply versatility. Another picture is of a handshake, obviously implying commitment, agreement, teamwork, etc. "The idea was to represent the school, students and professors as very professional and highly skilled," he said.

The photos are actually color 35mm negatives made into black-and-white prints.

"This increases the grain drastically," explains Swanson. It's also a great way to disguise any flaws or lighting problems that could make the pictures look amateurish.

He notes that he doesn't rely on computer programs to give him all the special effects he's looking for. He likes to experiment— a good way of stretching natural creativity.

The brochure is printed in black and silver on a lightweight coated stock. Even though most of the copy is reversed out of black and printed in silver, it's a solid sans serif that holds its readability well. The whole brochure is well organized and easy to scan—just what a busy executive needs to see from a design school.

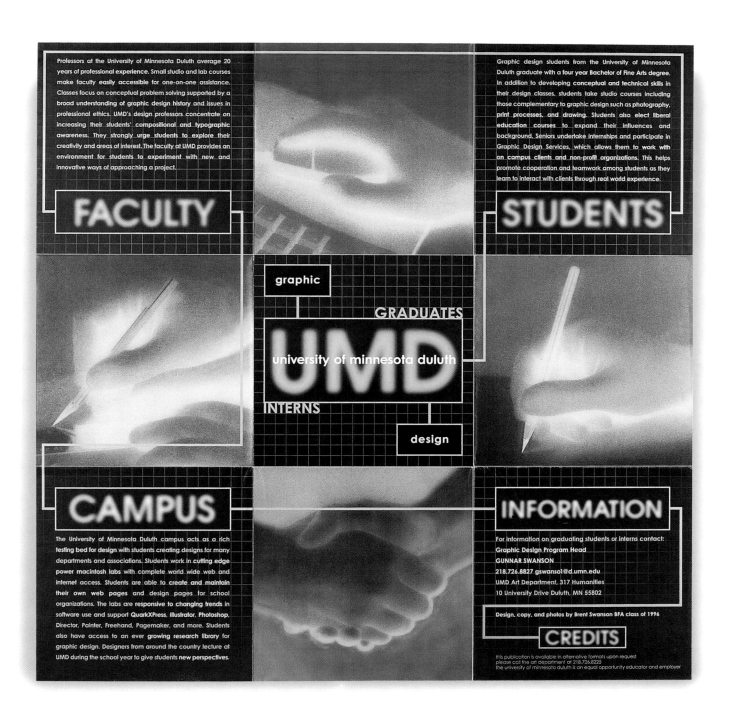

Professors at the University of Minnesota Duluth average 20 years of professional experience. Small studio and lab courses make faculty easily accessible for one-on-one assistance. Classes focus on conceptual problem solving supported by a broad understanding of graphic design history and issues in professional ethics. UMD's design professors concentrate on increasing their students' compositional and typographic awareness. They strongly urge students to explore their creativity and areas of interest. The faculty at UMD provides an environment for students to experiment with new and innovative ways of approaching a project.

FACULTY

Graphic design students from the University of Minnesota Duluth graduate with a four year Bachelor of Fine Arts degree. In addition to developing conceptual and technical skills in their design classes, students take studio courses including those complementary to graphic design such as photography, print processes, and drawing. Students also elect liberal education courses to expand their influences and background. Seniors undertake internships and participate in Graphic Design Services, which allows them to work with on campus clients and non-profit organizations. This helps promote cooperation and teamwork among students as they learn to interact with clients through real world experience.

STUDENTS

graphic

GRADUATES

UMD
university of minnesota duluth

INTERNS

design

CAMPUS

The University of Minnesota Duluth campus acts as a rich testing bed for design with students creating designs for many departments and associations. Students work in cutting edge power macintosh labs with complete world wide web and internet access. Students are able to create and maintain their own web pages and design pages for school organizations. The labs are responsive to changing trends in software use and support QuarkXPress, Illustrator, Photoshop, Director, Painter, Freehand, Pagemaker, and more. Students also have access to an ever growing research library for graphic design. Designers from around the country lecture at UMD during the school year to give students new perspectives.

INFORMATION

For information on graduating students or interns contact:
Graphic Design Program Head
GUNNAR SWANSON
218.726.8827 gswanso1@d.umn.edu
UMD Art Department, 317 Humanities
10 University Drive Duluth, MN 55802

Design, copy, and photos by Brent Swanson BFA class of 1996

CREDITS

this publication is available in alternative formats upon request
please call the art department at 218.726.8225
the university of minnesota duluth is an equal opportunity educator and employer

simple design for an elegant outcome

SHOWCASE '97 INVITATION FOR THE SOUTH SUBURBAN COLLEGE FOUNDATION

"I wanted to take a standard-size sheet of paper and do something different," says Bartecki. The college logo is a diamond shape—a square, really. Toying with the shape and the paper they'd picked out (Confetti in blue and yellow) Utterback and Bartecki came up with a two-piece self-mailer.

The lightly flecked paper creates elegant backdrop for the design that uses PMS silver and black inks. However, it is the format that makes the brochure a standout. "There's an illusion that this is a die cut of some sort," Bartecki explains. The deep blue panel is a horizontal piece folded into and around a rich gold vertical panel. "We folded them by hand ourselves to save money," adds Bartecki.

The vertical and horizontal pages are woven together so the reply card and envelope can be safely tucked inside. The design itself is minimal, combining script and sans serif type with small, illustrative bits of clip art. As each panel is lifted, more details about the fundraiser are revealed: date and time, then location and price, and finally the RSVP.

Bartecki and Utterback tackle numerous financially challenging projects for the college. "We're very diverse," says Bartecki. "It's less about being creative and more about being consistent in our look and feel within the college environment.

"Generally I'll come up with an idea," explains Bartecki, "and ask Susan [Utterback] how we can do this."

Bartecki also found cost savings and creativity benefits in trimming in-house design staff and using more freelancers. Unlike outside designers, "in-house people eventually start thinking alike," she points out. "Freelancers are more expensive, but I'm able to hire them as I need them on a project-by-project basis. I don't have to keep staff busy during slow times," she adds.

DESIGNERS:
Susan Utterback and Holly Bartecki

ORGANIZATION:
South Suburban College

SIZE:
16½" x 5½" (41.9cm x 14cm) folded to 5½" x 5½" (14cm x 14cm)

QUANTITY:
400

COST:
Pro bono design and printing

OBJECTIVE:
Since paper and printing were donated for this project, we needed a knockout design that wouldn't overtax the printer's generosity.

HOW WE SAVED:
Designing the piece as a self-mailer saved the cost of envelopes, which would have been expensive considering the irregular size (a square).

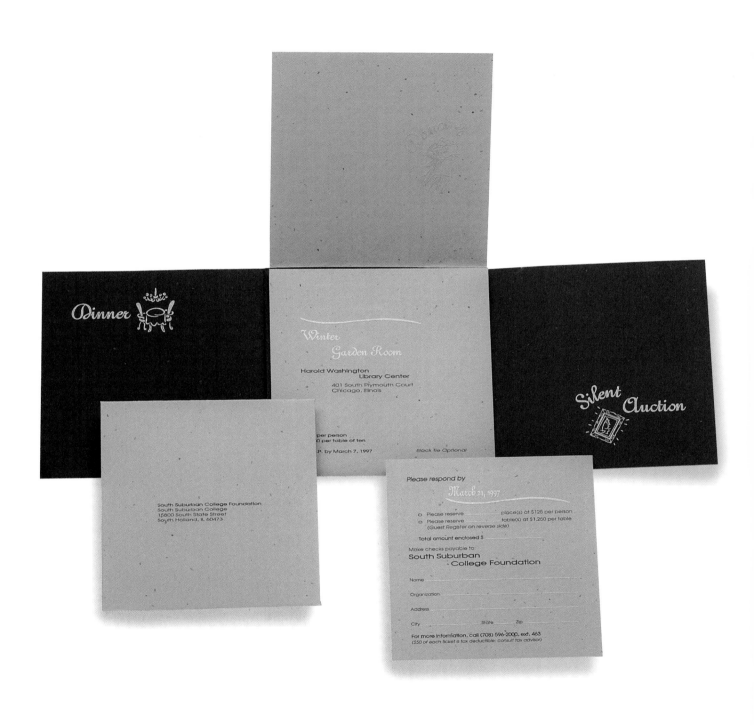

contemporary touches vitalize traditional message

CENTENNIAL NEWSLETTER FOR FROSTBURG STATE UNIVERSITY

CREATIVE COMMENTS:

It's not easy to marry contemporary design to a traditional, historical theme on any budget, but Sheirer pulls it off well. This unusual eight-page newsletter format with its vertical nameplate flap, is more cost effective than it looks. Printed on 11" × 17" (27.9cm × 43.2cm) sheets, the pages had to be trimmed to accommodate the bleeds. To fit under the flap, pages 1 to 6 also had to be trimmed to 7" (17.8cm) wide. (The flap is 2¾" [7cm] wide. When the flap is open, it makes the last two pages of the newsletter 9¾" [24.8cm] wide.) This format gives the newsletter a tall, vertical stress.

Sheirer is reserved in her use of the university's deep, riveting red. Only the reverse nameplate and thin vertical bands on the front and back covers are printed in the vivid second ink color.

The large black-and-white crowd shot across the bottom third of the front and back pages is simple, yet dramatic in contrast to the red nameplate. The photo is softly faded and weathered looking. Once you open the newsletter you see a smaller version of this same picture, with a caption, on page two.

The nontraditional format and dramatic color treatments add energy and life to the newsletter. Otherwise, the historical photos and standard two-column layout might make this a sleeper rather than a keeper.

Self-proclaimed "queen of the low budget" (according to her design firm's stationery), Sheirer uses her background in bookbinding to look for "different formats that won't jack up the price." "I wanted this newsletter to look like a little package," she explains.

the program *Mozart Requiem*. This performance will involve the talents of the Collegium Musicum, the University Chorale and the Emmanuel Episcopal Choir. The performance will be under the direction of Dr. Karen Soderberg and it promises to be smashing!

PUBLICITY & MARKETING
Committee co-chairs report that along with a standard "focus" of publicity on all aspects of the Centennial in 1998, additional internal and external projects will be undertaken. The first major publicity campaign has commenced with the current issue of the *Profile* with a page dedicated to the Centennial and six issues will be produced in 1997 and 1998. For the winter 1998 issue, the Centennial will be the cover story. Other ideas being organized include the production of a Centennial calendar,

Centennial video, a display of Centennial banners in the City of Frostburg and on campus, and the production of FSU Centennial Moments for WFWM and other local radio stations.

HISTORICAL PROGRAMS
The committee's projects are shaping up well. The largest of these efforts is a book about FSU's history. A number of faculty and staff are collaborating on this work. Final drafts are being

prepared and the historical book will be published and available for purchase sometime this winter. Two other programs in the preparatory and research stages are the pictorial display of FSU's history and an anecdotal history as related by faculty, staff and alumni. Plaques for some of the buildings on campus named in honor of notable persons are being designed.

ACADEMIC PROGRAMS
The Centennial Academic Programs Committee has scheduled four major on-campus events to commemorate FSU's Centennial. The first to be held during the week of March 9, 1998, will investigate "The Future of Academe" and will specifically examine three key questions: 1.) what are the obligations of the University both generally and specifically to the community? Focus will be on the arts, public education, business, and the social and physical sciences; 2.) what is the future of the profession? Specifically what is the relation between tenure and academic freedom?; 3.) what will be the effect of technology upon the delivery of instruction? For example, how will new technologies change the way faculty teach and students learn?

The second academic program, held July 19, 1998 in conjunction with that summer's Modern Humanities program, will feature a lecture by a visiting professor from the Empire State University, followed by a panel discussion on the topic of "The Future of

6

Interdisciplinarity." Focusing on graduate interdisciplinary efforts, this presentation will also concern interdisciplinarity goals of general education and in learning communities.

During the week of September 14, 1998 the University will present a symposium investigating the special identity of FSU. Drawing from the University's vision statement and strategic plan, "The Edge of Identity" will examine our attaining regional eminence in five fields of emphasis: education, business, the creative arts, environmental sciences, and in human services.

The final offering of the Academic Program Committee will be a regional conference describing and analyzing the contributions of women in Appalachian workplaces and institutions of higher education. The conference will invite papers from multiple

disciplines but will take the specific focus of a historical retrospective on the topic "A Hundred Years of Women at FSU."

CENTENNIAL REFLECTIONS
Your Memories are Frostburg's History
As we prepare for the 1998 celebration of Frostburg State University's Centennial, the FSU Centennial Committee invites you to share with us your memories of the school and the people who embodied its spirit. The Committee is seeking anecdotes, photographs and memorabilia. These materials will be used to inform and illustrate the publications and exhibits documenting Frostburg's 100 years of history. Centennial projects include the book of FSU's history, a calendar, film, audio history and photo exhibit.

7

FSU Centennial Celebration Committee

Elizabeth Adams
Co-Chair

Howard Adams
Co-Chair

Dr. Philip Allen
Dean of the School of Arts & Humanities, Liaison to the Arts Programs Subcommittee

Dr. David Gillespie
Director of the Lewis J. Ort Library, Liaison to the Academic Programs Subcommittee

Mr. Jim Limbaugh
Director of Special Projects, Liaison to the Historical Programs Subcommittee

Mr. Gary Love
Director of the Planned Giving Office, Liaison to the Special Events Subcommittee

Ms. Colleen Peterson
Associate V.P. of University Advancement, Liaison to the Publicity & Public Relations Subcommittee

DESIGNER:
Lisa Sheirer

ORGANIZATION:
Sheirer Graphic Design

SIZE:
7" × 10½" (17.8cm × 26.7cm)

QUANTITY:
5,000

COST:
$500

OBJECTIVE:
Use the university colors, red and black, on an in-house publication that could be printed by the campus "quick printer"—no traps or complicated stripping.

HOW WE SAVED:
Using a standard paper size, 11" × 17" (27.9cm × 43.2cm), and photos from the university library's special collection.

limitations shape the project

AURARIA CAMPUS EVENTS SCHEDULE

CREATIVE COMMENTS:

Creative folds and formats are high on Reichenberg's list of surefire ways to translate a low-budget project into an eyepopping publication. In fact, even when a project like the Auraria campus events schedule comes complete with a whole list of predetermined size restrictions, she manages to respond with a unique format solution.

The project was a redesign of a smaller format, approximately 8½" × 17" (21.6cm × 43.2cm) folded to 8½" × 8½" (21.6cm × 21.6cm). The new design had to be bigger to accommodate more copy, but the overall dimensions had to fit the maximum dimension of existing distribution racks. In addition, the schedule had to stay within the 11" × 17" (27.9cm × 43.2cm) capacity of the two-color press at the Auraria campus print shop.

"The limitations shape the project," says Reichenberg, who doesn't have any problem staying creative on lean budgets. "The restrictions tell you where you should be pushing the envelope on your design."

The short 2¼" (5.7cm) panel fold keeps the schedule narrow enough to fit in the racks. It creates an interesting and functional panel when it's lifted. Special events can be highlighted and billboarded here. The unique fold ties in nicely with the five-column grid on the inside of the brochure. The fold line runs along one of the dotted rules that separate the columns.

Most important, Reichenberg designed a layout specifically to fit a more economical press. The original schedule was printed two up on a 17" × 22" (43.2cm × 55.9cm) sheet. The two ink colors were applied separately in a work and turn setup. "This precluded tight registration," explains Reichenberg. "Now we print on a press that allows both inks to be printed in one pass, which means a tighter register, and the smaller 11" × 17" (27.9cm × 43.2cm) sheet eliminates the surcharge of oversize negatives and printing plates."

In fact, going to a larger format has saved the client money, which they can now channel into design. "The net budget change is $0-$50," says Reichenberg.

LECTURES

Stressed Out to the Max?
Nancy Mulholland, M.A., L.P.C.
Lecture to develop strategies for
compassionate self-care and to take
that first step for a stress-free life.
Tues., Mar. 3, 12:15–1:15 p.m.
South Classroom Rm. 136A
Info: 782-5289

**Laissez Les Bons Temps
Rouler: A Look at the
Cajun Culture**
A host of speakers will discuss the
intricacies of the Cajun Culture.
Mon., Mar. 9, Noon–1:00 p.m.
Tivoli 320 C
Info: contact the the Institute of
International and Intercultural
Education at 556-4004

**Anthropology
Colloquium Series**
Presented by the CU-Denver
Department of Anthropology.
Everyone is invited to attend,
refreshments will be served.
Info: 556-2621

Sincere Words, Clever
Words: Deception and
Truth in China
Dr. Susan Blum, CU-Denver
Department of Anthropology
Fri., Mar. 27, 4:00–6:00 p.m.
3rd floor conference room
1380 Lawrence St. Center

Nooners
A mid-day nourishment for
the body and mind. Series
involves life learning skills
and meets every Tuesday and
Wednesday. Co-sponsored by
The MET Student Activities
and CU-Denver Student Life.
Info: 556-2595

The ABC's of
Time Management
Katherine Trout, Assistance Center
for Learning
Tues., Mar. 3, 12:30 p.m.
Tivoli 329

How to Prepare Your Taxes
Terri Donahue,
Internal Revenue Service
Wed., Mar. 25, Noon
Tivoli 329

Ins and Outs of Mortgages
John Dresserlars, Patriot Mortgages
Tues., Mar. 31, 12:30 p.m.
Tivoli 329

Rap Session
A weekly series that includes
lectures, debates, forums, art
displays, and discussions with
a multicultural emphasis.
Info: 556-4247

History on Trial: Culture Wars
and the Teachings of the Past
Dr. Gary Nash
Thurs., Mar. 5, 2:00 p.m.
Tivoli 320 A & B

**Faculty
Upside-Down**
Students and professors are
able to meet outside the
classroom in an informal setting.
Info: 556-4247

Fri., Mar. 6, 11:00 a.m.
Fri., Mar. 27, 11:00 a.m.
Daily Grind

THIS MONTH
Auraria

Events at the Auraria Higher Education Center Campus
March 1998

LECTURES, CONT.

**Towering Issues
of Today**
Weekly lectures, forums
and debates on current issues.
Info: 556-3157

Israel at 50: Politics and
the Process for Peace
Yael Dayan
Member, Israeli Parliament
Mon., Mar. 23, 1:00 p.m.
Tivoli 320

Leadership Series
Info: 556-2597
Meets 2:00–3:00 p.m. in Tivoli 309

Mon., Mar. 2
Being Creative Everyday

Mon., Mar. 9
Realizing Our Own Potential

Mon., Mar. 23
Balance in the Workplace

Mon., Mar. 30
Getting the Most Out of Life

POETRY

Toads in the Garden
Shows begin with an Open Poetry
Reading at 7:30 p.m. A $2
donation ($1 with student ID)
is required. Daily Grind Coffee
House, Tivoli Student Union.
Info: 722-9944.

Open Reading for
Students and Faculty
Thurs., Mar. 5

Loretta Childers
Poetry reading
Thurs., Mar. 12

Barbara J. Suwyn
Ukranian folk tales and original
poetry. Suwyn will also sign books.
Thurs., Mar. 12

OFF CAMPUS

Hidden Heroines
of Jewish History
Sara Gilbert, program director
of the Hebrew Educational
Alliance, will provide insight into
the fascinating stories of Jewish
heroines overlooked.
Mon., Mar. 9 and Mon., Mar 23,
7:30–8:30 p.m.
Jewish Community Center
350 S. Dahlia
(Alameda & Dahlia)
Info and Registration:
399-2660, x179

WOMEN'S
HISTORY MONTH

Pornography & the
Exploitation of Women
Linda Lovelace
Mon., Mar. 2, 1:00 p.m.
Tivoli 640
Info: 556-2595

Gender and Leadership
Panel Discussion
Tues., Mar. 3, 2:00–4:00 p.m.
Tivoli Multicultural Lounge
Info: 556-2597

Writing Themselves
into the Landscape:
The History and Archeology
of the Women of Boggsville, CO
Bonnie Clark,
Historical Archaeologist
Wed., Mar. 4, 10:00–11:00 a.m.
Tivoli 320 C
Info: 556-8441

How Women Can Apply
for a Small Business Loan
Presented by Norwest Bank
Wed., Mar. 4, Noon
Tivoli 320
Info: 556-2595

Women in the Workforce
Workshops on gender equity in pay
and the glass ceiling, etc.
Thurs., Mar. 5, 10:30 a.m.–2:30 p.m.
South Classroom Lobby
Info: 556-2597

Title IX: History & Impact
Nancy Haberkorn, Office
of Civil Rights Region VIII
Thurs., Mar. 5, 1:00 p.m.
Golda Meir House
Info: 556-3113

Men Who Batter
Dr. Lee D. M. Bidwell,
Sociology Professor
Mon., Mar. 9, 1:00 p.m.
Tivoli 640
Info: 556-2595

Move to Home Ownership
Nancy, Lumbye, The Women's
Mortgage Connection
Wed., Mar. 11, 11:30 a.m.–12:30 p.m.
Tivoli 642
Info: 556-8441

WOMEN'S
HISTORY, CONT.

Race and Gender
Features women from different
races discussing their experiences
Wed., Mar. 11, Noon–2:00 p.m.
Tivoli Multicultural Lounge
Info: 556-2597

Sexual Harassment
Mary Lou Fenili, Assistant Vice
Chancellor of Academic and
Student Affairs
Tues., Mar. 24, 12:30 p.m.
Tivoli 329
Info: 556-2595

Hersterical Journey
Karyn Ruth White, Comedian
lighter side of the trials and
tribulations of women.
Wed., Mar. 25, 10:00–11:00 a.m.
South Classroom 136 A
Info: 556-2343

Head, Heart, Spirit
The 2nd Annual Women's
Leadership Conference discusses
leadership style and strengths.
All Day Fri., Mar. 27
Tivoli Student Union
Info: 556-8048

Sistah Pride
Conference is designed for African
American Females grades 5
through 12 and their mothers,
teachers, and counselors.
Sat., Mar. 28, 7:30 a.m.–3:00 p.m.
Tivoli Student Union
Fee for girls is $5, $10 for adults
Registration req., call 556-3992

Homophobia, Censorship,
and Family Values
Leslea Newman, author of Heather
Has Two Mommies
Mon., Mar. 30, 1:00 p.m.
Tivoli 640
Info: 556-3399

Women of the West Museum
Marsha Samuel, President/Chief
Executive of the Women of the
West Museum
Mon., Mar. 30, 3:00 p.m.
Tivoli 320 B
Info: 556-3113

Coming in April ...
Putting Women in Their Historic Places
**Saturday, April, 4, 8:30 a.m.–3:00 p.m.
St. Cajetan's Center on the Auraria Campus
9th & Lawrence Way**
Colorado History Group's Annual Spring Program
President Tom Noel hosts a program of talks, tours,
and musical entertainment celebrating the 150th
anniversary of the Seneca Falls Women's Rights
Convention and the role of Colorado Women in
historic preservation. For Information Call: 355-0211

Right: Margaret "Unsinkable Molly" Tobin Brown
Photograph courtesy State Historical Society of Colorado

MUSIC

**MSCD Department
of Music**
Info: 556-3180

General Student Recital
Mon., Mar. 2, 2:00 p.m.
Arts Building Rm. 295

Viola Master Class
featuring Steven Kruse
Mon., Mar. 2, 4:00 p.m.
Arts Building Rm. 295

South Indian Carnatik Festival
Sat., Mar. 7, 3:00 p.m.
Vocal Concert begins at 7:00 p.m.
St. Cajetan's, 9th and Lawrence
Free to MSCD Students

Symphony Orchestra
The Ariel Trio: Tamara Mullikin,
violin, David Mullikin, cello,
Susan Cable, piano
William Morse, director
Sun., Mar. 8, 7:30 p.m.
Houston Fine Arts Center,
Foote Recital Hall
7111 Montview Blvd.
(Montview & Quebec)
Info: 556-3180

Wind Ensemble
Alexander Invanov, director
Sat., Mar. 9, 2:00 p.m.
St. Cajetan's, 9th and Lawrence

Colorado Chambers Players
Barbara Hamilton-Primus,
artistic director
Mon., Mar. 23, 2:00 p.m.
Arts Building Rm. 295

Senior Recital
Laura Banks, mezzo-soprano
Assisted by Delorus Netzel, piano
Sun., Mar. 29, 3:00 p.m.
Wellshire Presbyterian Church,
Ammons Chapel
2999 S. Colorado Blvd.
Info and tickets: 556-3180

General Student Recital
Mon., Mar. 30, 2:00 p.m.
Arts Building Rm. 295

Conductor's Recital
featuring MSCD Conducting
Students
Mon., Mar. 30, 7:30 p.m.
St. Cajetan's, 9th and Lawrence

Gig Series
Treat yourself to various
musical acts over lunch every
Wednesday from 11:30 a.m. to
1:30 p.m. at the Tivoli Atrium.
Info: 556-2595

Mar. 5:
Julie Davis,
Female Vocal Folk Music
11:30 a.m.–12:30 p.m.

Phyliss Brock,
Female Vocal Folk Music
12:30 p.m. - 1:30 p.m.

Mar. 12:
Opalanga Pugh,
Cultural Storytelling
11:30 a.m. - 12:30 p.m.

Irepo Dancers, African
Dancing
12:30 p.m. - 1:30 p.m.

Mar. 26:
Celtic Fair, Irish Vocals
11:30 a.m. - 12:30 p.m.

DESIGNER:
Mary Reichenberg

ORGANIZATION:
Auraria Reprographics

SIZE:
11" x 17" (27.9cm x 43.2cm)
trimmed to 11" x 16¼" (27.9cm x
41.3cm) and folded to 8¾" x 8⅛"
(22.2cm x 20.6cm)

QUANTITY:
3,200

COST:
$200-250 (design); $700 (printing
and prepress)

OBJECTIVE:
Redesign the Auraria campus events
calendar in a format that

1. has more space for the schedule;
2. will still fit in the existing distri-
 bution racks; and
3. fits the limitations of a specific
 press in the Auraria campus print
 shop.

HOW WE SAVED:
Using a standard sheet size, two
ink colors, client-provided photos;
designing a format to fit a more
economical press.

a new angle for a new brochure

UNITED WAY *LISTENING TO OUR COMMUNITY* BROCHURE

Funders

Woodward Governor

Hewlett-Packard of Loveland

United Way of Loveland, Berthoud, Estes Park

Foote Charitable Trust

Study Conducted by: Rene Moquin Dialogos Consulting Estes Park, Colorado

For more information, please contact the United Way.

DESIGNER:
Susan Beam

ORGANIZATION:
Chili Graphics

SIZE:
15¼" x 15¼" (38.7cm x 38.7cm) folded into a triangle with two 7¾" (19.7cm) sides and one 11" (27.9cm) side

QUANTITY:
5,000

COST:
$3,750 (printing)

OBJECTIVE:
Publicize a joint study done by three local communities in a format that will get noticed and read.

HOW WE SAVED:
One ink color, no photos or complicated artwork, an out-of-state printer.

CREATIVE COMMENTS:

The routes designers take to get ideas are rarely traceable. The twists and turns taken from conception to delivery are caused by budget concerns, other people's input, deadlines and personal creativity. Beam's brainstorm is no exception. "I was thinking about the three communities involved in the study. That had me thinking of triangles. Then I was thinking of a pie and a slice of a pie," she recalls. "I got the final idea while I was vacuuming, which is when I get a lot of my ideas."

The United Way office wanted an unusual, eye-catching layout to publicize the results of an extensive community study. "They really wanted to encourage people to open and read the piece," explains Beam, "not just have them say, 'Oh, another thing from United Way,' and ignore it."

The triangular format is really the drawing card to this all-text layout. Other than two logos used in the brochure, there is no artwork.

Beam began the project by discussing her concept with a printer. Could it be done at a reasonable cost? Once she had the printer enthused about the idea, the layout was relatively simple. The sections are well labeled, and the copy on each panel is short and scannable. It's designed to be interactive and fun.

The brochure is designed to be a self-mailer, although it was eventually mailed in an envelope with other companion materials. An odd format like this does not fit the dimensions to qualify for bulk mail rates.

Beam worked with an out-of-state printer on the piece because the printer could do the work at a good rate. "I can send the files via E-mail with no problem," she says.

The challenge for low-budget clients, says Beam, is to understand the relationship between image and results. "I sometimes have to convince them to spend just a little more money in order to get the results they want."

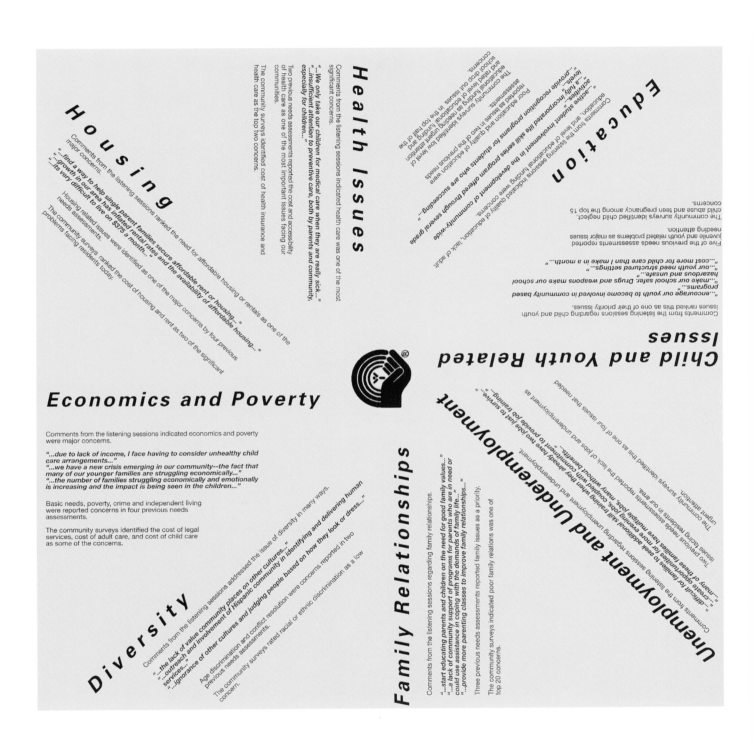

Housing

Comments from the listening sessions ranked the need for affordable housing or rentals as one of two major concerns.

"...find a way to help single parent families secure affordable rent or housing..."
"...growth in our area has inflated rental rates and the availability of affordable housing..."
"...its very difficult to live on $575 a month..."

Housing related issues were identified as one of the major concerns by four previous needs assessments.

The community surveys ranked the cost of housing and rent as two of the significant problems facing residents today.

Health Issues

Comments from the listening sessions indicated health care was one of the most significant concerns.

"...We only take our children for medical care when they are really sick..."
"...insufficient attention to preventive care, both by parents and community, especially for children..."

Two previous needs assessments reported the cost and accessibility of health care as one of the most important issues facing our communities.

The community surveys identified cost of health insurance and health care as the top two concerns.

Education

Comments from the listening sessions indicated low level of education, and level of educational quality of community-wide concerns.

"...active student involvement in the development several grade levels..."
"...provide recognition programs for students who are succeeding..."
"...a fully incorporated life skill series program offered through school activities..."

Poor education and issues in two of educational funding and concerns.

The community surveys identified low level of education as needing urgent attention in the top of the concerns.

Five of the previous needs assessments reported juvenile and youth related problems as major issues needing attention.

The community surveys identified child neglect, child abuse and teen pregnancy among the top 15 concerns.

Child and Youth Related Issues

Comments from the listening sessions regarding child and youth issues ranked this as one of their top priority issues.

"...encourage our youth to become involved in community based programs..."
"...make our school safer. Drugs and weapons make our school hazardous and unsafe..."
"...our youth need structured settings..."
"...cost more for child care than I make in a month..."

Economics and Poverty

Comments from the listening sessions indicated economics and poverty were major concerns.

"...due to lack of income, I face having to consider unhealthy child care arrangements..."
"...we have a new crisis emerging in our community--the fact that many of our younger families are struggling economically..."
"...the number of families struggling economically and emotionally is increasing and the impact is being seen in the children..."

Basic needs, poverty, crime and independent living were reported concerns in four previous needs assessments.

The community surveys identified the cost of legal services, cost of adult care, and cost of child care as some of the concerns.

Diversity

Comments from the listening sessions addressed the issue of diversity in many ways.

"...the lack of value community places on other cultures..."
"...outreach and involvement of Hispanic community in identifying and delivering human services..."
"...ignorance of other cultures and judging people based on how they look or dress..."

Age discrimination and conflict resolution were concerns reported in two previous needs assessments.

The community surveys rated racial or ethnic discrimination as a low concern.

Family Relationships

Comments from the listening sessions regarding family relationships.

"...start educating parents and children on the need for good family values..."
"...a lack of community support of programs for parents who are in need or could use assistance in coping with the demands of family life..."
"...provide more parenting classes to improve family relationships..."

Three previous needs assessments reported family issues as a priority.

The community surveys indicated poor family relations was one of top 20 concerns.

Unemployment and Underemployment

Comments from the listening sessions regarding unemployment and underemployment.

"...difficult for families to seek additional skill training and reventing jobs coupled with multiple jobs, many without benefits..."
"...create opportunities for these families that have two jobs just to survive..."
"...many of these families have already have two jobs just to survive..."
"...these opportunities to provide job training..."

Two previous needs assessments reported the lack of jobs and underemployment as one of four issues that needed.

The community surveys identified this as one of four issues and underemployment.

Two previous needs assessments reported the lack of jobs and underemployment in our area.

The community needs assessments reported the lack of jobs and underemployment as one of their issues facing residents needing urgent attention.

powerful,
inexpensive

seven

Ever had a great, seemingly inexpensive design go bust at the end? Like when the printer tells you the equipment won't handle that particular fold or format and it will have to be hand done instead? Or that cutting the paper to that size requires an extra carton? Or the extra heavy coverage means extra inking? The list goes on and on and on.

Printers can be your savior, or they can do you in. Make friends with at least one printer and one prepress person who can give insight and advice about production techniques and help you stay within a low budget.

If you aren't an expert at production, prepress or printing, take heart. Lots of designers and desktop publishers learn the hard way about what can and can't be accomplished. Get to know various support people that you work with. Printers, prepress operators and reps can all offer incredible amounts of advice that can help you develop your creative low- budget publications.

These designers prove that some of the best low-budget ideas begin at the end—knowing your printer's capabilities and options.

INSIDER ADVICE
Avoid paper passion

It's not uncommon for paper costs to be at least 50 percent of the print bid. If you want to whittle down the price, be flexible. Don't get "married" to a particular type of paper. Be open to substitutes or suggestions from the printer.

Ask yourself if the paper needs to contribute in any way to the design or just present the design. Obviously, the texture and color of the paper can be important added design elements in publications like brochures. But most news-letters and informational booklets look best on inexpensive offset paper. After all, you don't expect the reader to spend a lot of time admiring the stock.

production
techniques

Additionally, bright white, high-gloss paper has lost a lot of its glamour. In the old days, glossy stock was the instant choice of amateur newsletter designers aiming for a corporate or professional look. Today, we know that the glare of gloss and the reflection of bright white paper actually make reading more difficult. The matte sheets with lower whiteness ratings are also less expensive than gloss.

Avoid printer passion

A big budget buster is using one printer exclusively without soliciting at least three bids on each project. Newsletter publishers especially are prone to using printers they know or like. Of course, newsletter designers get a better deal on printing if they give a year's contract to one printer. Too often that year becomes two, then three, etc. Familiarity is comfortable, but can also be costly.

When you solicit bids, make sure all the specifications are the same. If a printer suggests a paper substitute that looks acceptable to you, get the weight and brand and grade so the other printers can rebid.

Use alternative-use papers

Cardboard and brown kraft paper are popular favorites right now, especially for small, limited-quantity brochures. Like the popular, but more expensive, flecked and heavily textured papers, cardboard and kraft paper add tactility. Also, using a stock normally associated with boxes and paper bags—utilitarian functions—can create an unusual, attention-getting design when combined with sophisticated type and layout treatments.

at a glance:

Avoid paper passion

Avoid printer passion

Use alternative-use papers

Piggyback

Try creative financing

Use trims and drills

Combine laser-printed originals with imagesetting

Don't make mistakes you have to pay for

Go directly to plate

Piggyback

Be snoopy. Ask the printer what other newsletters or magazines are being printed. What kind of paper and ink? If you use the same paper and ink colors, you may get a deal if the printer can run your job at the same time.

Try creative financing

Bartering is still alive and well. Does the printer need some design work? Photography? Copy? Lawn mowing? Strike a deal if you can. Warning: Put your deal in writing. Make the terms clear and build in a "what if" clause that saves you both if something goes wrong.

Use trims and drills

Straight trims are easy for almost any printer. But a straight trim doesn't have to be horizontal or vertical—think diagonal. If your printer has a drill or a punch, you can generally get holes put anywhere. Besides, asking doesn't cost anything. Imagine what you could do with the leftover trim paper. Confetti? Odd-shaped business cards? Notepads? Bill stuffers?

In fact, anytime you have to trim a piece you should contemplate using the waste for something—bookmarks (see section six), postcards, minibrochures.

Combine laser-printed originals with imagesetting

High-resolution imagesetting is a necessary expense for some projects. You might, however, save some money by using your lower-resolution printer for part of the job— perhaps inside pages. Reserve imagesetting for the covers.

Don't make mistakes you have to pay for

Proofread early and often. AAs (Author Alterations) are a waste of money. Printers justifiably charge for work they have to do over because of type or layout changes to the proof. The time to proofread is before the publication goes to the printer. Check critical names, phone numbers, dates and prices. A printer's proof is a quality check for color, photos and format issues such as folds, trims, etc.

Another costly mistake is not figuring the mailing weight before printing. Make sure the paper you've selected keeps you within your postage budget. You don't want to save money on design and printing only to lose it on mailing costs.

If you use business reply cards in a project, ask the printer or the post office for the minimum caliper or thickness of the stock for these types of cards. Many times designers automatically choose a stock that's thicker, and more expensive, than necessary.

Go directly to plate

The less work the printer has to do, the less you'll be charged. If the printer doesn't have to make negatives, strip in pictures or burn plates, you've saved some steps. However, printers' preferences and electronic capabilities are vastly different. What works great for one won't work at all for another. Before you transfer files for your project, test the transfer process. Printers aren't responsible for mistakes made during steps they aren't involved with.

three in one uses four-over-one

DIRECT MAIL BROCHURE FOR EYE PRIORITY

CREATIVE COMMENTS:

"Solving this multifaceted visual problem was like trying to create pieces of a picture puzzle before it has been put together," observes Cassady. "Each objective needed to be developed independently and modified to fit the whole picture and meet the requirements of cost effectiveness."

Since the doctors' relocation took place during the Christmas season, it was natural to think about combining the new address notice with their regular holiday greeting. In fact, the design sprang from a greeting card format.

Surprisingly, the full-color images are on the inside of the mailer. The outside is black-and-white with a mailer on one half and a relocation announcement (map included) on the other half. The mailer hardly looks festive, but the teaser headline, "Free Holiday Gifts Inside!" on the mailing panel makes opening this almost irresistible.

The inside bursts open with full color and visual activity. The humorous Santa illustration, which combines the names of the doctors and staff with a caricature of the new office building, serves the greeting card purpose. Holiday coupons and a sweepstakes entry form encourage patients to visit the new office.

"Unlimited budgets are definitely easier," points out Cassady. "But when you have limitations like budget, it forces you to be creative." He likens it to people who do their best work right before the deadline. "The more difficult the problem, the more creative you can get."

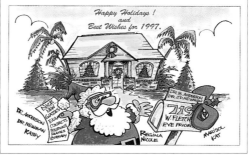

DESIGNER:
J.R. "Jack" Cassady II

ORGANIZATION:
Cassady Enterprises

SIZE:
8½" × 11" (21.6cm × 27.9cm) folded to 8½" × 5½" (21.6cm × 14cm)

QUANTITY:
Approximately 4,000

COST:
$1,127

OBJECTIVE:
Create a single direct mail piece that would accomplish three separate objectives:
1. announce the doctors' new location;
2. encourage patients to come to the new office; and
3. serve as a holiday greeting and gift card from the doctors and staff.

HOW WE SAVED:
Printing full color on one side and black and white on the other (⁴/₁, or "four-over-one" in printing lingo), along with having one piece serves three functions. Also, designing the piece as a self-mailer saved the need for envelopes.

no-frills drills: a "hole" new perspective

LIGHT AT THE END OF THE TUNNEL DIRECT SELF-MAILER FOR MCNB BANKING CENTER

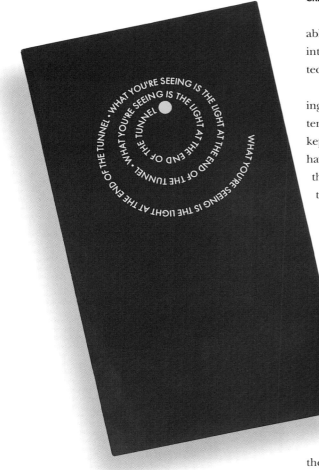

CREATIVE COMMENTS:

"Active," "eye-catching" and "affordable" go a long way toward describing Suhr's intriguing combination of type, color and technique.

"The project began with a brainstorming session with the client," explains Suhr. "The term 'seeing the light at the end of the tunnel' kept coming up in reference to people who have paid off loans." So the copywriter wrote to this theme, and Suhr carried it through in the two-color design.

Suhr makes maximum use of the "light" concept. Suhr makes an inexpensive drill the pivot of the entire design, marrying the outside and inside headlines perfectly to the technique. On the front, reverse type—"What You're Seeing Is the Light at the End of the Tunnel"—spirals toward a ¼" (0.6cm) hole revealing only a vibrant yellow dot. The midnight blue cover opens up to a bright yellow spread featuring the bank's ½ percent loan discount incentive. On the left panel, the headline "How Does It Feel to See the Light?" is nestled perfectly next to the drilled hole.

Of course, creativity is not without compromise. "The original design used a black cover, which was more striking," she explains. "But the deep blue is one of the bank's corporate colors."

Suhr works with financial institutions on a regular basis, some conservative and some willing to push the design envelope now and again. Staying creative means "taking all the rules and restrictions the client gives you and pushing them to the max. I've been doing this a long time," she notes. "Ideas come easier now."

HOW DOES IT
FEEL TO SEE
THE LIGHT? ● **Congratulations** —

your last loan payment is just
around the corner, and
MCNB Banking Center is
beaming at your success.

We want you to know how
much we appreciate your
solid loan relationship by
offering a golden opportunity
to help you reach additional
financial goals.

1/2 %

Consumer Loan Discount*

We have a bright idea to reward you for
your hard work.

When it's time to begin a new loan
relationship — whether you're buying a
new car, making home improvements, or
any other purpose — **simply bring
this coupon** to any MCNB Banking
Center for a ½% discount on any
installment loan!

MCNB Banking Center congratulates
you and we want you to consider us for
all your banking needs. We offer
products and services that will make
your financial situation shine.

Enjoy the Light at the End of the Tunnel

This offer is effective _____ and may change without notice.
Standard credit qualifications apply. Member FDIC.
* ½% interest rate discount is not available for mortgage loans or
home equity lines of credit.

EQUAL CREDIT OPPORTUNITY LENDER

DESIGNER:
Cindy Suhr

ORGANIZATION:
Mills Financial Marketing

SIZE:
10" × 9" (25.4cm × 22.9cm) folded
to 5" × 9" (12.7cm × 22.9cm)

QUANTITY:
2,500

COST:
$967

OBJECTIVE:
A piece to encourage customers
who had or were about to pay off
existing installment loans to contin-
ue their relationship with the bank.

HOW WE SAVED:
The hole in the cover is not a die
cut, but a drill.

cutting quality where it won't show

CARSON CITY PARKS & RECREATION BOOKLET

Team up a tight budget with an even tighter turnaround and you generally have a recipe for boring, do-what-we've-always-done design. Instead, Brown pounds away at the corners of this two-color project, "Those of us who grew up in the dark ages before computers and electronic design have an edge, I think," quips Brown, whose design career began with traditional pasteup and layout.

"The client didn't have a clue what they wanted on the cover of the booklet," Brown explains. They didn't even have any photographs. "I could have used clip art," she says, "but it just didn't feel right."

The black-and-white high-contrast photos actually come from Brown's own in-house stock photo supply that she's built up over the years. "I got the idea for the cover as I flipped through the pictures." It's not uncommon for Brown to get her best ideas this way—by "playing."

"As I play with the design it usually tells me what it wants to be. Especially when it's a one-shot deal, not a regular client," she says. "I might flow in the text and see what I have to work with spacewise." This "just do it" approach is especially useful on tight turnaround projects where forward progress is important. Screening the photos makes the title treatment pop out.

The text-heavy inside pages could be daunting except for the softly screened logos and the teal rules separating the sections. Functional and easy on the eye, the justified single columns are broken up with frequent paragraphs and small caps subheadings.

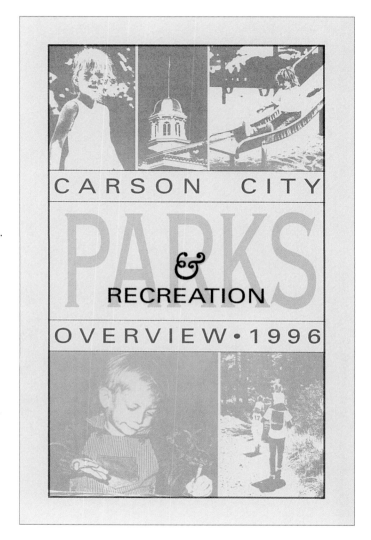

Adult Softball
Nevada Landmark Society
Carson City Capitals Baseball
Carson City Bobby Sox
Sierra In Line Hockey
Carson City Little League
Carson City Pop Warner
BMX
Youth Sports Association
High Desert Soccer
Carson City Babe Ruth
High Sierra Radio Control Flying Club
AYSO Soccer
Comets Softball
Rattler Soccer
Silver Sage Pistol Club
Carson City Tennis Club
Carson City Railroad Association
Carson City Aquatic Club
Carson City High School Rodeo Club
Capital City Gun Club
Carson City High School Swim Team
Super Outlaw Karts
Bonanza Kennel Club
Retired Senior Volunteer Program
Carson City Horsemen's Club
Carson Valley Arabian Association
Nevada State Horsemen's Association
High Desert Team Penning
Carson Rifle and Pistol Club
Ormsby Sportsman's Association.
Silver State Games

14

*The following pages are devoted to
contributions submitted by various user groups
in response to our request
for additional information for this publication.*

CARSON CITY AQUATIC CLUB

The Carson Aquatic Club is a nonprofit corporation established in 1976. The swim team is a member of United States Swimming. This competitive swimming team is coached by a professional staff led by head coach Xiaohong Wang, the 1991 World Champion and the 1992 silver medalist in the 200 meter butterfly at the Barcelona Olympic Games.

The team has 80 competitive swimmers ranging in ages 5 to 19. With the enclosure of the outdoor pool, we believe it is possible to grow to 200 swimmers. Recent success includes a 9th place team finish at the Junior National Championships something considered unique for a town the size of Carson City.

The Carson Aquatic Club has coached swimmers who achieved the following: 5 Senior National Qualifiers, 16 Junior National Qualifiers and a multitude of Far Western Qualifiers. We have had relay teams and individual swimmers within the top sixteen in the United States in their age groups. We have played a role in a total of 13 Carson City residents receiving either partial or full swimming scholarships to major universities. Our swimmers rated high in academic achievement with the average grade point for the team above 3.2.

We have brought many families from other cities to our town for our swim meets, even the Chinese Olympians. Our high school has won 4 boys and 4 girls state swimming championships. Every swimmer who ever scored a point at the high school state championships was a member of the Carson Aquatic Club at one time or another.

CAPITAL CITY GUN CLUB

The Capital City Gun Club is a Carson City park for the public's enjoyment of shotgunning. The club itself was formed in the early 1940s by a group of Carson City residents interested in shotgunning. The current location is the third, and was at the time of its inception, the only thing out on Arrowhead Drive which, was a dirt

15

DESIGNER:
Syd Brown

ORGANIZATION:
brown, brandt, mitchell & murphy

SIZE:
5½" × 8½" (14cm × 21.6cm)

QUANTITY:
250

COST:
$971 (design and prepress—
$459; printing—$512)

OBJECTIVE:
We had ten days to go from a
fuzzy concept to a printed piece.

HOW WE SAVED:
Stock photos were used for the
cover, and only the cover was
sent to a service bureau for high
resolution imagesetting output.
The inside pages were printed from
color separations done on Brown's
600-dpi laser printer.

CARSON CITY SHADE TREE COUNCIL

1996 ACCOMPLISHMENTS

The Carson City Shade Tree Council enjoyed a very productive 1996. The Council continues to be successful in promoting proper tree care and awareness of the urban forest in our community. The Council has also been instrumental in obtaining the "Tree City USA Award" for the second straight year.

A "Tree Selection Guide" for Carson City was prepared and published, as well as a "Preferred Tree Species" list for the Community Development Department to use in assisting with various development projects throughout the city.

The Nevada Division of Forestry awarded a $2,500 grant to the Council in 1996 to use for tree planting and education. This money was put to good use, for it enabled the Council to fund a tree care seminar for public employees and the general public. This grant has been integral to the success of the Annual Arbor Day Celebrations by the Council, which proclaimed Arbor Day for the fifth year in 1996. A 13-foot Blue Spruce was planted at Lone Mountain Cemetery to celebrate Arbor Day. As an annual part of the ceremony, the George Washington Ferris Award was presented to the Odd Fellows service organization for their dedication to trees in the community.

Other notable accomplishments of the Council include the completion of a tree inventory program for public right-of-ways, assisting city staff in obtaining $20,000 for a consulting arborist, and providing interview criteria for the hiring of the new Streets Division Superintendent of the Public Works Department. The Council is always willing to assist city staff with programs which benefit the community's urban forest. They took an active role in promoting the "Live Christmas Tree Program," a new program initiated by the Utilities Department to encourage citizens to buy live Christmas trees from local vendors and donate the trees to city parks to be planted after the holidays.

Following the considerable damage to trees in the community from the snow storm in December, the Council assisted city staff in assessing the damage to trees caused by the event.

Perhaps the most important role the Shade Tree Council plays in the community is in recognizing and encouraging local businesses and citizens to become active in promoting tree awareness. Donations of $100 or more towards Arbor Day tree planting are recognized by adding the donor's name to a plaque in the Community

18

Center. The Council was an active participant in the passage of the Question #18 Tax Initiative, which included planting street trees in Carson City. They were successful largely due to their efforts in educating the public and conveying the importance of trees in the overall quality of life for everyone, which was what the tax initiative was all about.

The Carson City Shade Tree Council enjoyed considerable success and accomplished the goals and objectives set by the group for 1996. The hard work and dedication of the volunteers who serve on the Council will ensure continued success in future endeavors.

SILVER STATE GAMES

The cooperation and assistance that the Silver State Games received from the Parks and Recreation Department, the Sheriff's Department, Public Works, the Treasurers' office and the Carson City administrative division was exemplary.

In its first year, the Silver State Games operated on a budget of $226,000 that serviced over 2,400 athletes from throughout the state. By the conservative estimates of Al Kramer, a board member of the Silver State Games and Carson City's Treasurer, the Silver State Games had an extended economic impact of over $820,000 on Carson City. For a first year event, we were very pleased to positively impact the community while expanding amateur sports in Nevada.

The 1997 Silver State Games are gearing up to be bigger and better. We are expecting over 4,500 athletes this year in 27 sport disciplines. One of our goals is to make the Silver State Games a showcase event for Carson City. With our plans for a free Opening Ceremonies program, our new "Fire Up Nevada!" community outreach program and our constant promotion of the Games, we think Carson City is in for a great July weekend of sports.

As the only recognized U.S. Olympic Committee multisport, grassroots program in Nevada, the Silver States Games are proud to be a part of the Carson City identity. We're looking forward to a great second year. Thanks Carson City!

19

"branching" out for big ideas

CAREER DAYS JOB FAIR BOOKLET AND COLLATERAL MATERIAL

CREATIVE COMMENTS:

Broyles's job fair booklet is proof that it pays to get out of the office and away from your computer now and again. You don't have to go far either. "The twigs [for the booklet binding] were found in the backyard. I used peach and lemon tree branches," she explains.

"The idea of the job fair is that it is a place where consumers use their raw materials to get a job." Broyles's use of raw materials parallels that concept nicely. Branches, corrugated cardboard, kraft paper and twine scream texture. The urge to touch the package is irresistible.

With such a limited quantity, a press run would be out of the question, so the booklet pages, labels and cover pages were printed on the in-house Canon color laser printer. Creative positioning and printing on 17" × 11" (43.2cm × 27.9cm) sheets made the project even more economical. To mimic the look of a double-sided page, Broyles used a French-fold technique. "Two consecutive pages are printed side by side. The sheet is folded to 8½" × 11" (21.6cm × 27.9cm) with the printed side facing out," she explains. Then the sheet is cut in half, making four pages that are 8½" × 5½" (21.6cm × 14cm). The loose edges are bound, and an additional ½" (1.3cm) is lost each way in the trimming.

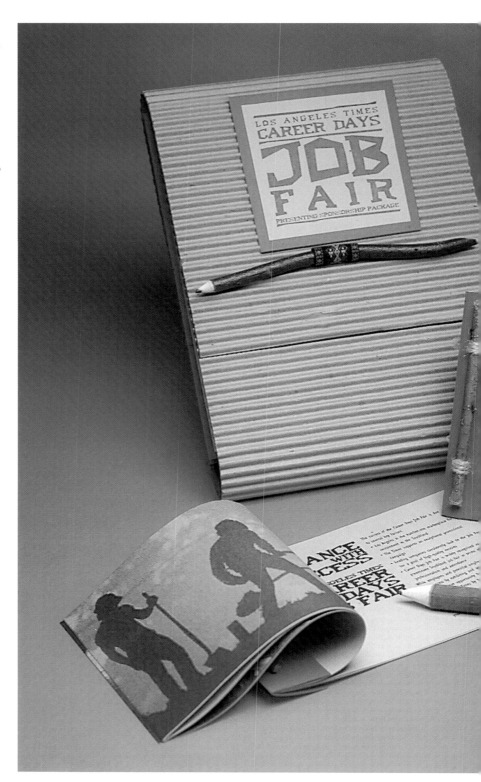

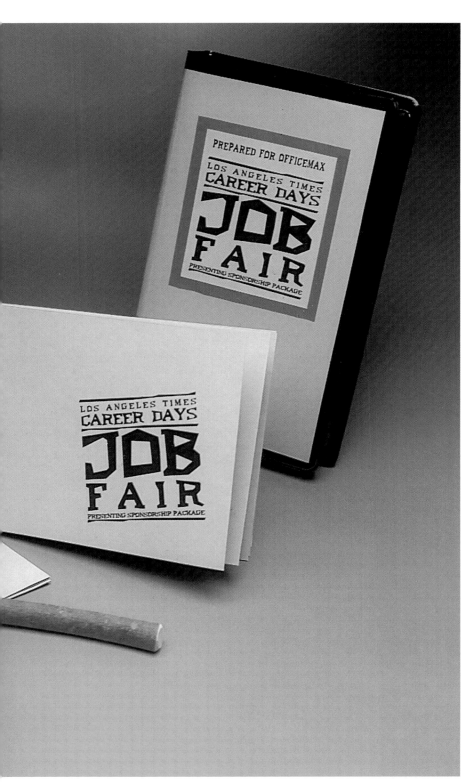

DESIGNER:
Donna Broyles

ORGANIZATION:
Los Angeles Times, Creative Services Department

SIZE:
Booklet—8" × 5" (20.3cm × 12.7cm); other labels, etc., were various sizes

QUANTITY:
30 sets

COST:
$100

OBJECTIVE:
Get sponsors for the *Los Angeles Times* Career Days Job Fair.

HOW WE SAVED:
Twine and twig handmade binding, in-house laser printing.

a fresh angle

PREP CLUB BROCHURE FOR WESTERN BANK

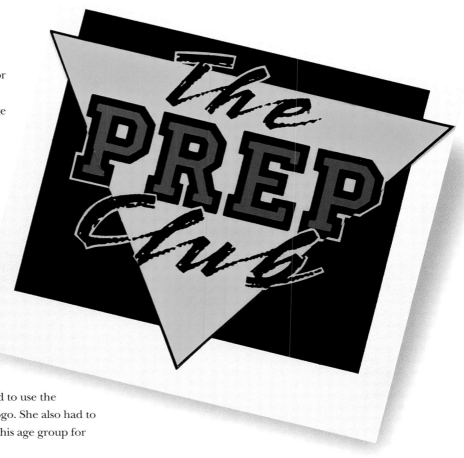

CREATIVE COMMENTS:

Tight budget? No problem and no whining for Suhr. She takes the restrictions as a personal challenge to exercise her creativity. "These are the restrictions. This is the budget. This is what we need to accomplish. How do I get there?"

When Western Bank needed a striking multipurpose brochure to promote a special financial club for fifteen- to twenty-two-year-olds, Suhr had more than budget restrictions. She had to use the club's existing Prep Club logo. She also had to have maximum bang with this age group for minimum bucks.

The logo sparked a pennant theme with Suhr. Working with the printer, she created a faux die cut. The triangular front cover is simply two straight cuts by the printer. "The challenge for the printer," explained Suhr, "was really lining the front and back perfectly so the logo on the cover lined up with the one inside." Precision trimming and folding were a large part of the success of this piece.

DESIGNER:
Cindy Suhr

ORGANIZATION:
Mills Financial Marketing

SIZE:
8" × 14" (20.3cm × 35.6cm) folded
to 8" × 7¼" (20.3cm × 18.4cm)

QUANTITY:
2,500

COST:
$2,114

OBJECTIVE:
Take the existing logo and come
up with a design appealing to
fifteen- to twenty-two-year-olds.

HOW WE SAVED:
Using diagonal cuts as opposed
to die cuts.

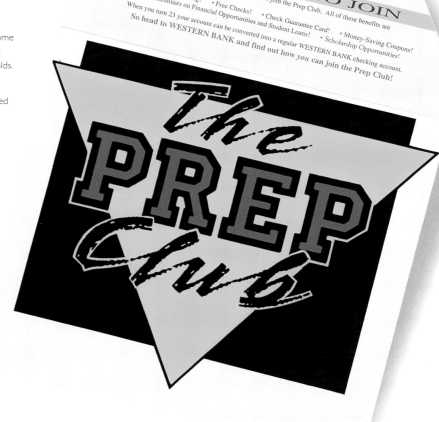

Do you
want to know
how to get a good
credit rating? Would you
like money-saving coupons?

If this is music to your ears, then the Prep Club™ is for you. Prep
Club members pay annual dues which entitle you to take advantage of
many valuable services. By being a member of WESTERN BANK's Prep
Club, you learn sound financial habits. Most important you begin to build a credit
history which can lead to a sound credit rating.

HERE'S HOW TO JOIN

If you are between the ages of 15 and 22 you can join the Prep Club. All of these benefits are
yours for annual dues of $24.99:
• Unlimited Check Writing! • Free Checks! • Check Guarantee Card!
• Student Seminars on Financial Opportunities and Student Loans! • Money-Saving Coupons!
When you turn 23 your account can be converted into a regular WESTERN BANK checking account. • Scholarship Opportunities!
So head to WESTERN BANK and find out how you can join the Prep Club!

making the most of
one- and

Every designer's color perspective is different. Some designers say they save money on projects by limiting the number of ink colors they use. Other designers have a different take. They think of it as adding color to an otherwise black-ink-only project.

All of them agree, however, that if there's room in the budget for a touch of color, then you've got a powerful visual aid that you need to make the most of.

First you have to pick the *right* color, right being defined by the audience. Color is emotional and symbolic. People have strong attractions and aversions to certain colors. Cultural connotations have to be respected as well.

"Your response to color is inherited, and it is learned," says Carlton Wagner, founder of the Wagner Institute for Color Research in Santa Barbara, California, and a world-renowned expert on color. "Response depends on several factors including your sex, age, intelligence and education. Also such factors as temperature, climate, socioeconomic background and regional attitudes will affect color response."

When you're choosing added color, choose what suits the purpose of the publication and the audience. Organizational colors, for example, are a good choice for newsletters and brochures since readers will pick up the link quickly.

Readability has to be the other consideration for newsletters and booklets. Studies still show that black text on a pale yellow or cream-colored background is read most quickly. When choosing an alternative to black for small text, stick to an almost black color—navy, dark green, brown, etc. You can use screens of the color for light variation.

Black goes with any other color, so it's common to see simple two-color layouts with black text for readability and a second accent color applied to art, headlines and rules for organization and interest.

If you're using two different colors together—blue and yellow, for example—you have to be aware of something called the "adjacency factor." When two colors appear side by side, the eye's perception of the colors is different than when the colors are viewed separately. For example, the shade of yellow you've chosen may look cool or sallow when it abuts the blue. When you pair two colors,

two-color
printing

be sure to view them together. Sometimes perception of two colors together creates the illusion of a third color.

Of course, the other player in color perception is paper. Even white sheets, depending on their whiteness and brightness, will affect how the colors appear. The texture and coating of the paper—matte, gloss, dull, uncoated, pebbled, etc.—add to ink shadows and dimensions that you need to be aware of. Printers carry samples from various paper manufacturers for just this reason. They can show you how ink colors, even black ink, vary from one paper to another.

Unfortunately some designers are hesitant to print color on colored paper. Unless you've seen a printed sample using the colors you've chosen this can be a risky thing. However, it's a great way to get more bang for your printing buck. The paper acts like a second or third color.

When you're using people photos, be wary of colors that turn faces blue or green or any other unnatural shades.

INSIDER ADVICE
1 + 1 = 3

Two colors can easily look like three if you experiment with screens of the two colors printed on top of each other.

Go for the bold

Pick complementary colors, which are opposite each other on the color wheel (yellow and purple, for example), for maximum contrast. Depending on the message, audience and how you apply the color to the layout, these color choices can be startlingly effective.

Cool vs. warm colors: know the difference

Without reading a word, recipients of your publication develop expectations based on the design. Color is a powerful player in this initial image building. It's not just the general color you've chosen that you have to worry about, but the shade. If this weren't true, food package designers wouldn't spend thousands of

at a glance:

1 + 1 = 3

Go for the bold

Cool vs. warm colors: know the difference

Try the compatibility strategy

Show some restraint

Piggyback your job with another one

Avoid tight register

Wrap the color

Print ½

Let the paper be a second or third color

Create faux backgrounds

Be wary of heavy coverage

Be unpredictable

Shop around

Try a split fountain for a rainbow effect

Remember: Black is a color, too

Inquire about specialty inks

dollars testing how consumers react to various colors on detergent boxes and soup cans. They know that every color has a warm or cool shade. Yellow is not just yellow.

Try the compatibility strategy

Another approach is to pick shades that are three hues apart on the color wheel. The colors are more compatible and less likely to jolt the eye with contrast.

Show some restraint

"I'm paying for the color, so I want lots of it!" Almost every designer has heard this a time or two. Think about what you're doing with the color. You don't want to overwhelm readers to the point that they can't decide what to look at first.

Piggyback your job with another one

If the printer doesn't have to clean and reink the press between jobs, you can sometimes get a price break on one or both projects. You might even piggyback your job with someone else's if your schedule is flexible enough. If you print on the same type of paper they're using, you'll get even more of a break.

Avoid tight register

If a layout calls for precision alignment or intricate trapping, the printer might charge more to compensate for extra wastepaper required to get it just right.

Wrap the color

Create motion with rules or graduated screens that flow over the gutter to the next page, over the fold or from the front to the back. Watch bleeds—images that go off the cut edge of a page. Bleeds may add cost to a job because they need to be printed on oversized paper and trimmed. Or they can be printed on standard size sheets (like 8½" × 11" [21.6cm × 27.9cm]) and trimmed, resulting in a slightly undersized publication. Check with the printer first.

Print ½

This is printing code for "one-over-two," meaning you print one side in two colors and the other side in a single color. Depending on the type of equipment your printer has, this can be a cost cutter.

Let the paper be a second or third color

If you're limited to one color, especially a dark ink like forest green or deep burgundy, experiment with how transparent screens of that color will mix with different paper colors. You may want to choose a brighter ink shade if you print on a dull paper. Remember, if you're using photos, especially of people, the ink and paper color will have a huge impact on how the photo "feels." For example, pictures of blue people, whether it's the paper or the ink, are uncomfortable.

Create faux backgrounds

Use an inexpensive white paper, then print an overall background to give the paper a rich texture. For example, flecks can mimic the look of "hairy, feely" paper, or a pale screen of a blue ink that you're already using can emulate a non-repro blue grid that designers and engineers might relate to. Screen your one or two ink colors if necessary to make sure the texture doesn't interfere with the message.

Be wary of heavy coverage

Large blocks of any dark color sometimes add to design costs. It's not just the additional amount of ink that printers are factoring in, but the waste factor. To cover a large area with ink, printers have to allow for "ghosting" (the faint image of one area of the page printed on another area), picking (unintended spots or holes in the dark area) and extra drying time. Sometimes heavy coverage requires a piece to be run through the press more than once.

Be unpredictable

Grass is always green. Water is always blue. How about brick red grass and shocking pink water? Look at your photos and artwork and think about printing them in an unexpected color. This works especially well for "mood" photos or background images that are screened behind text or other images.

Shop around

Saying that printing costs vary is probably the ultimate understatement. When you have a tight budget and a project that screams for color, talk to at least three printers. Before you have the job designed, discuss options with each printer. However, for the final bid, make sure you're comparing "oranges to oranges." Each printer needs a fair chance to bid on identical specifications and options.

Try a split fountain for a rainbow effect

A split fountain requires a printer to divide (split) an on-press ink fountain into two or more sections. A different ink color is put in each split. As the press runs, the colors blend together. Generally this works best for short-run jobs, under one thousand impressions. The split-fountain effect varies from piece to piece, so it's not recommended for publications that need to look exactly alike. Talk this option over with the printer before you commit to it. The cost of a split fountain may run about the same as a two-color job, but quotes vary widely. Some need to run the press at slower speeds than normal. There may be more wastepaper involved. Every printer's equipment responds differently to this technique. Ask your printer to show you some samples of other jobs that used a split fountain.

Remember: Black is a color, too

Black is synonymous with elegance and sophistication. The drama of black-and-white publications can be quite arresting in this day and age of wild color. Unfortunately, new or novice designers forget to really use black as a color, either boldly or minimally. Think about featuring large areas of black prominently with a second color.

Inquire about specialty inks

Information doesn't cost you anything, and any printer will gladly fill you in about all the different types of inks. Make sure you have a handle on how the ink responds to the type of paper or printing method you are using. For example, metallic inks print very differently on coated and uncoated paper stock, as do opaque inks. If you don't know about an ink's effects on paper, or if you are unsure about how certain inks stand up to the printing process, ask your printer. You'll be glad you did.

who says the sky has to be blue?

1997 CLINICAL CARE CONFERENCE BROCHURE AND SYLLABUS COVER FOR THE AIR MEDICAL PHYSICIAN ASSOCIATION

CREATIVE COMMENTS:

Sophisticated, elegant and interesting: These design concepts were a long way from being a reality when Strother began the project for the Air Medical Physician Association. The client not only had a low budget, but had no photography or artwork. "In addition, the brochure is just a list of schedule information such as times, dates, names of classes and speakers," she says. "In other words, not very exciting material to work with."

So, Strother began at the top—literally—with a sky image. "To get across the idea of flight, I used a background pattern of sky and clouds from a stock photography CD. I didn't want to use blue because it seemed too cliché," she explains.

Tan and black inks were an easy choice for Strother. "I've used the combination before. It's very sophisticated." She got a lot of mileage out of the simple photograph, using it as a soft tan screen behind the text on the pages inside. To add even more visual interest, Strother inserted small squares of the same background using different screen values. The background package adds life and movement to what could be static and strictly functional copy. The type is still highly readable, however, and very well organized. The busy professional would have no trouble scanning for the information she needs.

Strother uses her black ink with panache as well. Used for drama on the cover, the black ink takes a secondary role on the inside. It's not only used to keep the small text highly readable, but it's used as a heavy ¼" (0.6cm) frame around each inside spread.

"I really rely on a big library for inspiration," she says. "I like looking through design books and collections for new ideas.

"It's not uncommon for me to rip a page out of a magazine and save it because I like what they did with the type or the color combination or the way they treated a photo."

Strother admits, however, that her creativity for low-budget projects depends on a lot of things. "It depends on how busy I am, how easy the client is to work with and how interesting the project is." (Strother confesses that her contact for this project, Pat Petersen at the Air Medical Physician Association, is a dream client. "She's so easy to work with that it makes the job fun.")

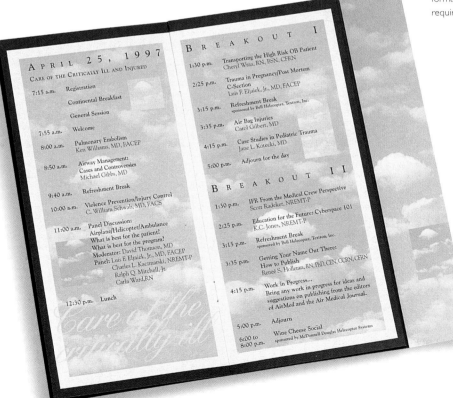

DESIGNER:
Erin Strother

ORGANIZATION:
Studio E

SIZE:
Brochure—4¼" × 9" (10.8cm × 22.9cm); Cover—8½" × 11" (21.6cm × 27.9cm)

QUANTITY:
6,500 brochures and 300 covers

COST:
$3,800 (printing and design)

OBJECTIVE:
Invent an inexpensive marketing design for the Association's annual conference.

HOW WE SAVED:
Stock photography, and a self-mailer format so no additional envelope is required.

simple photos plus strategic color placement equals dramatic results

CENTRAL VALLEY BANK SELF-MAILER

CREATIVE COMMENTS:

"Make it corporate and agricultural," a conceptual dichotomy that's challenging enough without having to work on a tight budget as well.

The mailer had to appeal to the agricultural community, yet maintain the dependable, corporate image of the bank. "I got handed the copy," Felton explains. "Once I read it, I knew I needed something different and dramatic.

"I don't start by worrying about the budget," she explains. "The copy helps me a lot. In this case, I had the idea in my head after reading the headline and text."

The photos, which Felton took herself to keep costs down, are simple yet striking. The front cover image of a hand holding an uprooted plant was taken to tie directly into the headline "A Deeply Rooted Commitment."

The hand, the soil and the green plant popping out of the earthy black photo are strong visual draws to the target audience. The entire brochure is clean and uncluttered. This is a functional and useful type of public relations piece. Copy is brief, short and airy— easily scannable for key information. The second ink color is used minimally on headlines and to call out important points such as location, hours and phone numbers. The glossy paper is not only perfect for maintaining sharp photos, but it also gives the piece a corporate business feel.

Tight budgets don't seem to bother Felton in the least. "The personality of the client tells me what sort of look they're after. Sometimes I look through stock photos and an idea will come from that. I do a lot of 'thumbnailing' too."

"As Central Valley Bank moves to its new location, you will notice the same people, expertise and personal service you have come to expect in Sigourney."

"Our dedication to the area's needs is evident through our loan portfolio. We have increased our loan volume tenfold in the last year."

Our Commitment:

To Work Side By Side

Why does Central Valley Bank have a vested interest in your success? Because the people who work here are your neighbors and friends. We care about you because we care about our community.

The professionals from both Central Valley Bank and the former Boatmen's branch are the same people you have always relied upon for financial solutions. We promise to continue yielding the expertise and advice you need from your banker.

Our Commitment:

To Maintain Our Strength —
Which Stems From A Firm Foundation

Central Valley Bank looks forward to a healthy future — one that is built on very solid ground. Our management team offers over 200 years' combined experience making sound business decisions, which has translated into 27% growth in assets over the last two years. Now with the incorporation of Boatmen's Sigourney location, we have doubled our size.

This strength means you can rest assured that your deposits are secure and that our lending practices are quality-driven.

It also means we'll be here for many years to come.

We Want To Cultivate A Relationship With You.

Our next step is to earn your respect by being advocates of the community's success. We also hope to earn your trust, and would be honored to serve you.

Central Valley Bank invites you to visit soon, and to consider cultivating a relationship with us.

As of June 24, 1996, Central Valley Bank will be located at:

112 North Main Street
(the former Boatmen's Bank location)

Our hours are:
Lobby
Monday - Thursday
9:00 a.m. - 3:00 p.m.
Friday
9:00 a.m. - 5:30 p.m.
Drive-Up
Monday - Thursday
9:00 a.m. - 3:00 p.m.
Friday
9:00 a.m. - 5:30 p.m.
Saturday
9:00 a.m. - Noon
To reach us by phone:
(515) 622-2381

Central Valley Bank. Planting the Seeds for Your Success.

DESIGNER:
Jennifer Felton

ORGANIZATION:
Mills Financial Marketing

SIZE:
15" x 10" (38.1cm x 25.4cm) folded
to 6" x 10" (15.2cm x 25.4cm)

QUANTITY:
1,500

COST:
$879 (printing)

OBJECTIVE:
Increase the image awareness of a
bank among agricultural clients.

HOW WE SAVED:
Felton took the photographs herself,
and two colors were used as
opposed to four.

the evolution of a newsletter

ABSORB, LOVELAND MUSEUM AND GALLERY NEWSLETTER

CREATIVE COMMENTS:

"I've never used the same colors twice," says Alden about the newsletter that he's been designing since its inception in 1992. "I look back and I see not only the newsletter itself evolving, but my own design technique changing."

The newsletter now has a set format with predictable variables. As contrary as that sounds, it's a layout that makes sense and works well for a museum and art gallery. The grid, for example, is always two columns on the inside pages. The cover always has a strong single graphic or photo. The paper stock is always a smooth matte sheet. The body text is currently Mrs. Eaves by Emigre.

Ink colors are the biggest variable. "The colors I select may relate to the season or the theme of the issue," explains Alden, "or I may use a featured exhibit or piece of artwork for color inspiration."

"The nice thing about designing for a museum and gallery is having an abundance of visually compelling resources," says Curator of Interpretation Tom Katsimpalis. "We always have historical photos or art photos."

Alden frequently uses duotones to add interest to images, especially on the cover. He also toys with the type on the cover, usually a quote pulled from the inside or lines of poetry. He mixes fonts, going with an updated family one issue then switching to an Adobe Photoshop or Adobe Illustrator special effect for the next one.

"On the inside pages I try to use color merely for emphasis. I like to make the type strong enough that even without the color it would still be attractive," Alden points out.

Staying creative means staying in touch with other designers, according to Alden. He belongs to the local American Institute of Graphic Arts (AIGA) group. "The meetings allow me to bounce ideas off of other designers. I know artists in other parts of the country, too, who I see at conferences, and we exchange ideas.

"Of course," he says, "everyday life— music, art, books, television, people, etc.— provides a lot of inspiration for me."

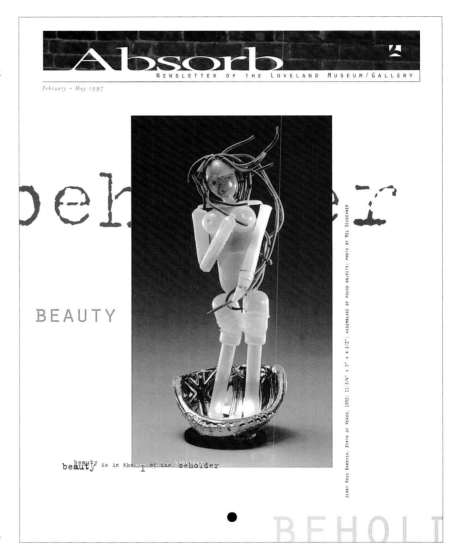

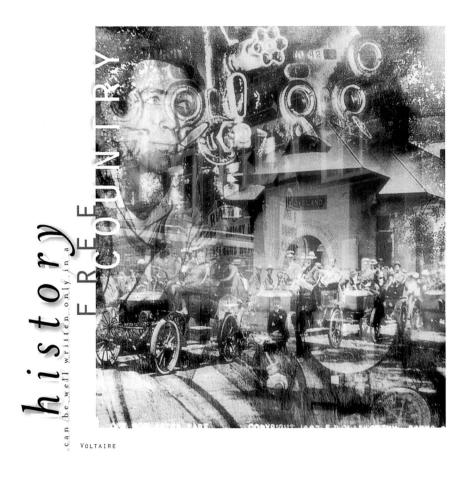

DESIGNER:
Stuart Rankin Alden

ORGANIZATION:
Lightsource Creative Services

SIZE:
34" x 11" (86.4cm x 27.9cm) folded in half twice to 8½" x 11" (21.6cm x 27.9cm)

QUANTITY:
Approximately 8,000

COST:
$2,122 (design, production and printing)

OBJECTIVE:
Promote, inform and create interest in the Loveland (Colorado) Museum and Gallery.

HOW WE SAVED:
Only two ink colors, a standardized layout that makes the design go more quickly, folding rather than saddle stitching.

October

Art Gallery

CONTEMPORARY AMERICAN CERAMICS

October 11 - January 4

Opening Reception: Saturday, October 11, 1:00 - 3:00 p.m.

SLIDE-ILLUSTRATED TALK BY ALDO MORONI, 3:00 - 4:00 P.M.

An exciting and diverse representation of ceramics today. The following artists from across the United States are included in this exhibition:

Stephen M. Braun · Wilson, OR
Cristina Cariaso · Portland, OR
Linda Cordner · Brooklyn, NY
Aurore Chabot · Tucson, AZ
Richard Cleaver · Baltimore, MD
Cameron Crawford · Chico, CA
Bruce Gueswel · Loveland, CO
Chris Gustin · South Dartmouth, MA
Susan Harris · Cedar City, UT
Margaret Harden · Boulder, CO
Elaine O. Henry · Emporia, KS
Lula Lynden · Fort Collins, CO
Marilyn Lysohir · Moscow, ID
Aldo Moroni · Minneapolis, MN
Tesa Peterson · Billings, MT
Joanna Queen · Boulder, CO
Nathaniel Samuels · Ann Arbor, MI
Marcia Selsor · Billings, MT
Gary Voss · Fort Collins, CO
Lana Wilson · Del Mar, CA

Foote Gallery/Auditorium

POSTERS BY CHAZ MAVEYANE-DAVIES

Through October 31

A satellite exhibition in conjunction with the Colorado International Invitational Poster Exhibition 1997, Colorado State University, Fort Collins.

Chaz Maviyane-Davies was born in Zimbabwe in 1952 and fled to neighboring Zambia in 1974. A year later he went to London to specialize in graphic design, receiving his BA from Middlesex Polytechnic, London, and an MA at the Central School of Art and Design, London. In 1991 he received an Advanced Diploma in Filmmaking at the

Central St. Martin's School of Art and Design, London. His prize-winning posters have been exhibited throughout the world. Maviyane-Davies has stated, "Designers can choose to be wise or passive in what they do regardless of their ideology—but if they choose to be wise and then they should be careful whom they influence; they really serve. My work is about politics, as it affects people in one way or another. I'd like to think it's for the good of mankind."

Window on Main Street

OBJECT PRESERVE

Ongoing

Featuring acquisitions and donations to the Museum's collection made during 1996 and 1997.

Green Room

TIBET

Through January 18

An exhibit that includes items from private collections, antique and contemporary farmer's helmets from around the world, and photographs, trophies and ribbons from the Loveland Fire Department collection.

Fifth Street (outside of Museum)

YESTERYEAR ENGINE AND TRACTOR DISPLAY

Saturday, October 18, 10 a.m. – 4 p.m.

Come to Fifth Street and see 1920's - 1950's tractors made by John Deere, Minneapolis Moline, Allis Chalmers, Gibson, McCormick Deering International, Case and others, plus hit-and-miss farm engines and more!

November

Foote Gallery/Auditorium

STUDENT ART INSPIRED BY INDEPENDENCE FROM ROBERT...

November 17 – December 28

As part of a new outdoor education program, Russian artists Sergei Daniel, Vladimir Obotin and Mira spent a week teaching art classes for the Loveland Academy of Fine Arts. These works selected works reflecting their instruction. In order K-12 taken as part paintings by high school pastels by middle school students and watercolors school students. The young artists have pieces on exhibit.

January

Art Gallery

JIMMY ERNST

January 15 – April 12

Works by the son of Max Ernst, one of the Dadaism and Surrealism. Jimmy Ernst (19... grew up in the thick of artistic ferment in pre-... Europe and later made his way to the United gifted artist in his own right.

Foote Gallery/Auditorium

R2-J SCHOOL DISTRICT STUDENT ART SHOW

January – March

A hanging museum exhibit by elementary... high school students.

ART GALLERY

Elizabeth Catlett: Works on Paper, 1944-1992
February 10 - March 21

This exhibit was organized by the Hampton University Museum, Hampton, Virginia. It is a retrospective celebration of the successful marriage of this gifted artist's mastery of printmaking and her socially conscious beliefs that, "Art should come from and be for the people. We have to create an art for liberation and for life."

Elizabeth Catlett (b. 1919) has been called "one of the most significant African American artists in history." She participated in the Harlem Renaissance and the Works Progress Administration. She received her formal training at Howard University, the Art Student's League in New York City, and the State University of Iowa. In 1947, partly due to the oppressive Joseph McCarthy era, Catlett moved to Mexico. She worked at the Taller Graphics Workshop, where her colleagues included Diego Rivera, David Siqueiros and Francisco Mora, who she married in 1947. Catlett became a Mexican citizen, and Professor of Art at the National University of Mexico, School of Art, a position she held until her retirement in 1976. In Mexico she experienced a working collective, committed to the social relevance of art, to the needs and concerns of ordinary people, and to the continuation of the long populist tradition of printmaking in Mexico. Her work is recognized for capturing the ideas and aesthetic mood of the black arts movement in the United States.

"The role that Catlett has charted for herself of being an artist, social and political activist, wife, mother and grandmother has sometimes proven difficult and has not been without pain. She has worked hard to 'keep the faith' and to ignite the flame of hope through her art, not only for those of us of African descent, but to all ordinary people who are in need of, and in search of the liberation of heart, mind and spirit."

Samella Lewis, Ph.D.
Professor Emeritus, Scripps College
Catlett's biographer

FOOTE GALLERY/AUDITORIUM

Loveland's Original Sweethearts: Ted and Mabel Thompson
Through February 18

In conjunction with the 50th anniversary of the Loveland Valentine Remailing Program in February 1996, the Museum will recognize the contributions of Loveland's original sweethearts, Ted and Mabel Thompson. The compilation of information, documents and awards that chronicle the lifetime activities in Loveland of the Thompsons came to the Museum after the death of Mabel Thompson in June of 1994. Ted died two years earlier. Because of Mabel's tireless and unceasing gathering of photographs and articles, the Museum has excellent material about a wide range of topics such as the Remailing Program; the County Fair, Rodeo, and the 4-H; the Centennial Commission; and the Bureau of Reclamation. Awards to the Thompsons from community, state, national organizations, and dignitaries, along with photographs will be on display.

February

SPECIAL EXHIBIT/ WINDOW ON MAIN STREET

Barbed Wire and Related Items
Ongoing

From the collections of Rocky Mountain Tool Collectors member John Gilmore and Billy Thornton, president of the Front Range Wire Collectors. This exhibit includes samples of barbed wire, stretchers and other tools, as well as liniment, lotion, balm, salve, ointment and crème especially made for barbed wire cuts or scratches "for both man and beast."

SPECIAL EVENTS

50th Anniversary Celebration of Loveland's Valentine Remailing
Saturday, February 3, Foote Gallery/Auditorium, 12-3 p.m.

The public is cordially invited to join in the celebration of the 50th anniversary of Loveland's unique Valentine Remailing Program. All past Miss Loveland Valentines have been invited to the event. They will bring personal memorabilia to display during the reception. Bring a sweetheart and see the Museum's revamped Sweetheart Town. Valentine exhibit and enjoy refreshments and music from the late 40's, 50's and 90's provided by Solid Sound.

Art Exchange Art Auction Exhibition
February 20 - March 1, Foote Gallery/Auditorium

Artwork from personal collections is being offered during a silent bid exhibition. A portion of the Art Exchange proceeds will be used to benefit an Art and Humanities Scholarship Fund at the Museum. The event concludes with a live auction on Friday, March 1, beginning at 7 p.m. Tickets for the live auction are $10. Donors of work accepted for the auction receive free admission.

Art Workshop for Kids: Cardboard Creatures
Saturday, February 21, Classroom, 12-3 p.m.

Learn to design and assemble a 3-D animal using cardboard. The creatures will be decorated with paint, markers, ribbon and glitter.
For grades 3-6.
Fee: $12
Instructor: Heather Frank
Advance registration required by February 17.

March

ART GALLERY AND FOOTE GALLERY/AUDITORIUM

Colorado Governor's Invitational Art Show and Sale
March 31 - April 28

Saturday, March 30
Preview Party 5:00-6:30 p.m.
Opening Reception 6:30-10:00 p.m. ($35.00 per person)

Regional sculptors and painters. Sponsored by Rotary Clubs of Loveland. Raffle proceeds and all commissions on art sales go to Rotary Clubs of Loveland. For information please call Jan Pierce, Chair, 970-663-0919.

SPECIAL EVENTS

Poetry Reading: David Zeks
Thursday, March 7, Foote Gallery/Auditorium, 7 p.m.

David Zeks was born in Norfolk, Virginia, in 1967. He attended 1986-1990, where he received his B.A. in Communications Commonwealth University from 1992-1995, where he studied Arts and fiction under Paula Marshall. In 1994, he received School of Humanities and Sciences. David Zeks has published journals such as The Dominion, The Richmond Arts, Mill Mountain Review.

Once I walked across Norfolk,
not because I wanted to,
or because I wanted to see what my grandfather
but because my car had broken down,
right in front of a bar
where a tired dancer
was coming on for the afternoon shift.
Her hair was turning dark at the roots,
and there was only one sailor in the place,
sipping draft beer with his head down.
A black Santa Claus stood on Wards Corner,
clanging a red bell at the passing traffic.
When I walked through the black neighborhoods,
dogs began to bark,
and two old men with smoke-colored hair
stopped stringing colored lights in the branches
of a tiny dogwood.
Almost every chimney streaming with smoke
which curried off in the direction of the Bay.

Poetry Reading Performance
Windows: An Essence of Poetry and Theatre
Aldrich
Friday, March 8, Foote Gallery/Auditorium, 7 p.m.

Local poets have been invited by Linda Aldrich to write window of windows as their inspiration. Their readings responsive theatre by students from area high schools w... Linda's drama workshops which have also dealt with the w... a spontaneous, loosely structured presentation combining a multi-dimensional, cross-generational and totally wor... Aldrich. Poets include Veronica Patterson, Evan Oakl... Hammond, Charlotte Miller, Melissa Katsimpalis, Bruce M... Jack Martin, Deb Schnierer, Stephanie Anderson, Maggie... and Shawna Jackson.

Poetry Reading Performance
Lola Haskins
Tuesday, March 12, Foote Gallery/Auditorium, 7...

Florida writer Lola Haskins has been published and has audiences worldwide both in person and on radio. She m... actually performs them rather than giving a straight readin... published in numerous anthologies and periodicals Hask... books. Extranjera, 1996; Visions of Florida, 1994; Hou... Ambitions for the Piano, 1990; Across Her Broad Lap Som... Castings, 1984; and Planting the Children, 1982.

October

Foote Gallery/Auditorium
[text illegible]

Thursday, October 2, 7:00 p.m.

[body text illegible]

Foote Gallery/Auditorium
[text illegible]

Thursday, October 30, 7:00 p.m.

[body text illegible]

Veronica Patterson *[text illegible]*

Three Photographs Not of My Father

[poem text largely illegible]

VERONICA PATTERSON

[right column body text illegible]

I WISH I HAD STARTED SOONER— BEGINNING GENEALOGY WORKSHOP

Saturday, October 25, 1:00 – 3:30 p.m.

An introduction to methods and resources that can be used in genealogical research.

Instructor: Grace Goss
Ages: 12 and over
Fee: $10.00
Registration and payment required by October 18; no refunds after registration deadline.

Play Pianissimo

[poem text illegible]

Lola Haskins
from *Forty-Four Ambitions for the Piano*

blond ponytails

[poem text illegible]

SPECIAL EVENTS

Poetry Reading: Patricia Dubrava
Thursday, March 21, Foote Gallery/Auditorium, 7 p.m.

[text illegible]

Workshop for Kids: Walking Sticks
Sunday, March 30, Classroom, 12-3 p.m.

[text illegible]
Fee: $12
Instructor: Heather Frank
Advance registration required by March 23.

April

SPECIAL EVENTS

Poetry Reading: Deb Schmoerer
Thursday, April 11, Foote Gallery/Auditorium, 7 p.m.

[text illegible]

Poetry Reading: A Gathering of Voices
Thursday, April 25, Foote Gallery/Auditorium, 7 p.m.

[text illegible]

Norma Hammond
[text illegible]

Star St. Clair
[text illegible]

Bruce Miller
[text illegible]

Autumn Gwost
[text illegible]

[text illegible]

Charlotte Miller
[text illegible]

Art Workshops for Kids: May Day Baskets
Saturday, April 27, Classroom, 12-3 p.m.

[text illegible]
Fee: $12
Instructor: Heather Frank
Advance registration required by April 20.

ART GALLERY
Troy Dalton
May 4 - July 7

[text illegible]

FOOTE GALLERY/AUDITORIUM
Drawings and Paintings by Eugene A. Schilling
May 4 - July 7

[text illegible]

Eugene Schilling, *Into The Dark*, charcoal, 38cm x 50cm

SPECIAL EVENTS
Puppet Show: "My Magic Garden"
Saturday, May 11, Foote Gallery/Auditorium, 11 a.m. and 2 p.m., free admission.

[text illegible]

Puppet Masters will present My Magic Garden, Saturday, May 11, at 11 a.m. and 2 p.m., in the Foote Gallery/Auditorium.

[text illegible]

Art Workshop for Kids: Jointed Puppets
Saturday, May 25, Classroom, 12-3 p.m.

[text illegible]
Fee: $12
Instructor: Heather Frank
Advance registration required by May 18.

colorfully conservative

PACLEASE TRUCK RENTAL AND LEASING COMPANY TRANSPORTATION NEWSLETTER

DESIGNER:
Juli Saeger

CREATIVE DIRECTOR:
Leslie Phinney

ORGANIZATION:
Phinney/Bischoff Design House

SIZE:
8½" × 11" (21.6cm × 27.9cm)

QUANTITY:
10,000

COST:
$2,000 (printing)

OBJECTIVE:
A series of informative external newsletters for fleet operators, leasing managers and potential clients of PacLease Truck Rental and Leasing Company.

HOW WE SAVED:
Two colors only, consistent format.

CREATIVE COMMENTS:

A conservative client. A copy-intense quarterly newsletter. Eight pages of long articles. No photos. (One corporate mug shot per issue doesn't count.) No charts. No art. No way?

On the contrary, Juli Saeger found inspiration in the challenge. "When a second color is all you've got, it's important to stretch it as much as possible," she says.

Her design mission began with the newsletter's nameplate and subtitle: Transportation, Trends and Outlooks. "The simple graduated screen suggests a horizon," explains Saeger. "The type is meant to convey the idea of a road and a truck." (Note the tire-

like Os in "TRANSPORTATION.") The vertical placement of the nameplate on the front is copied on the back for a standing column heading, "Clear Thinking About Fleet Issues."

The outside pages of the newsletter are extremely consistent from issue to issue. The only big change is the second ink color. "With the amount of time I had to design each issue, I knew I didn't want to reinvent the wheel every time."

The client wanted a standard look, especially on the outside pages. "As I got to know the client, I got a little bolder. But only on the inside pages," Saeger says.

Using the power of color, Saeger brings text-only stories alive. She doesn't even have to

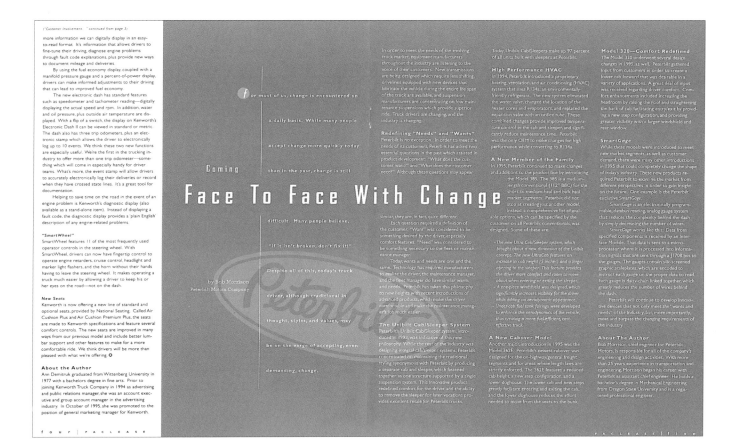

("Customer Involvement," continued from page 3)

more information we can digitally display in an easy-to-read format. It's information that allows drivers to fine-tune their driving, diagnose engine problems through fault code explanations, plus provide new ways to document mileage and deliveries.

By using the fuel economy display, coupled with a manifold pressure gauge and a percent-of-power display, drivers can make informed adjustments to their driving that can lead to improved fuel economy.

The new electronic dash has standard features such as speedometer and tachometer reading—digitally displaying the actual speed and rpm. In addition, water and oil pressure, plus outside air temperature are displayed. With a flip of a switch, the display on Kenworth's Electronic Dash II can be viewed in standard or metric. The dash also has three trip odometers, plus an electronic stamp which allows the driver to electronically log up to 10 events. We think these two new functions are especially useful. We're the first in the trucking industry to offer more than one trip odometer—something which will come in especially handy for driver teams. What's more, the event stamp will allow drivers to accurately electronically log their deliveries or record when they have crossed state lines. It's a great tool for documentation.

Helping to save time on the road in the event of an engine problem is Kenworth's diagnostic display (also available as a stand-alone item). Instead of displaying a fault code, the diagnostic display provides a 'plain English' description of any engine-related problems.

"SmartWheel"
SmartWheel features 11 of the most frequently used operator controls in the steering wheel. With SmartWheel, drivers can now have fingertip control to operate engine retarders, cruise control, headlight and marker light flashers, and the horn without their hands having to leave the steering wheel. It makes operating a truck much easier by allowing a driver to keep his or her eyes on the road—not on the dash.

New Seats
Kenworth is now offering a new line of standard and optional seats, provided by National Seating. Called Air Cushion Plus and Air Cushion Premium Plus, the seats are made to Kenworth specifications and feature several comfort controls. The new seats are improved in many ways from our previous model and include better lumbar support and other features to make for a more comfortable ride. We think drivers will be more than pleased with what we're offering. ◇

About the Author
Ann Demitruk graduated from Wittenberg University in 1977 with a bachelors degree in fine arts. Prior to joining Kenworth Truck Company in 1994 as advertising and public relations manager, she was an account executive and group account manager in the advertising industry. In October of 1995, she was promoted to the position of general marketing manager for Kenworth.

For most of us, change is encountered on a daily basis. While many people accept change more quickly today than in the past, change is still

Coming

Face To Face With Change

difficult. Many people believe,

"If it isn't broken, don't fix it!"

Despite all of this, today's truck

driver, although traditional in

thought, styles, and values, may

be on the verge of accepting, even

demanding, change.

by Bob Morrison
Peterbilt Motors Company

In order to meet the needs of the evolving truck market, equipment manufacturers throughout the industry are listening to the voice of their customers. New transmissions are being designed which require less shifting, drivelines equipped with new devices that lubricate the vehicle during the entire life span of the truck are available, and suspension manufacturers are concentrating on low maintenance suspensions which provide superior ride. Truck drivers are changing, and the industry is changing.

Redefining "Needs" and "Wants"
Peterbilt is no exception. In order to meet the needs of its customers, Peterbilt has asked two essential questions in the past which assisted in product development: "What does the customer want?" and "What does the customer need?" Although these questions may appear similar, they are, in fact, quite different.

Each question required a definition of the customer. "Want" was considered to be something desired by the driver, especially comfort features. "Need" was considered to be something necessary to the fleet or maintenance manager.

Today, wants and needs are one and the same. Technology has required manufacturers to realize the driver, the maintenance manager, and the fleet manager do have similar wants and needs. Peterbilt has taken this philosophy to new heights with recent introductions of advanced products, which make the driver comfortable and make the maintenance manager's job much easier.

The Unibilt Cab/Sleeper System
Peterbilt's Unibilt Cab/Sleeper system, introduced in 1993, was indicative of this new philosophy. While the rest of the industry was designing integral cab/sleeper systems, Peterbilt concentrated on maintaining the traditional styling synonymous with Peterbilt by producing a separate cab and sleeper, which fastened together as one structure supported by a four-point suspension system. This innovative product redefined comfort for the driver, and the ability to remove the sleeper for later vocations provides excellent resale for Peterbilt trucks.

Today, Unibilt Cab/Sleepers make up 97 percent of all units built with sleepers at Peterbilt.

High Performance HVAC
In 1994, Peterbilt introduced a proprietary heating, ventilation and air conditioning (HVAC) system that uses R134a, an environmentally-friendly refrigerant. The new system eliminated the water valve, changed the location of the heater cores and evaporators, and replaced the expansion valve with an orifice tube. These combined changes provide improved temperature control in the cab and sleeper and significantly reduce maintenance time. Peterbilt was the only OEM to make changes for high performance while converting to R134a.

A New Member of the Family
In 1995, Peterbilt continued to make changes and additions to the product line by introducing the Model 385. The 385 is a medium-length conventional (112" BBC) for the short- to medium-haul and bulk haul market segments. Peterbilt did not stop at creating just another model. Instead, a comprehensive list of available options, which can be specified by the customer on all Peterbilt conventionals, was designed. Some of these are:

• The new Ultra Cab/Sleeper system, which brought about a new dimension of the Unibilt concept. The new UltraCab features an increase in cab height (5 inches) and a larger opening to the sleeper. This feature provides the driver more comfort and room to move about when entering or exiting the sleeper.
• A one-piece windshield was designed, which significantly increases visibility for the driver while adding on an aerodynamic appearance.
• Under-cab fuel tank fairings were developed to enhance the aerodynamics of the vehicle, thus creating a more fuel-efficient, cost-effective truck.

A New Cabover Model
Another major introduction in 1995 was the Model 362E. Peterbilt's newest cabover was designed for the on-highway/general freight segments and for areas where length laws are strictly enforced. The 362E features a reduced cab height, a new step configuration, and a lower doghouse. The lower cab and new steps greatly facilitate entering and exiting the cab, and the lower doghouse reduces the effort needed to move from the seats to the bunk.

Model 320—Comfort Redefined
The Model 320 underwent several design changes in 1995, as well. Peterbilt gathered input from customers in order to create a lower cab forward that was desirable in a variety of applications. A great deal of input was received regarding driver comfort. Comfort enhancements included increasing the headroom by raising the roof and straightening the back of cab, facilitating entry/exit by providing a new step configuration, and providing greater visibility with a larger windshield and rear window.

SmartGage
While these models were introduced to meet new market segments, as well as customer demand, there were many other introductions in 1995 that could completely change the shape of today's industry. These new products required Peterbilt to examine the market from different perspectives in order to gain insight on the future. One example is the Peterbilt exclusive SmartGage.

SmartGage is an electronically programmable, databus reading, analog gauge system that reduces the complexity behind the dash by simply decreasing the number of wires.

SmartGage works like this: Data from specified components is received by an Interface Module. That data is sent to a microprocessor where it is processed into information signals that are sent through a J1708 bus to the gauges. The gauges contain silk-screened graphic scaleplates, which are encoded to instruct each gauge on the proper data to read. Each gauge is daisy-chain linked together, which greatly reduces the number of wires behind the dash.

Peterbilt will continue to develop innovative devices that not only meet the "wants and needs" of the industry, but, more importantly, meet and surpass the changing requirements of the industry.

About the Author
Bob Morrison, chief engineer for Peterbilt Motors, is responsible for all of the company's engineering and design activities. With more than 25 years experience in transportation and engineering, Morrison began his career with Peterbilt as assistant chief engineer. He holds a bachelor's degree in Mechanical Engineering from Oregon State University and is a registered professional engineer.

tamper with her three-column grid. "I read the articles to glean something for a concept. I try to convey the meaning of the content visually," she explains.

Most of the time, however, Saeger's visual interpretation is subliminal. It doesn't include any added illustration or changing fonts. She applies simple techniques like reversing the headline out of a band of color, added letter spacing, sidebars reversed out of black, full pages of text reversed out of the second color, pull quotes set off with color or reversed, mixing blocks of solid black with blocks of solid color, etc.

When Saeger does use clip art, it's usually subtle and minimal. She'll screen art in back of the text or nestle it in a corner, blending it into the background. Saeger proves that a conservative look is not synonymous with boring and that it is possible to maintain a consistent layout without falling into a rut.

"Constantly looking around" is how Saeger keeps her well of ideas fresh. "I pay attention to everything—TV, books, magazines, everything.

"Especially with some of the tight deadlines I work on," she explains, "I don't have the luxury of shopping for an idea. I've got to have them here, right now."

faux home page clicks with client's objective

THE CHAMBER ANNUAL REPORT

CREATIVE DIRECTOR:
Sonia Greteman

ART DIRECTOR:
James Strange

DESIGNER:
Craig Tompson

ORGANIZATION:
Greteman Group

SIZE:
8" × 8" (20.3cm × 20.3cm) (folded)

QUANTITY:
5,000

COST:
$1,500 (printing)

OBJECTIVE:
The Wichita Area Chamber of Commerce wanted their annual report to look and feel like an interactive Web site.

HOW WE SAVED:
Two colors only; inexpensive paper (Astrobrite); self-mailer.

CREATIVE COMMENTS:

Regardless of whether you're computer savvy, the dramatic black cover of this square brochure with its simple "Click here" command button lures you inside. If you "lift here" (because it's a die-cut flap) you'll find copy that says "The Chamber Home Page."

Complete with menus, cursor arrows, icons and even a Macintosh-like trash can on the back page, this paper home page is low-bandwidth reading. Greteman says, "At the time, the Chamber had just gotten their Web site, and they thought it'd be fun to have their annual report modeled after a home page."

By covering full panels with black and olive green, the bright, warm yellow paper color is minimized but accentuated. The designer uses the paper color well, weaving it into the design by reversing icons and text.

The pages are "linked" to each other with lines and broken rules that run from one to another. The interactivity really takes off on the middle inside panel where you're presented with four custom-drawn icons representing "What's New," "What's Done," "What's Hot" and the infamous "Help" button. "We created illustrations geared to the verbiage," explains Greteman.

The various color blocks, reversed images and screened artwork bring a three-dimensional quality to this page. Of course, when you "click" or lift each block you're presented with a foldout panel of information. "We kept the information under each panel simple and clean—easy to read," Greteman says.

"The printer didn't have to make custom dies for these panels," adds Greteman. "There were no curves to worry about, so he could use his own straight-line dies, which saved us some money."

Tight budgets require more creativity according to Greteman. "You have to do more with less. You have to have the desire to solve the problem."

DIY—
do it

at a glance:

Use leftover paper or wastepaper

Be your own printer

Utilize rubber stamps

Do your own die cutting

Fold it yourself

Stick it!

Find your own visuals

What do self-promotions, pro bono work, friends, relatives and start-up businesses have in common? They all need inexpensive design—*really* inexpensive design. And they all need "a lotta look" for less money for good reason. After all, you never know when that money-strapped relative will finally hit the big time, due in part to your brilliant promotions. You'll definitely be in line for your much deserved compensation. Or maybe you just like the feeling of donating your design expertise to a good cause.

Sometimes doing things yourself is the most creative option. Of course, you might argue that time is money and every minute you're doing something like rubber-stamping two hundred envelopes or gluing cards onto a brochure you're not billing hours. Other designers find they can do "mindless" things while they brainstorm for another project. Or they enlist the help of their employees, families and friends, as well as the client.

The best do-it-yourself designs are forgiving—small imperfections and roughness add to their charm. There's also the high value of personal touch to consider. In a culture geared to high-tech promotion, sometimes the magic is in the obvious hands-on approach. Take, for example, the hand addressed envelope technique favored by direct marketers. Even though the handwriting is usually done mechanically, it still adds a human touch, which tends to stand out.

INSIDER ADVICE
Use leftover paper or wastepaper

Do you have small quantities of paper left from other jobs or from spec pieces? Can the publication be printed on mismatched sheets? Can you scrounge up enough paper to cover a small job? How about asking a printer to throw cutoff scraps in a pile for you?

nine

N I N E

yourself

Be your own printer

Small quantity? Ten to one hundred? Print copies from your own printer or photocopier. If it's low resolution, make the jaggedness part of the design.

Utilize rubber stamps

Funky, grungy and cheap! Stamp a logo or pattern on a cover or envelope. It adds a personal and artsy feel.

Do your own die cutting

Break out the scissors and craft knife. Make imperfections a part of the design.

Fold it yourself

Want a unique fold that the printer would have to charge extra for? Want to just save a little more money on a basic fold? Turn your project into a bonding activity for family and friends or into busywork for TV time.

Stick it!

Have you moved? Don't reprint business cards and promotional material; use stickers! Use your own printer to make new address labels and then stick them in place over the old copy. Use labels with an odd shape or color to keep them from looking tacky and cheap. Do you need a fast and fun visual for a few brochure covers? Stickers are an inexpensive and easy option. Endless images, from holograms to cartoons to purely functional, are available. How about enhancing envelopes with stickers or seals? Stickers add weight and attention to almost any piece.

Find your own visuals

Look around. Can you use paper bags? Wrapping paper? Notebook paper? String? Yarn? Twine? Rubber bands? Stickers? Junk mail? Self-stick notes? What's within reach right now that you can incorporate into your next project?

whimsy means work

MOONLIGHTING DESIGN SELF-PROMOTION BROCHURE

DESIGNERS:
Dawn Eggleston and Karen Hunter

ORGANIZATION:
Moonlighting Design

SIZE:
17" × 5" (44.5cm × 12.7cm), folded to three 6" × 5" (15.2cm × 12.7cm) panels

QUANTITY:
600

COST:
$768

OBJECTIVE:
A promotional brochure that
1. was not the usual 8½" × 11" (21.6cm × 27.9cm) trifold;
2. best described who we are, how we work and what we do;
3. got and kept attention.

HOW WE SAVED:
We hand cut the moon flap (a do-it-yourself die cut), affixed our business card inside with double-sided tape and folded the piece.

CREATIVE COMMENTS:

From the inside of the brochure:

moonlighting design (moon'light-ing di-z n') n. 1. Creates high-quality designs that leave you moonstruck. 2. Works by the light of the silvery moon to exceed your deadlines. 3. Works like a moon doggie to make sure your projects cost less than moonshine.

Strong visual copy springboards naturally to a strong unforgettable concept. Copywriter Susan Hewitt made the most of the company name, Moonlighting Design, playing heavily on "moon" phrases from "moon doggies" to "Moon Over Miami." The concept is blended throughout the piece in copy and design.

Eggleston and Hunter started their design partnership as a sideline to their daytime jobs with a commercial bank. Hence, Moonlighting Design. When their division was closed down, their part-time passion became a full-time business.

"We wanted a promotional brochure that was not the usual 8½" × 11" (21.6cm × 27.9cm) trifold. We wanted our work to break out of the mold." Their lighthearted and fun concept required silver opaque ink on a midnight blue stock. The custom die cut of the moon silhouette that forms the front flap would have been the budget breaker for the team had they not found a creative compromise.

The printer delivered the brochures flat and Eggleston and Hunter used X-Acto knives to hand cut the moon flap. No two are exactly alike, but who will notice? The response to the brochure? "Great!" says Hunter.

Where do Eggleston and Hunter get their best creative ideas? During lunch or dinner, late at night—really any time.

stamping out that "churchy" look

FOX VALLEY CHURCH INVITATION

DESIGNER:
Tom Hubley

SIZE:
Six cards, each 3 ½" × 4 ¼" (8.9cm × 10.8cm), wrapped and tied with twine

QUANTITY:
300

COST:
$210

OBJECTIVE:
Create a friendly, modern invitation to a six-part series of sermons by a local pastor. The piece had to carry a good amount of information about individual sermons and dates.

HOW I SAVED:
"I created the rubber stamp [for the wrapper] and stamped each cover. I also tied the twine."

CREATIVE COMMENTS:

"I didn't want it to look like it came from a church," says Hubley. "Most pieces done for churches are dated, predictable and boring."

Hubley pushed away from his personal impressions to create an invitation that was everything his prejudices weren't—contemporary, unique, warm, tactile. The brochure is opposite everything he finds negative about publications from churches.

Each of the six cards is printed in black ink, six up on an 8½" × 11" (21.6cm × 27.9cm) tan, flecked card stock.

The front of each card uses a unique Adobe Photoshop illustration of embossed pieces of paper produced by Hubley to represent the theme of the series, "Love." Cover copy is minimal: the date of the sermon. The topic of each sermon, pertinent scripture, time and location are printed on the back.

Hubley used strips of brown packaging paper to hold the sets together. "To make the outside cover attractive and eye catching, I

created the swirl rubber stamp from material at the art supply store," he explained. "I simply chose the swirl because it seems trendy right now." Even though the outside wrapper is glued shut, Hubley added the twine. "The natural papers and twine give it a friendly, earthy feel," says Hubley.

Where does Hubley get his creative ideas? "I research design, design history. But I don't just get ideas from design books. I look at everything—magazines, library pieces, television, newspapers, anything really."

the $0 budget project

LEAF CAFE LETTERHEAD AND SECOND SHEETS

DESIGNER:
Matt Pulcinella

SIZE:
8½" x 11" (21.6cm x 27.9cm)

QUANTITY:
unknown

COST:
$0

OBJECTIVE:
Develop letterhead for a friend's coffee shop on a budget of $0.

HOW I SAVED:
Each sheet was printed on my laser printer using some old recycled natural paper stock I had lying around.

CREATIVE COMMENTS:

No cash? No problem! (Maybe there's a cup of coffee in it for Pulcinella in return for his donated design time.)

Since a coffee shop isn't a stationery-intensive environment, laser printing a minimal number of cover sheets and second sheets seems the perfect option (especially when Pulcinella decided to use up paper stock he had left from another project).

As for the design itself, Pulcinella said he needed a design that wouldn't suffer from low-resolution laser printing.

"The relaxed design reflects the café's beatnik atmosphere," explains Pulcinella. "The wavy lines in the background represent both steam and smoke, because this cafe features a cigar room." The coffee cup and wavy lines were scanned from old magazines.

The layering of the wavy lines (above the cup, in back of the cup and as a background for the entire sheet) gives the stationery a three-dimensional look. The jaggy edges of the black reverses (under the cup and at the bottom of the page) were done to mimic the jagginess of leaf edges, according to Pulcinella.

"I get my design ideas from the client without them really knowing about it," says Pulcinella. "I listen to not only what they say about their design ideas, but everything they say. For example, this design began with my friend wanting a coffee cup. Then she just happened to mention a restaurant with the type of atmosphere she was going after. That gave me more visual ideas to add to the coffee cup," he explains. "Listen to everything."

The Leaf Café

133 Chester Pike • Ridley Park PA 19078 • 610.362.0470

wine packed with wow!

ART DIRECTION CHRISTMAS GIFT/PROMOTION PACKAGE

CREATIVE COMMENTS:

Martha Stewart, grande dame of homemade-gift giving, would be proud of Art Direction's personal ingenuity and creativity.

Williamson, creative director for Art Direction, believes budget shouldn't influence creativity one way or another, "To quote one greater than me, 'The idea is everything.'" [Victor Hugo] The team at Art Direction took an idea and then set about making it as cost effective as possible.

But their idea didn't come without some logistical problems. "The concept of a triangular box caused a few problems until we worked out a die cut that folded in on itself," Williamson explains. "We needed to reinforce the sides and base to support the weight of the bottle.

"We sourced various board suppliers for the best stock and best price too," she explained. "The corrugated board was chosen specifically to represent the lines that run through the logo."

The triangular shape, borrowed from Art Direction's logo, is a recurring image throughout the entire package. The "Merry Christmas" bottle labels, printed in black, gold and spot varnishes, incorporate the Art Direction triangular logo, as does the interlocking "star buckle" on the box.

The triangles in the logo are symbolic, representing an advertising firm that's moving up and forward. They also represent stylistic *A* and *D* for Art Direction.

Visual stimuli keep Williamson creative. "I find it extremely useful to experience as much visual stimuli as possible—watching movies and music videos, reading magazines, browsing through shops. Listening to CDs while I work helps too. I am generally aware of the different cultures and environments around me."

PACKAGE DESIGNER:
Emma Keddie

DIRECTOR:
Trevor Beaumont

FINISHED ARTIST:
Fiona Cooper

ORGANIZATION:
Art Direction

SIZE:
360mm (height); 125mm (width); 125mm (depth)

QUANTITY:
36 sets

COST:
$A1,084 (does not include wine)

OBJECTIVE:
A sophisticated, personalized and dazzling holiday gift and self-promotion for clients that was inexpensive, but didn't look that way.

HOW WE SAVED:
Each card and box was handmade by our staff.

fast, flexible and functional self-promotion

WEB DESIGN SERVICES PROMOTION FOR P.PUBLISHING

CREATIVE COMMENTS:

Few things change faster than Web pages on the Internet. It just makes sense that a Web page design company would need a promotional piece that could be changed just as fast. Marketing the company's Web page design skills in print form led Prochnow to a format that's easy to modify and functional for their potential clients as well.

"We wanted something glossy without spending a lot of money," Prochnow explains. "After all," she continues, "one key attribute that is paramount to survival in the cutthroat business of Web site design is low-cost production. This frugal ethic is even more important in the venue of self-promotion."

Their solution consists of three parts:
1. a kraft paper sheet printed in black on their office laser printer;
2. a coated letter-size sheet printed in full color on the Epson printer; and
3. a top-loading poly page binder insert (not shown).

The kraft paper is a refreshing break from office white. It's also the perfect background for the grunge type and "Wired" layout they've gone for on the page.

The color sheet is jammed with screen shots, forms, tables, client names—things that suggest the scope of what the company can do.

The plastic sleeve is very practical. Not only does it keep the presentation tidy, it strongly suggests to the client, "I should keep this."

They produce the piece on an "as needed" basis. "We vary our inserts depending on the client," Prochnow explains. "My partner and I get our ideas by talking and a lot of brainstorming."

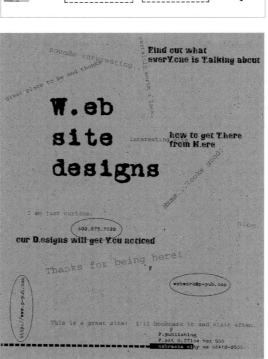

DESIGNER:
Kathy Prochnow

ORGANIZATION:
P.publishing

SIZE:
8½" × 11" (21.6cm × 27.9cm)

QUANTITY:
Varies

COST:
$.10/set

OBJECTIVE:
A low-cost promotional piece that could be easily tailored to a specific type of client.

HOW WE SAVED:
Everything is printed in-house.

picture this!

BUSINESS CARD FOR JOY MALINOWSKI, FILMMAKER

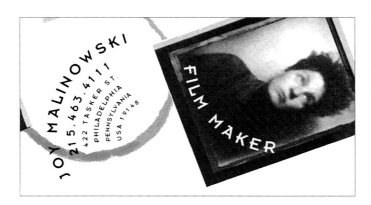

DESIGNER:
Lisa Sheirer

ORGANIZATION:
Sheirer Graphic Design

SIZE:
2" × 3½" (5.1cm × 8.9cm)

QUANTITY:
5,000

COST:
Approximately $250

OBJECTIVE:
Malinowski was headed to London for a filmmakers conference and needed impressive cards to hand out, and she needed them fast!

HOW WE SAVED:
Sheirer used a black-and-white picture of Joy Malinowski from one of those instant photo booth strips and scanned a coffee stain to use as background art. Sheirer even burned the plates and did the printing and trimming herself!

CREATIVE COMMENTS:

Strapped for cash and in a hurry is not the type of stuff ideal clients are made of—unless they're your best friends. Sheirer drew on her friend's imaginative and funky personality to create a fun, highly personalized business card for the filmmaker. Sheirer incorporated her favorite photo of Joy, a slightly fuzzy, off-center image from a photo booth strip, and a circular stain used to reflect two of her friend's favorite beverages—wine and coffee. The stain is the only color on the card.

The type is curved. Why? "I just decided to repeat the circular pattern of the stain," Sheirer admits.

Sheirer went as far as printing the cards herself. "I have a friend who owns a print shop. He showed me what to do. I even burned the plates and trimmed the cards. In fact, I literally trimmed the cards and raced directly to the airport with them so Joy and I could catch the plane to London for the film conference."

What you don't see when you see just one of the cards is that each one is different. Sheirer laid the cards out on a big sheet in a random pattern. "I don't even remember how many cards were on a sheet," admits Sheirer. Sometimes a cutoff corner of the photo shows up on another card—oh well, it all adds to the charm and creativity of the filmmaker and designer.

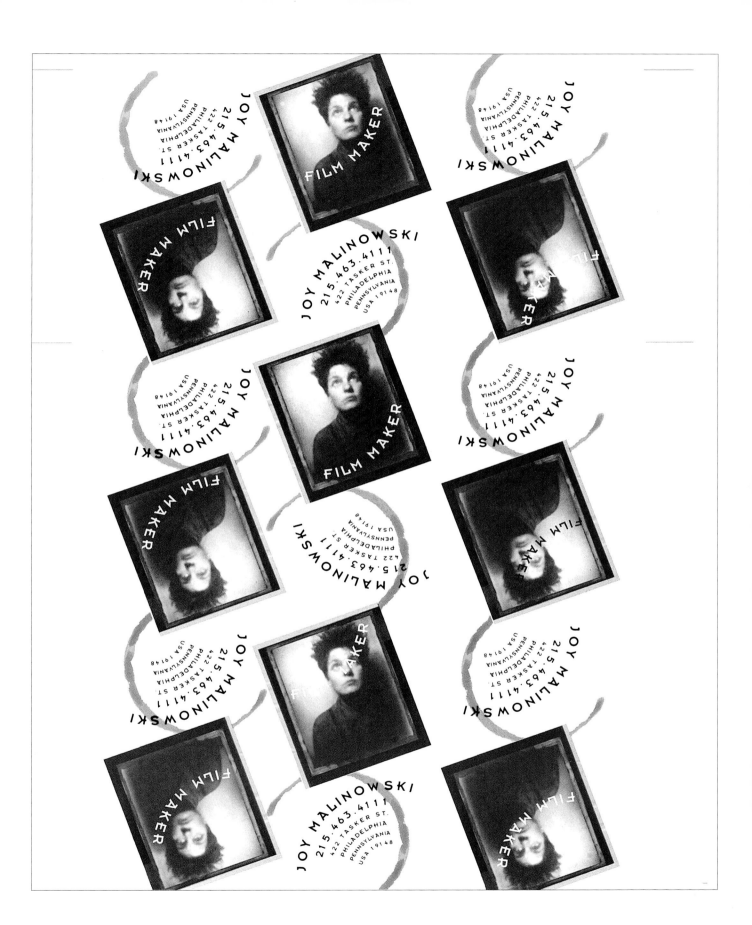

INDEX OF CLIENTS

Air Medical Physician Association, 118-119

Art Direction, 136

Auraria, 98-99

Better & Better, 68-69

Carson City Parks & Recreation, 108-109

Central Valley Bank, 120-121

Citizens First National Bank, 80-81

Cleveland Clinic Foundation, 52-53

Cornish College of the Arts, 28-29

Cutler-Hammer, 16-17

Delaware Theatre Company, 42-43

Eye Priority, 105

Fox Valley Church, 133

Frostburg State University, 78, 79, 96-97

Harris Corporation, 60-61

Idler, The, 54-55

Joy Malinowski, Filmmaker, 138

La Fura dels Baus, 30-31

Leaf Cafe, 134

Los Angeles Times, 110-111

Louisiana Philharmonic Orchestra, 32-33

Loveland Museum and Gallery, 122-123

MCNB Banking Center, 106-107

Metropolitan Water District of Southern California, 76

Mississippi Public Health Association, 62-63

Moonlighting Design, 132

Naropa Institute Continuing Education, 84-86

Natural Product Research Consultants, 20-21

Nevada Milepost, 44-45

North Dakota Association of Counties, 64-65

P.publishing, 137

Paclease Truck Rental and Leasing Company, 126-127

South Suburban College Foundation, 94-95

Sporting Gourmet, 66-67

St. Louis Effort for AIDS, 22-23

Sutton Place Gourmet, 70-71

Tech-Rentals, 18-19

Tektronix, 36-37

Tulane University Medical Center, 46-47, 48-49

UMD Environmental Studies Program, 91

UMD Fine Art Department, 92-93

United Way, 100

University of Utah Continuing Education Creativity in Advertising, 35

University of Utah Continuing Education Theatre School for Youth, 34, 82-83

Western Bank, 112-113

Wexner Center for the Arts, 50-51

Wichita Area Chamber of Commerce, 128-129

Williams, Kastner & Gibbs, 14-15

INDEX OF DESIGN FIRMS

Art Direction, 136

Auraria Reprographics, 98-99

Broom & Broom, 36-37

brown, brandt, mitchell & murphy, 44-45, 108-109

Cassady Enterprises, 105

Chili Graphics, 100

Copperleaf Visual Communications, Inc., 66-67

DCE Design, 34, 35, 82-83

Feldman Design, 52-53

Greteman Group, 128-129

Harris Design d/b/a Orbit Integrated, 42-43

Hubley, Tom, 133

Intelligent Design Enforcement Agency, 16-17, 68-69

Jill Tanenbaum Graphic Design & Advertising, Inc., 70-71

Kiku Obata & Company, 22-23

Lightsource Creative Services, 122-123

Los Angeles Times, 110-111

Magrit Baurecht Design, 14-15, 20-21, 28-29

Metropolitan Water District of Southern California, 76

Mills Financial Marketing, 80-81, 106-107, 112-113, 120-121

Mississippi State Department of Health, 62-63

Moonlighting Design, 132

North Dakota Association of Counties, 64-65

P.publishing, 137

Phinney/Bischoff Design House, 126-127

Pulcinella, Matt, 134

Sheirer Graphic Design, 78, 79, 96-97, 138

South Suburban College, 94-95

Studio E, 118-119

Swanson Graphic Design, 92-93

Tech-Rentals, 18-19

Tom Varisco Designs, 32-33, 46-47, 48-49

Toni Schowalter Design, 60-61

Typeware, 30-31

UMD Graphic Design Service, 91

Vermilion Design, 84-86

Wexner Center for the Arts, 50-51

Zone Publishing, 54-55

INDEX OF TERMS

A

Accent colors, 13
Alternative-use paper, 103
Archives
 clip art, 59
 photographs, 74

B

Backgrounds, 41
 faux, 116
Bartering, production, 104
Big clip art, 58
Bit-mapped clip art, 59
Black, using, 117

C

Cameras, 75
Captions, photographs, 75
Childlike concept, 9
Clip art, 56-71
 archives, 59
 big, 58
 bit-mapped, 59
 customizing, 58, 68
 dominant, 58
 internet, finding on, 59
 mixing with photographs and
 illustrations, 75
 montages, 59
 old collections, 59
 originality, 58
 picture fonts, 59
 screening, 59
 small, 58
 text-heavy material, using in, 58
 wrapping text, 58
Collections
 clip art, 59
 photographs, 74
Color printing. *See* One- and two-color
 printing
Colorizing portions, photographs, 75

Conformity, grids, 41
Consistency
 fonts, 26
 text, 13
Contradictory to content, fonts, 26
Contrasty, 8
Cool v. warm colors, 115
Crumpling, fonts, 34

D

Die cutting, 131
Digesting, format, 90
Do-it-yourself designs, 130-139
 die cutting, 131
folds, 131
 found objects, 131
 leftover portions, printing on, 130
 printer, from your own, 131
 rubber stamps, 131
 stickers, 13
 waste portions, printing on, 130
Dominant clip art, 58
Dreamy concept, 9
Drills, production, 104, 106

E

Edges, photographs, 74
Elegant concept, 8
Emotional concept, 8

F

Faux backgrounds, 116
Folds, 90, 91, 131
Fonts, 24-37
 consistency, 26
 contradictory to content, 26
 crumpling, 34
 free, 27
 headlines, 26
 Internet, finding on the, 27
 key words, 26
 motion, using, 26
 multiple deck headings, 26
 personal preferences, 26

photographs, complementary with, 26
 picture fonts, 59
 platforms, transferring between, 27
 readability, 26
 scratching, 34
 shapes, words into, 27
 testing, 27
 texture, 27
 typography, professional, 27
Format, 88-101
 borrowing, 90
 digesting, 90
 folds, 90, 91
 grids, 92
 preprinted, 90
 printers, advice from, 90
 segmenting, 90
 size, 90
 tradition, going beyond, 90
 waste portion, printing on, 90
Found objects, 131
Found photographs, 75
Free fonts, 27

G

Grids, 38-55
 adjusting, 40
 background, 41
 changing, 41
 conformity, 41
 format, 92
 horizontal space, 41
 interrupting, 40
 left margins, 40
 neutral space, 41
 squares, 50
 surprise, adding, 41
 uneven column widths, 40
 white space, 52

H

Headlines, 12, 26
Horizontal space, grids, 41

I

Illustrations, mixing with photographs and clip art, 75

Imagesetting, 104

Inks, specialty, 117

Instant camera, 75

Internet

clip art, finding on the, 59

fonts, finding on the, 27

Interrupting grids, 40

K

Key words, 26

L

Leading, 12

Left margins, grids, 40

Lightening up, text, 12

Loud concept, 8

M

Mixing black-and-white and color photographs, 75

Mixing photographs, clip art, and illustrations

photographs, 75

Montages, clip art, 59

Motion, fonts that use, 26

Multiple deck headings, 26

N

Neutral space, grids, 41

O

Odd concept, 8

One- and two-color printing, 114-129

backgrounds, faux, 116

bidding, 117

black, using, 117

bleeds, 116

compatibility colors, 116

complementary colors, 115

contrast colors, 115

cool v. warm, 115

faux backgrounds, 116

heavy coverage, 117

"one over two," 116

paper, colored, 116

piggybacking, 116

restraint, 116

screening, 115

specialty inks, 117

split fountains, 117

tight register, avoiding, 116

unpredictability, 117, 118

warm v. cool, 115

Opposite concept, 8

P

Painting over photographs, 74

Paper

alternative-use, 103

colored, 116

interesting, 12

leftover portions, printing on, 90

passion, avoiding, 102

pinstripe, 14

waste portions, printing on, 90

Paragraphs, shortening, 12

Personal preferences, fonts, 26

Photo booth, 75

Photographs, 72-87

archives, 74

captions, 75

colorizing portions, 75

distorting, 74

edges, 74

fonts complementary with, 26

found, 75

instant camera, 75

mixing black-and-white and color, 75

mixing with clip art and illustrations, 75

painting over, 74

photo booth, 75

repeating, 74

stock, 74

student photographers, 74

text, putting in, 75

Picture fonts, 59

Piggybacking

one- and two-color printing, 116

production, 104

Pinstripe paper, 14

Platforms, transferring fonts between, 27

Playful concept, 9

Preprinted format, 90

Printers

advice from, 90

be your own, 131

bidding, 117

passion, avoiding, 103

Production, 102-113

alternative-use paper, 103

bartering, 104

drills, 104, 106

imagesetting, 104

paper, alternative-use, 103

paper passion, 102

piggybacking, 104

printer passion, 103

proofreading, 104

testing, 104

trims, 104

Proofreading, 13, 104

Pull quotes, 12

R

Readability, fonts, 26

Rubber stamps, 131

S

Scratching, fonts, 34

Screening

clip art, 59

one- and two-color printing, 115

Segmenting, format, 90

Shape-filled concept, 9

Shapes, words into, 27

Similar concept, 8

Size of format, 90

Size-shifted concept, 9

Small clip art, 58
Specialty inks, 117
Split fountains, 117
Squares, grids, 50
Stickers, 131
Stock photographs, 74
Structured concept, 8
Student photographers, 74
Subheadings, 12

T
Testing
 fonts, 27
 production, 104
Text, 10-23
 accent colors, 13
 consistency, 13
 headlines, 12
 leading, 12
 lightening up, 12
 paper, interesting, 12
 paragraphs, shortening, 12
 photographs, putting in, 75
 proofreading, 13
 pull quotes, 12
 subheadings, 12
 wrapping, 58
Texture, fonts, 27
Time-related, 8

Trims, production, 104
Two-color printing. *See* One- and two-color
 printing
Typography, professional, 27

U
Uneven column widths, grids, 40
Unexpected, 8
Unpredictable, 9

W
Warm v. cool colors, 115
Waste portions, printing on, 90, 130
White space, grids, 52
Wrapping text, 58